BRANDT NUDES

BRANDT NUDES
A NEW PERSPECTIVE

With commentaries by Mark Haworth-Booth
and original preface by Lawrence Durrell

144 duotone illustrations

Thames & Hudson

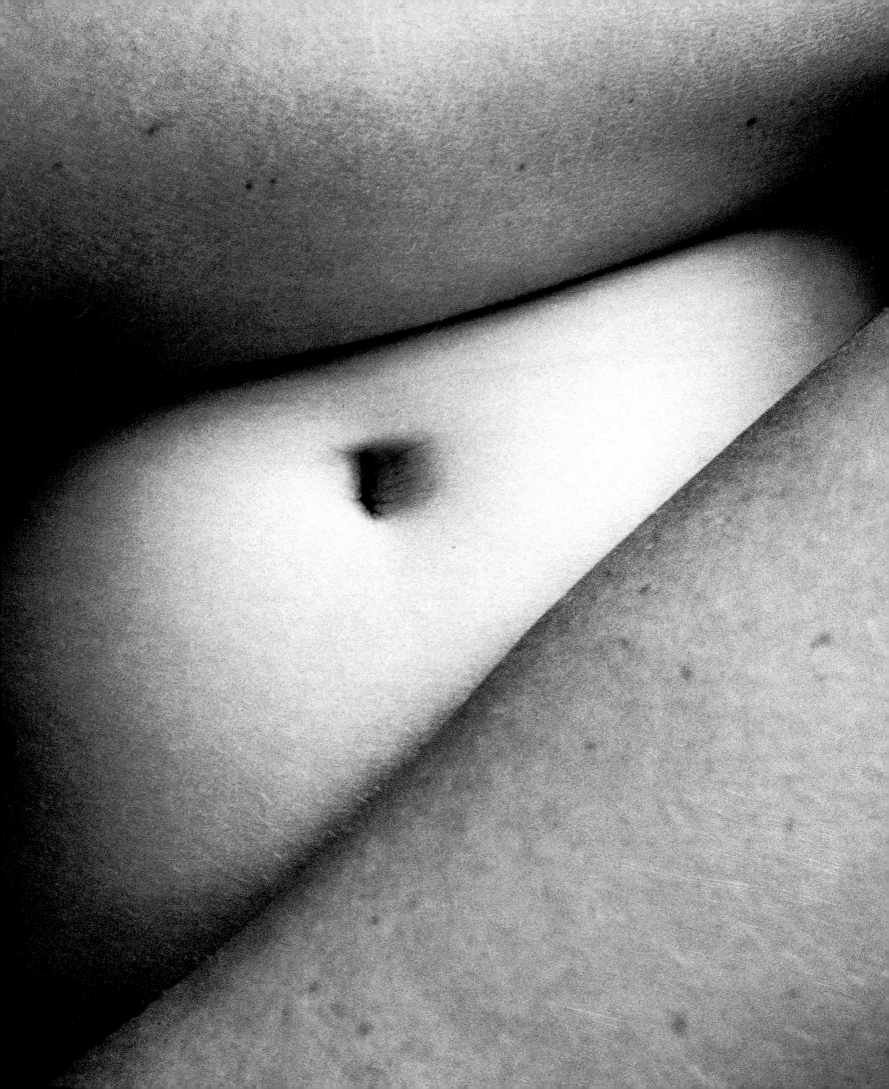

'Celui-là, c'est un maître!'

We were sitting in front of an olive wood fire, Brassaï, the child and I, talking photographs. All around us, spread on the floor, were Brassaï's illustrations to a book on Paris. But the remark he made was about an English photographer who is easily his peer – Bill Brandt.

Nor is the mention of Brassaï here inapposite, for if he is the European maître, Brandt is incontestably the English. And so different are their styles that it is worth comparing the two approaches to photography, for they complement one another by their very difference.

Brandt uses the camera as an extension of the eye – the eye of a poet; he is to photography what a sculptor is to a block of marble. His pictures read into things, try to get at the hidden presence which dwells in the inanimate object. Whether his subject is live or not – whether woman or child or human hand or stone – he detaches it from its context by some small twist of perception and lodges it securely in the world of Platonic forms. Brassaï is the poet of the human condition, his best pictures are snatched from real life, and reflect the poignance and beauty and despair of the human condition. Even when he goes after a tree or a park bench it is the human connotation which sticks out; his work is touching by its humanity.

But Brandt broods over the nature of things and makes a quiet poetic transcript of them; his work is a prolonged meditation on the mystery of forms. In his best pictures one comes up against the gnomic quality which resides in poetry and sculpture, one forgets the human connotation as if one were reading a poem – even though, as I say, the subject is a human being.

These pictures express the extraordinary merits of his work far better than words can; the play of form and tone sail up out of the prints to startle and confuse one by their authority. If Brassaï finds his style best in his illustrations to the Paris of a Henry Miller or Carco, then Brandt's work should fittingly illustrate Rilke's *Duinese Elegies*.

There is nobody of his stature in England today.

Lawrence Durrell, 1961 [1]

5

1. First published in *Perspective of Nudes*, 1961

Bill Brandt thought of his nudes as the fullest expression of the poetic photography to which he aspired. The present book is the most extensive representation of this part of his oeuvre. His long exploration of the nude – essentially from the early 1940s to the late 1970s – is perhaps the most imaginative, intense and controversial of all his projects.

This essay describes the process by which the series began and developed into the books *Perspective of Nudes* (1961) and *Bill Brandt: Nudes 1945-1980* (1980). Brandt himself laid out those books in carefully chosen visual chapters. He sometimes mixed early and late photographs in the sections, depending on the theme, and the same practice has been followed here. The early experiments in the pages of this introduction are followed by Brandt's first section: nudes in interiors, photographed with a conventional camera (a Miroflex) and then a newly-acquired wide-angle one. Next, he moves closer to the body and allows the camera to reveal the body in bold and unexpected ways. In section three he moves closer in still, and the limbs float into ambiguous patterns. Section four releases the body to the beach; section five relocates the model to interiors, mostly studios. Section six shows us the body transformed by objects, and

section seven returns us to the seashore in a sublime finale.

Bill Brandt (1904-83) took up photography as a career in Vienna in 1928, but the seeds of his photography of the nude were planted in Paris in 1930.[1] 'Those were the exciting days', he recalled, 'when the French poets and surrealists recognised the possibilities of photography… Man Ray, the most original photographer of them all, had just invented the new techniques of rayographs and solarisation. I was a pupil in his studio, and learned much from his experiments.'[2]

A Salvador Dali print and a Man Ray photograph of a nude hung in Brandt's London flat in the 1930s. One of his early experiments with the nude is a solarised photograph which he inscribed 'Wien-London' and dated 1934: the year he settled in London.[3] Brandt built up an extensive library, the contents of which embraced standard works by Freud, an abundance of poetry, classics of English and foreign literature – including de Lautréamont, Beckett, Sartre and Camus – plus many books on modern art, including works on Degas, Renoir, Bonnard, Matisse, Picasso, de Chirico, Modigliani and Arp.

Brandt regularly published his photographs in the sumptuous Paris art magazine *Verve*, launched in 1937,

1. P. Delany, *Bill Brandt: A Life* (London, 2004) illuminates the early years, when Brandt began experimenting with nude photography, and re-dates the apprenticeship to Man Ray from 1929 to 1930
2. N. Warburton, ed., *Bill Brandt: Selected texts and bibliography* (1933), p.29
3. Formerly in the collection of Rolf Brandt

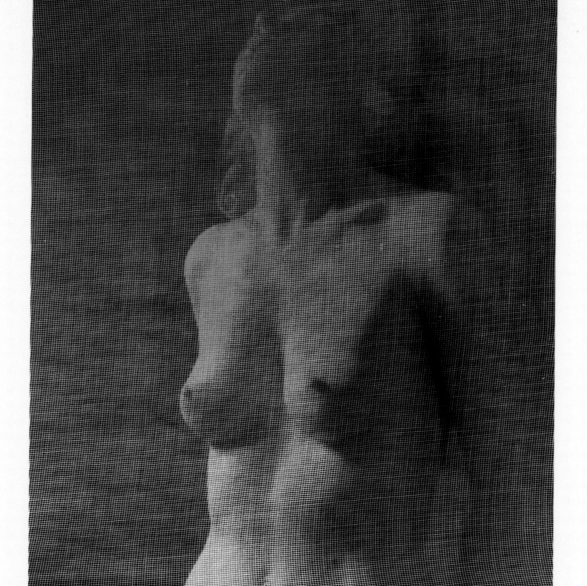

which featured paintings, drawings and sculpture from the Ecole de Paris, together with leading European photographers and writers. *Verve* constantly published nudes in all media and printed an essay on the subject by Paul Valéry in its second issue, in Spring 1938. Valéry traced the subject back to the discovery of nakedness in the Garden of Eden, humanity's primal scene, and reflected that 'The prestige of the Nude was a natural by-product of that glamour of secrecy and instant danger with which, in its dual role of an illicit revelation and a pernicious lure, it was invested….' All these qualities inhabit the early sections of this book and reappear towards the close.

By the end of the 1930s Brandt was familiar with Man Ray, Edward Weston (with whom he exhibited in the touring version of *Film und Foto* of 1929) and the world of Parisian art. However, Kenneth Clark described the problem of this branch of photography in the opening pages of *The Nude: A Study of Ideal Art* (1956). Unlike the sculptors of athletes in classical Greece, photographers – despite all their skill and

tricks – were crucially hampered by the remorseless realism of their medium: 'We are immediately disturbed by wrinkles, pouches and other small imperfections which, in the classical scheme, are eliminated. By long habit we do not judge it as a living organism, but as a design; and we discover that the transitions are inconclusive, the outline faltering. We are bothered because the various parts of the body cannot be perceived as simple units and have no clear relationship to one another. In almost every detail the body is not the shape which art has led us to believe that it would be'.

Bill Brandt's great series of nudes, made in exactly the same years as Clark researched and wrote his treatise, rebuts all of Clark's thoughtful objections – as we shall see. The series began quite modestly with a nude, veiled by muslin in the style of Man Ray and Erwin Blumenfeld, which was published in *Lilliput* in February 1942. Others, simple standing nudes, were emphatically-lit in ways that hint at what was to come.

8

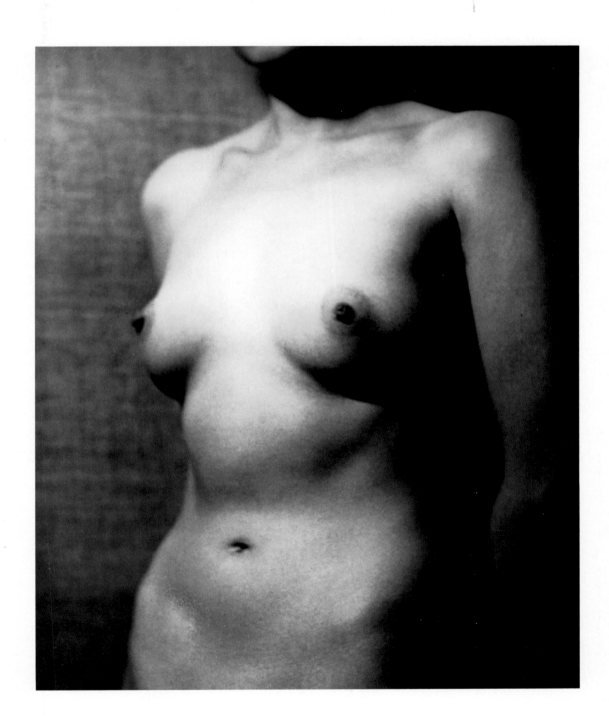

9

10

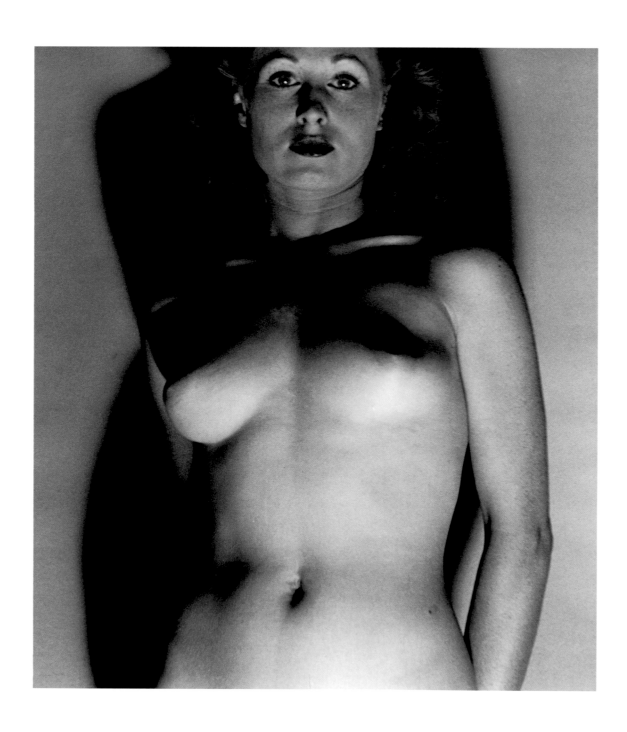

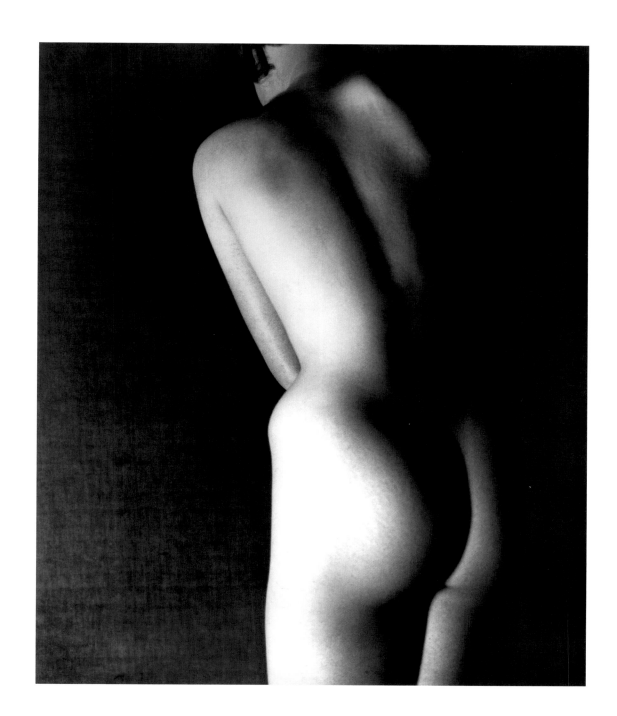

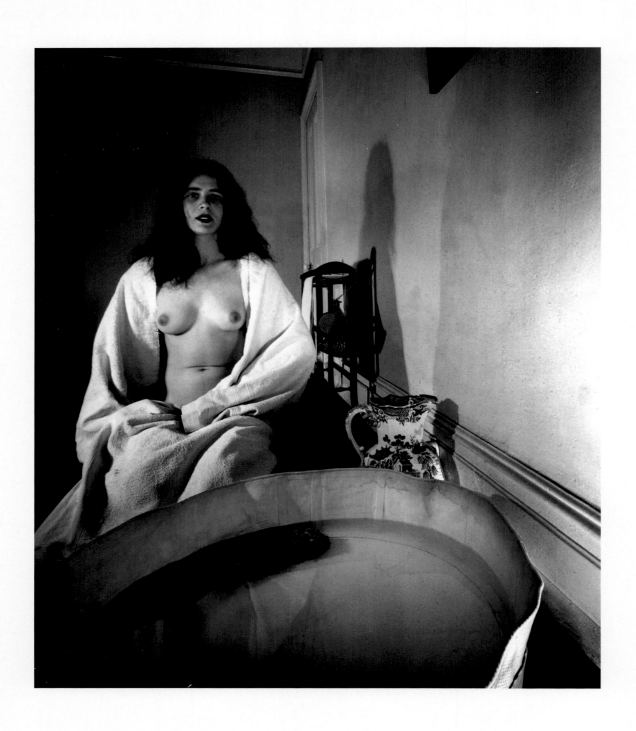

1

'It was after the war, when I was busy photographing London celebrities for English and American magazines, that I began to feel irritated by the limitations imposed by such jobs. I was taking portraits of politicians, artists, writers, actors, in their own surroundings, but there was never enough time for me to do what I wanted. My sitters were always in a hurry. Their rooms were rarely inspiring backgrounds, and I felt the need for exciting backgrounds to make pictures of the portraits. I wanted more say in the pictures; I wanted rooms of my own choice. And so I came to nudes. Nudes, at that time, were photographed in studios. I thought of photographing them in real rooms....' [1]

Brandt suggested the idea to Leonard Russell, editor of *The Saturday Book* (an annual compendium of essays and images), who commissioned a set of 16 photographs. When the publication's proprietor began a 'Purity' campaign and Russell withdrew the commission, Brandt went ahead anyway. Ian Jeffrey has written about the 'challenge to male apprehension' offered by the direct gaze of the early nudes (published in *Lilliput* in 1948-49). [2] Brandt greatly admired Balthus and the unsettling combination of realistically rendered nude women and conventional interiors also recalls Francis Gruber (1912-48), whose work – which parallels the Existentialist novel – Brandt would have seen in *Verve*. The earlier nudes were made on 90 x 120 mm negatives with the Zeiss-Ikon Miroflex Brandt used for his early reportage. In 1945 the V&A showed a Picasso and Matisse exhibition – a vivid sign that peace had truly returned. Perhaps the event helped to prompt Brandt's new ambition for his photography?

A year earlier advised by the painter photographer Peter Rose-Pulham, Brandt bought a secondhand brass and mahogany camera. He thought it was Victorian but it was actually a 1931 Kodak Wide-Angle. It had a fixed lens, covering a 110 degree angle. Anything four feet or more from the lens would be in focus. The lens, with an aperture as minute as a pinhole, focussed on infinity. Brandt's friend Norman Hall noted that he sometimes referred to the nudes he made with this camera as 'Infinities'. [3] Now strongly-shadowed figures begin to loom uncannily from twilit rooms.

13

1. N. Warburton, op. cit., p. 121
2. I. Jeffrey, *Bill Brandt: Photographs 1928-1983* (1993), p. 38
3. N. Hall, ed., *Photography Year Book* 1962, p. 165

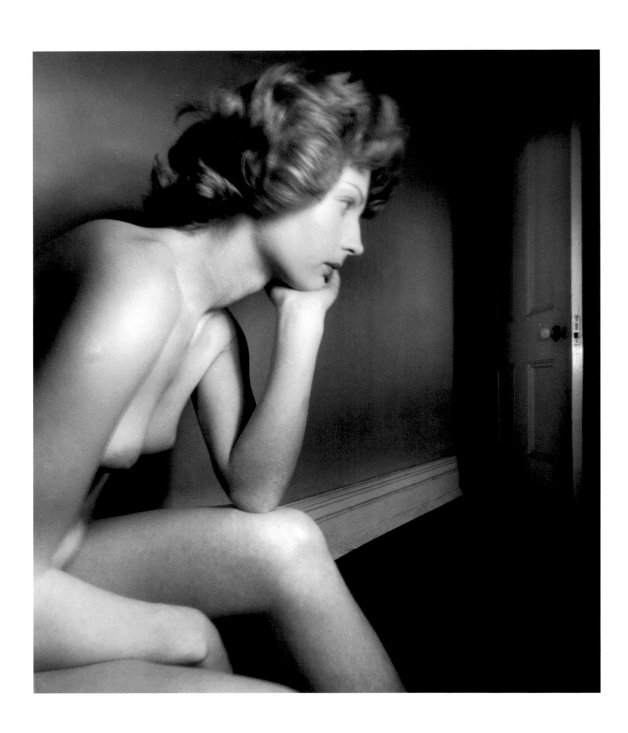

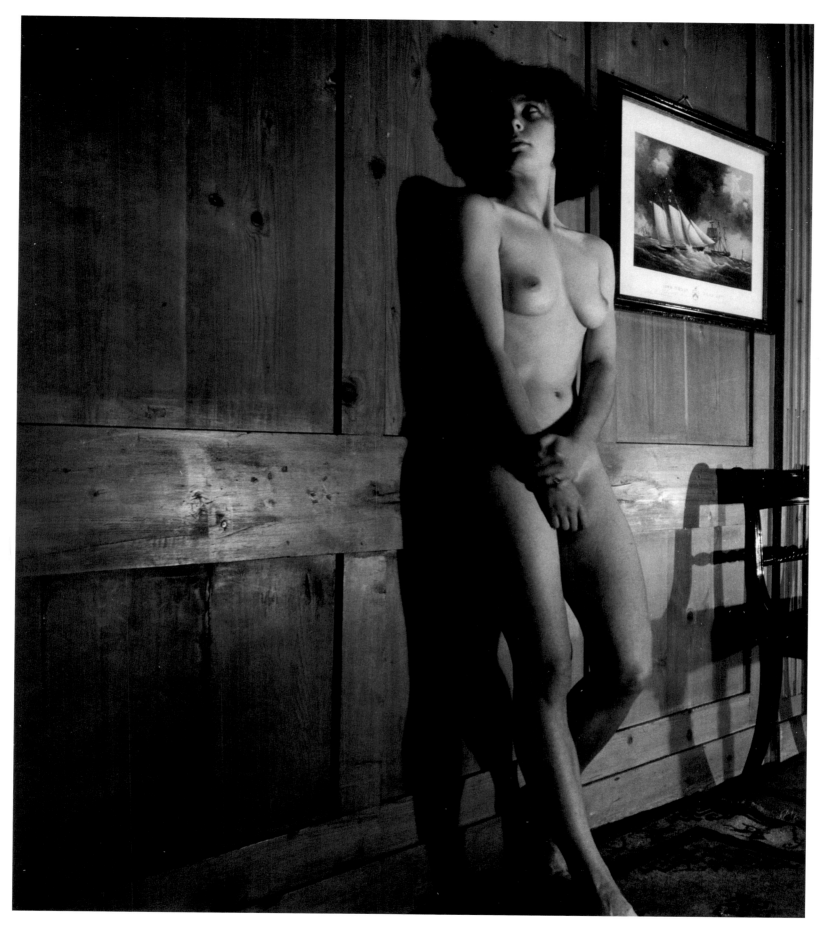

15

16

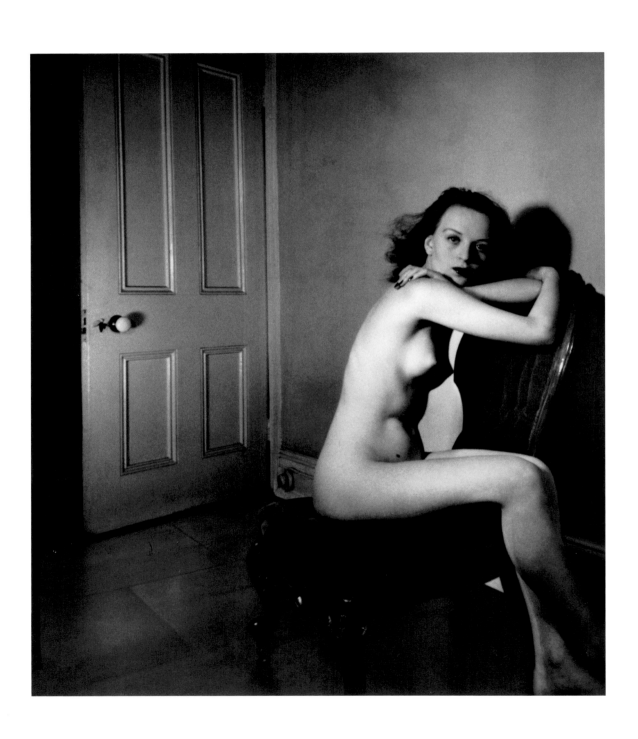

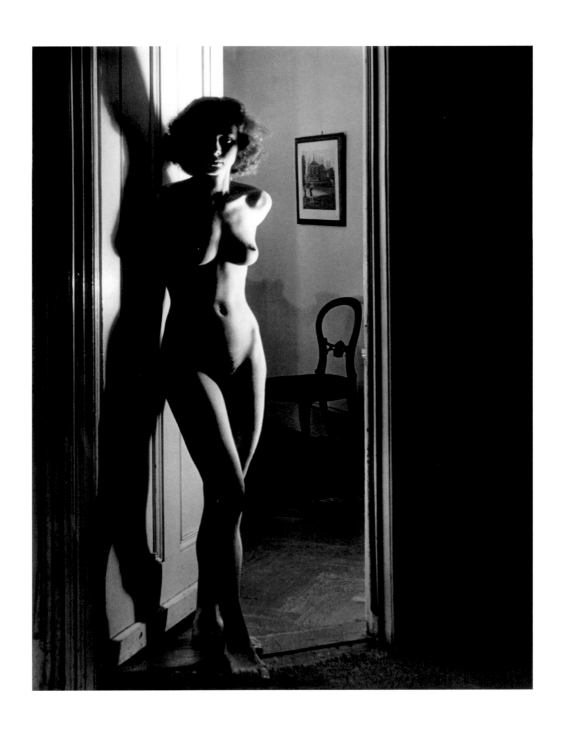

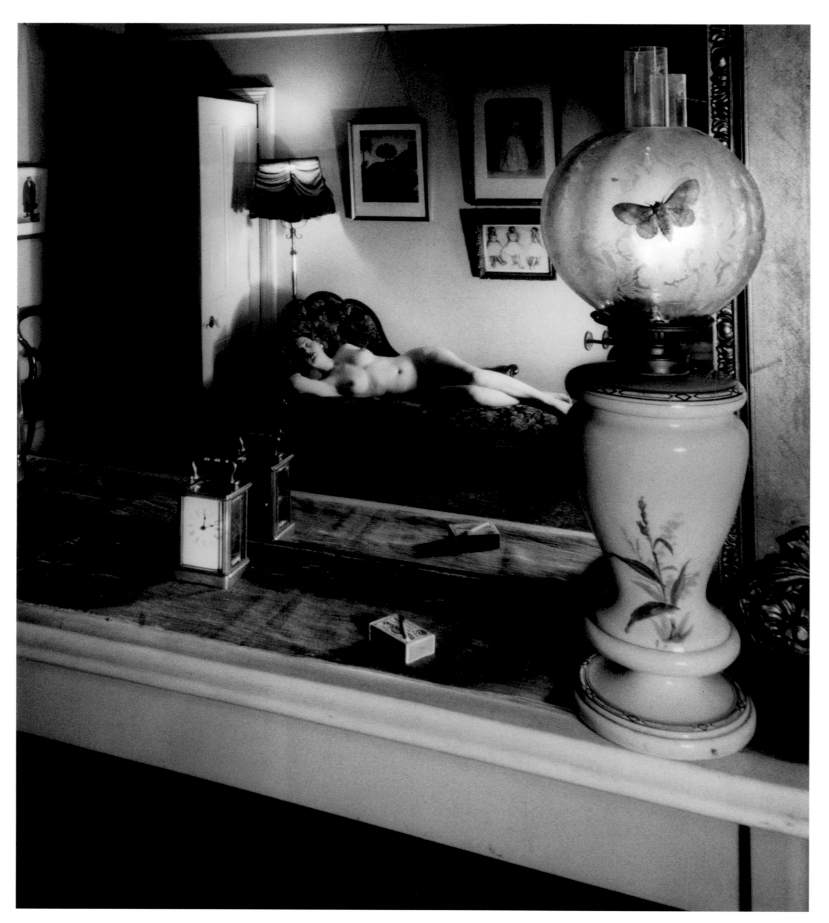

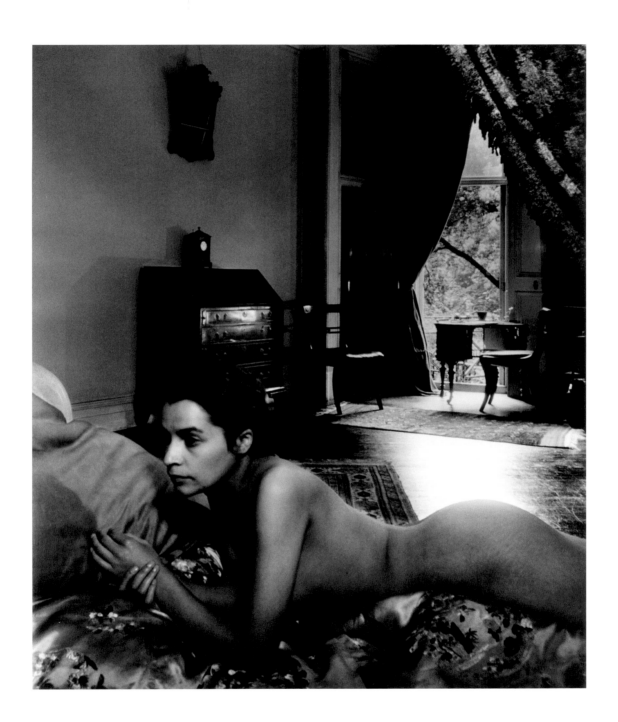

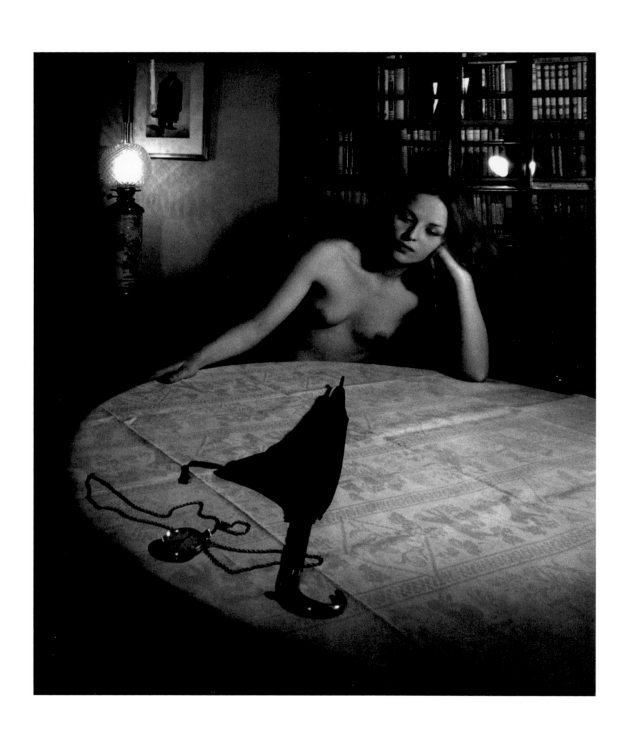

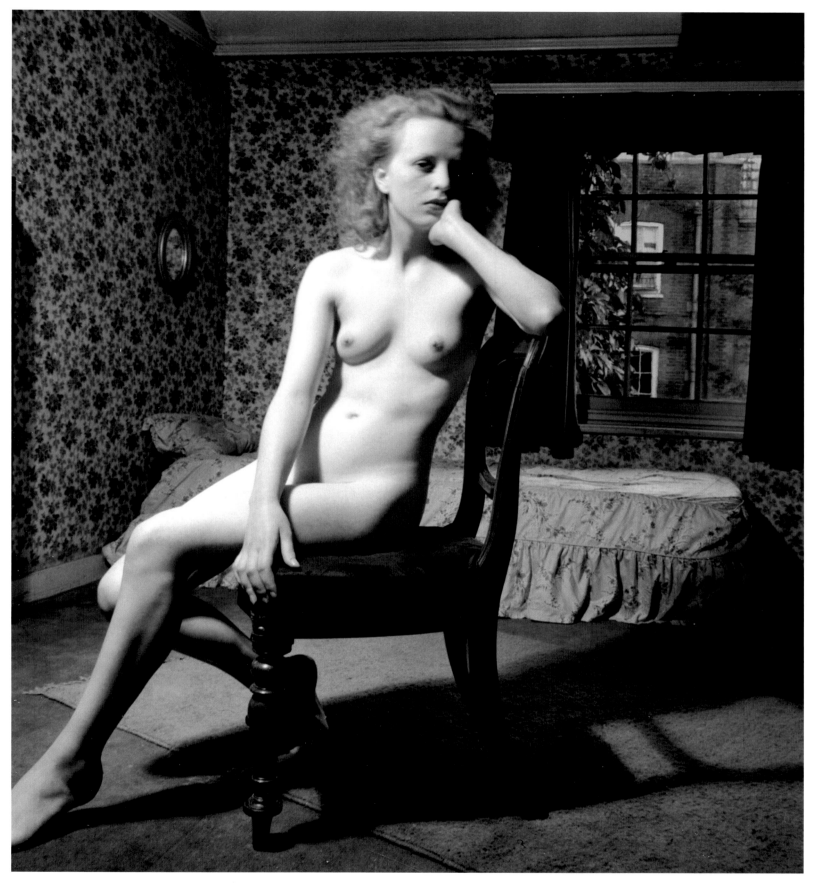

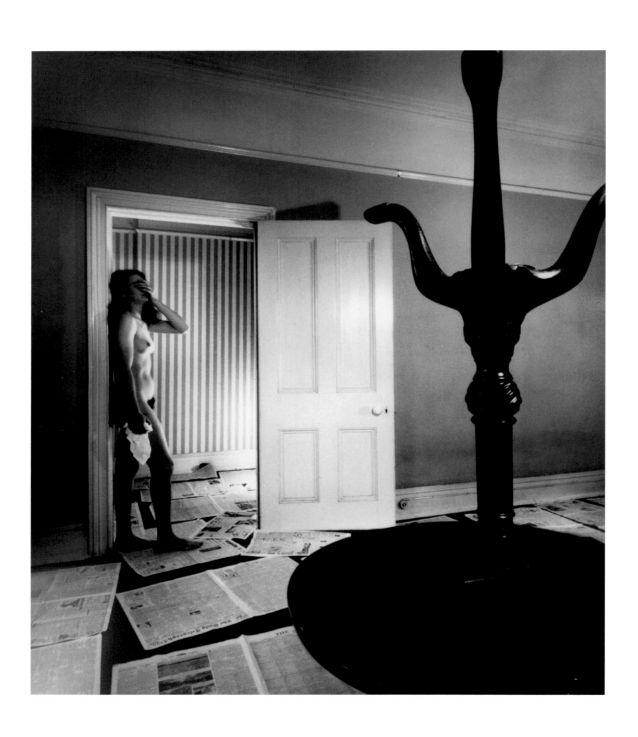

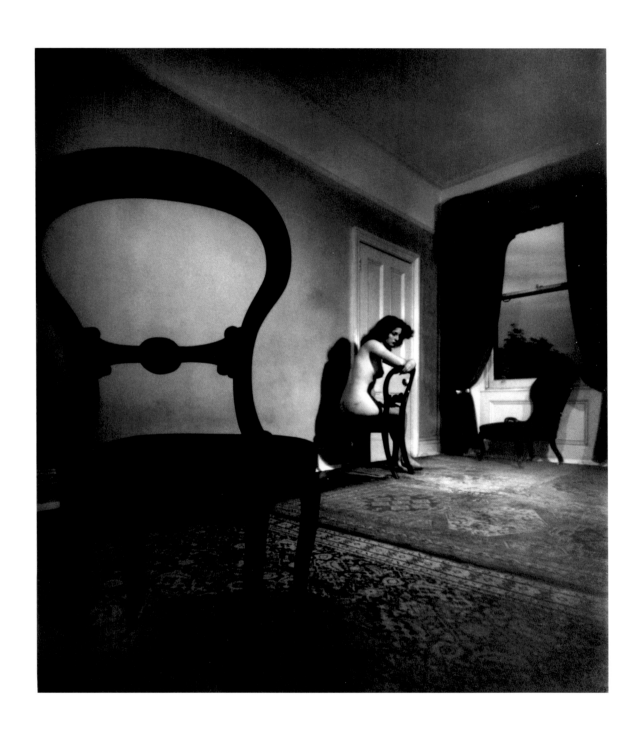

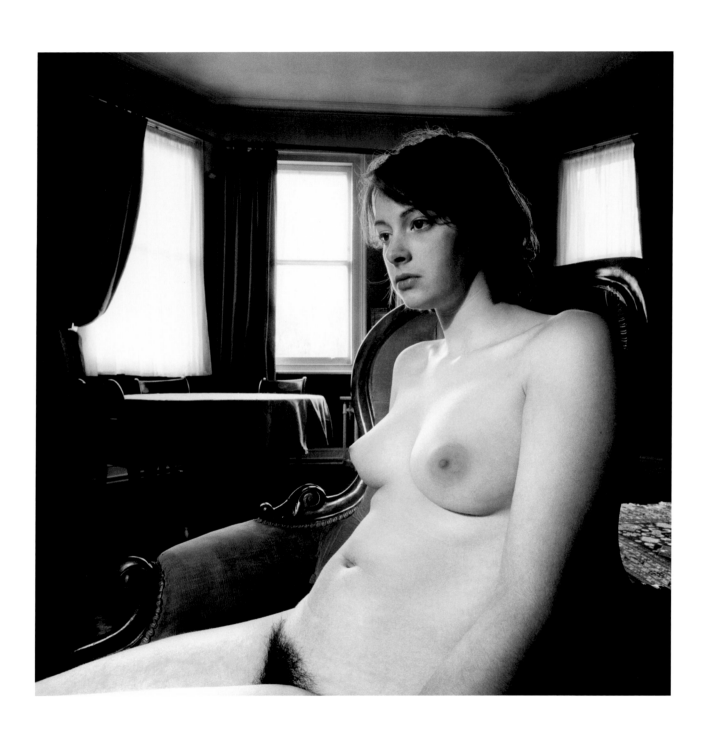

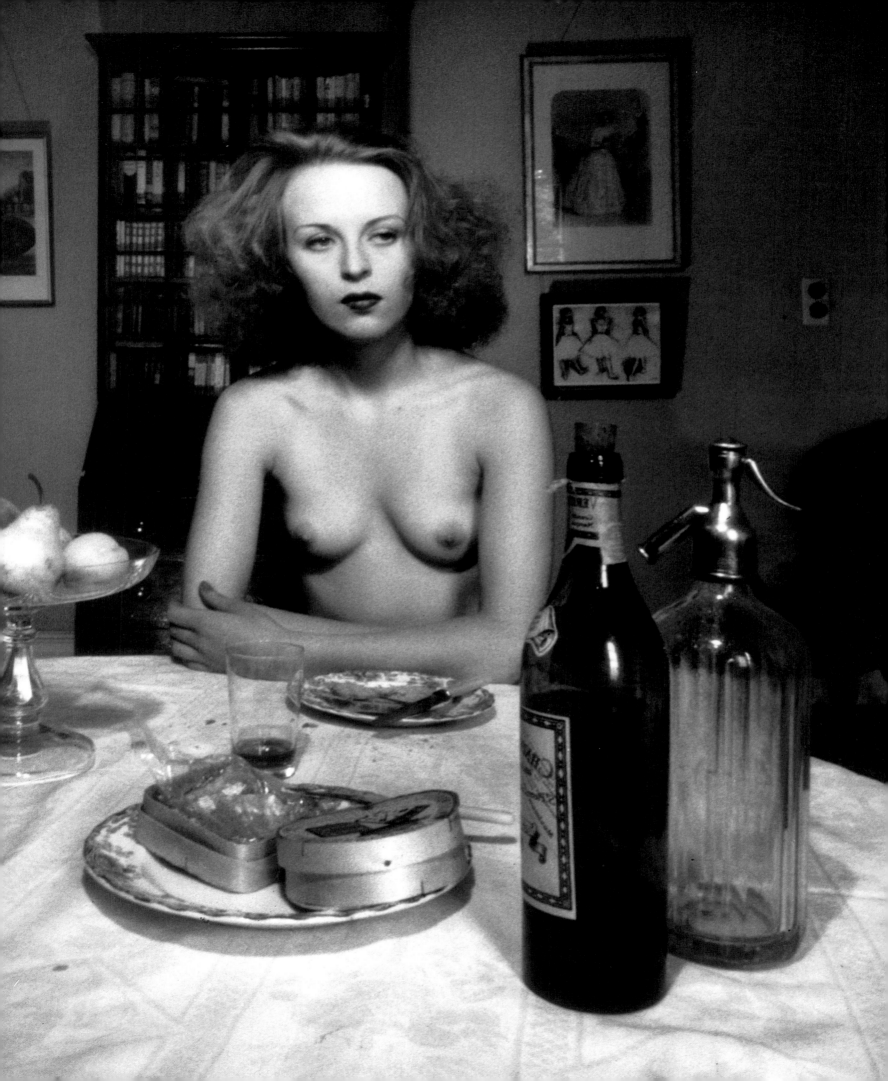

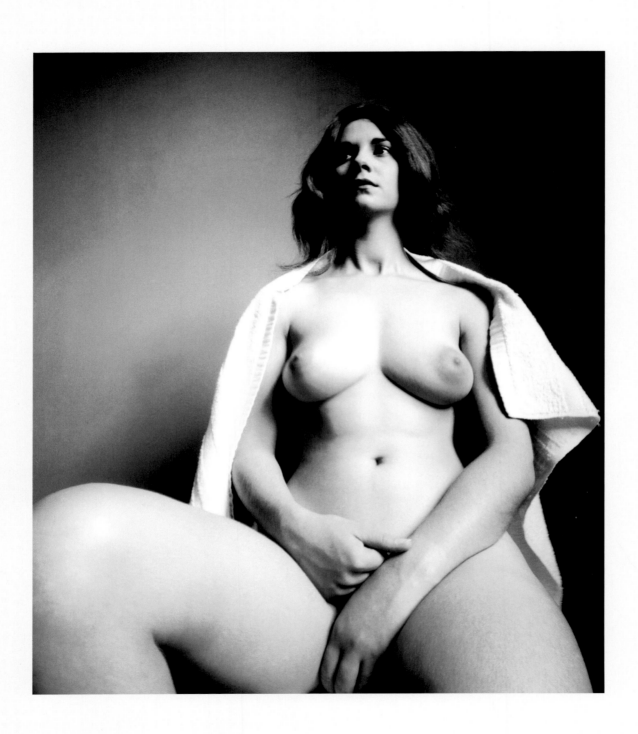

2

'Delighted to have found a camera which was not designed to imitate human vision and conventional sight, I let myself be guided by the lens.' [1] Even under the dark cloth, the image seen on the ground glass of the Kodak Wide-Angle – with its 130 x 160 mm negative – is very dim. Brandt was working almost blind and his technique relied on chance. This appealed to his Surrealist sensibility, as did the crime scenes hidden in the history of the camera itself.

The adoption of wide angle, deep focus photography derived from Brandt's enthusiasm for Orson Welles's film *Citizen Kane* (1941). Deep focus and oppressive spaces appear in the next Welles film, *The Magnificent Ambersons* (1942). The paintings of Balthus and Magritte also stage surprising events in charged, tightly-defined spaces.

Brandt generally employed professional models and used rooms belonging to his friends and family. However, Marjorie Beckett, who became his second wife, sometimes modelled for the series and appears in perhaps the most tender and erotic of all the nudes, number 29. [2] The somewhat Victorian setting of this and other photographs connects with Brandt's passionate rediscovery of the period, shared by the writer Sir John Betjeman and painters such as John Piper.

Victoriana are also to be found – alongside Picasso and photographs by Brandt – in the pages of the Surrealist magazine *Minotaure*. Like Man Ray, Brandt manipulated wilfully. In number 57 he balanced his photo-floods and the natural light outside but then dodged the sky to achieve a more subdued, twilit, effect. Number 37, taken in the house of Brandt's father at Micheldever in Sussex, has been interprveted by David Alan Mellor in terms derived from the influential writings of Jacques Lacan: it was surely no coincidence that the uncanniest of the late '40s nudes, 'Micheldever Nude' (1948) – a sphinx-faced chimera gazing gorgonically at camera and spectator, her right arm extended in demand – was photographed in a darkened room, with door ajar, in Brandt's father's house. For there, at the table, the anamorphic projection of Brandt's 6x8 view camera distended and attenuated into an anxiety-provoking vision of the power of the Father and the disclosure of the Woman's body. There, traced out like the enigmatic skull in Holbein's *Ambassadors* (1533) or Dali's soft objects, is 'the phallic ghost... the imaged embodiment of castration'. [3]

27

1. N. Warburton, op. cit., p, 122-23
2. Numbers cited refer to page numbers
3. M. Haworth-Booth & D. Mellor, *Bill Brandt: Behind the Camera* (1985-2004), p.85

28

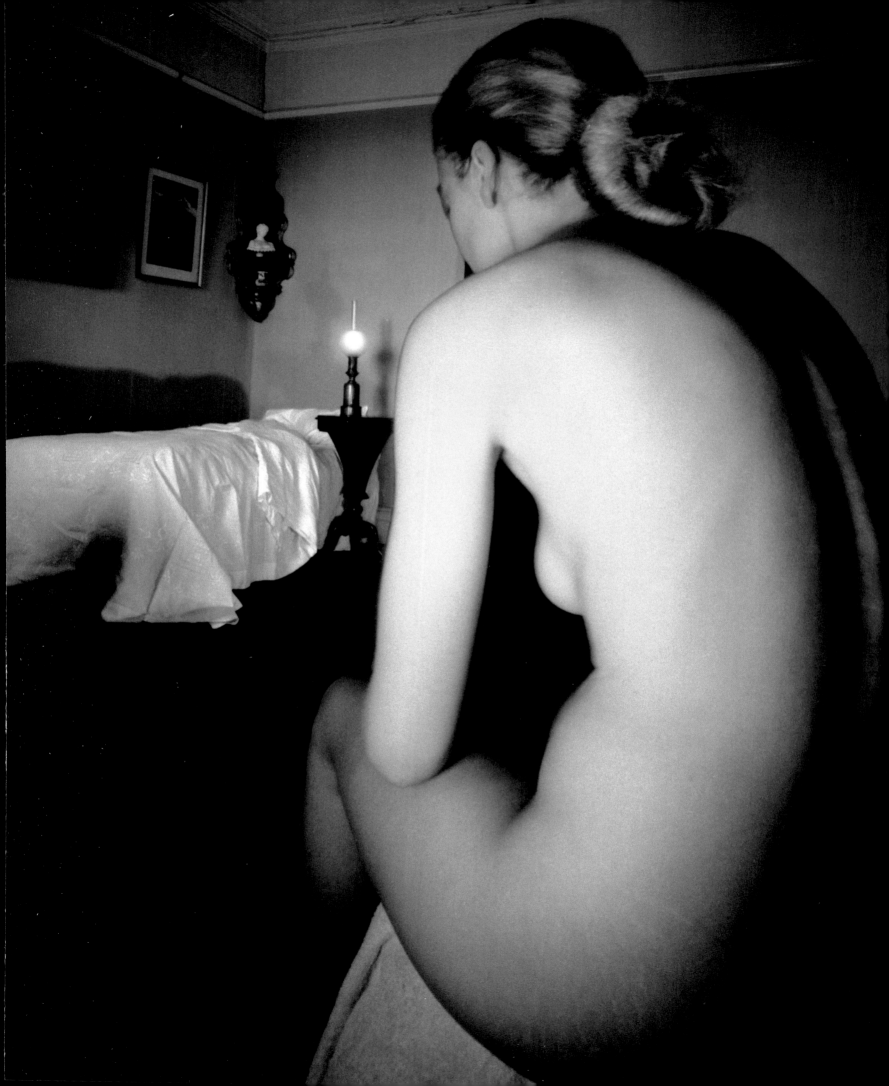

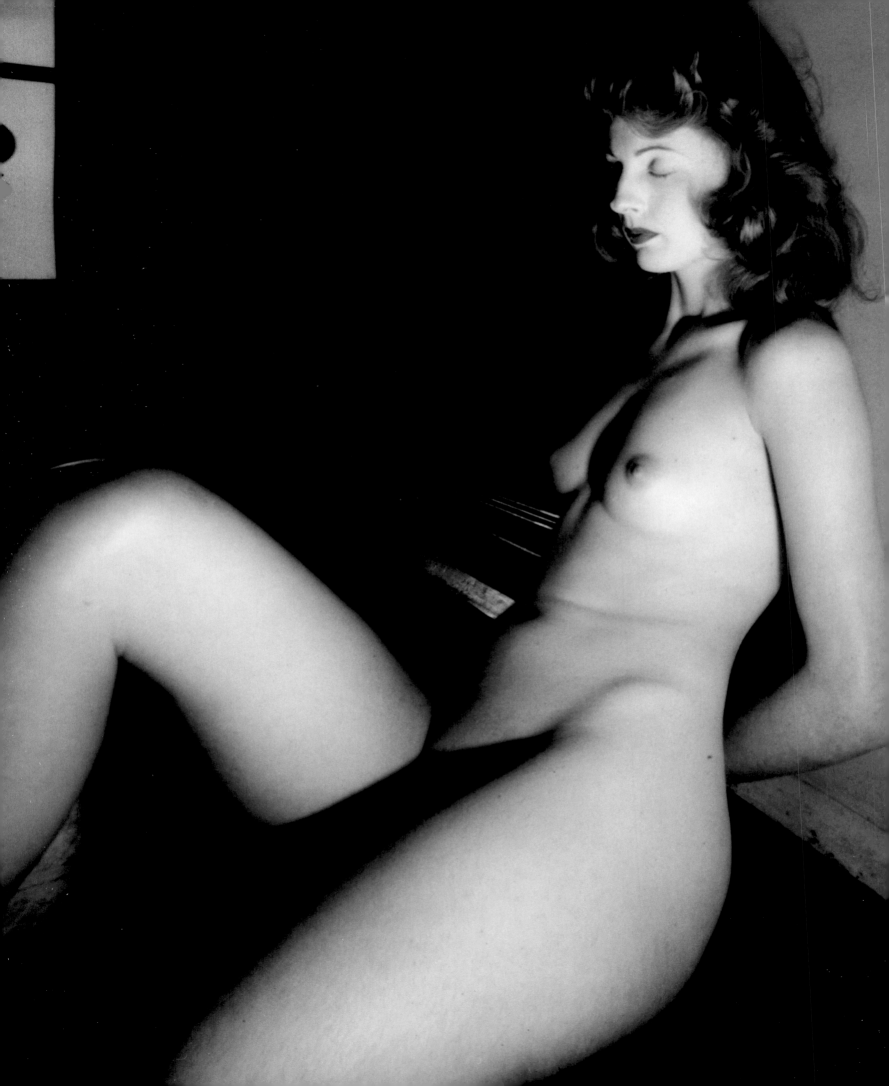

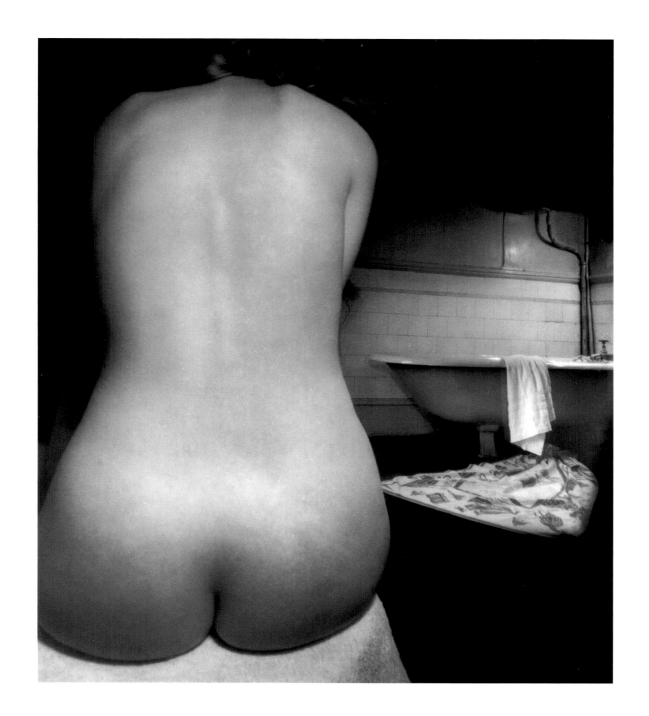

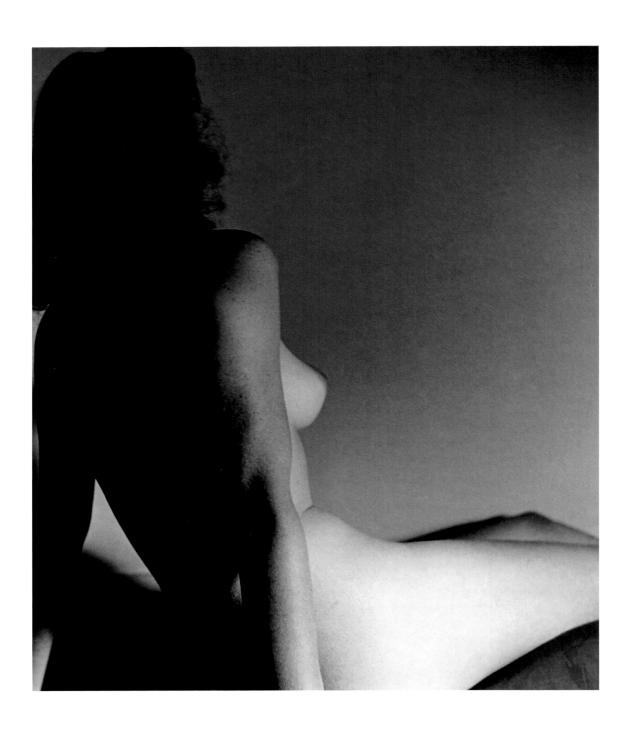

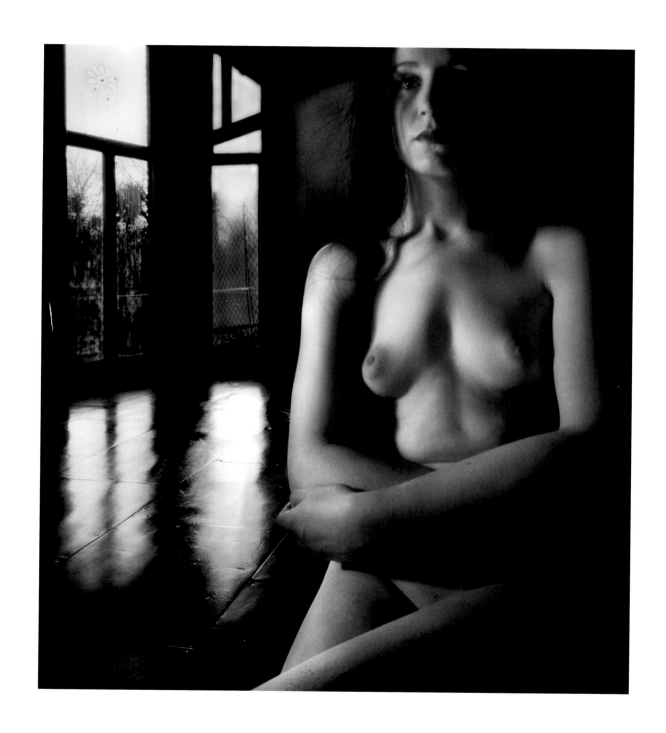

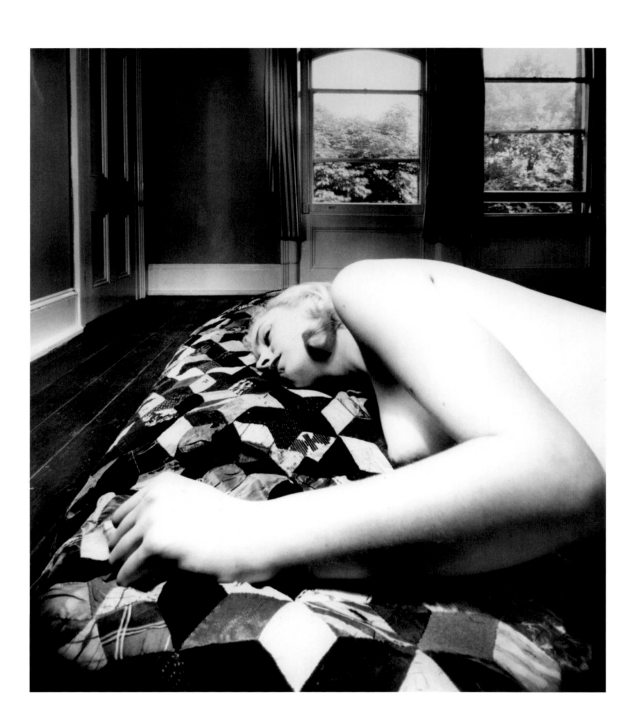

34

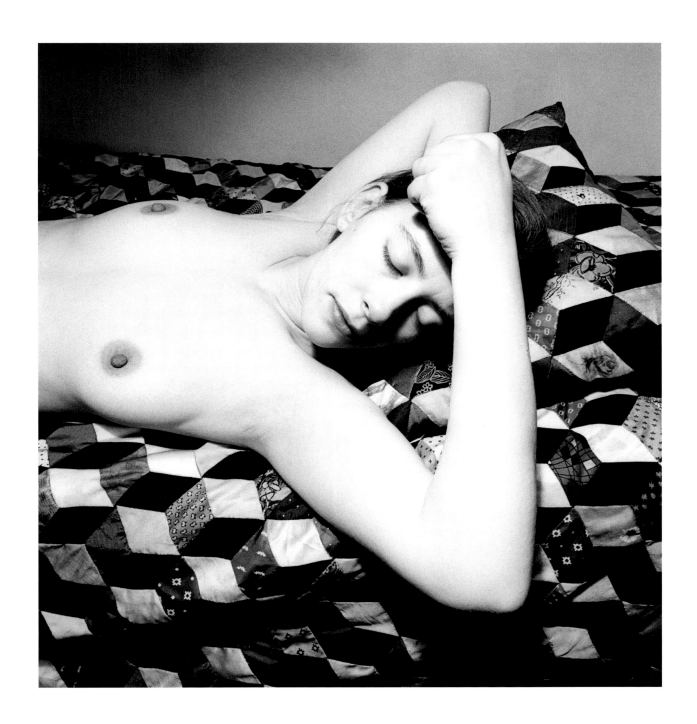

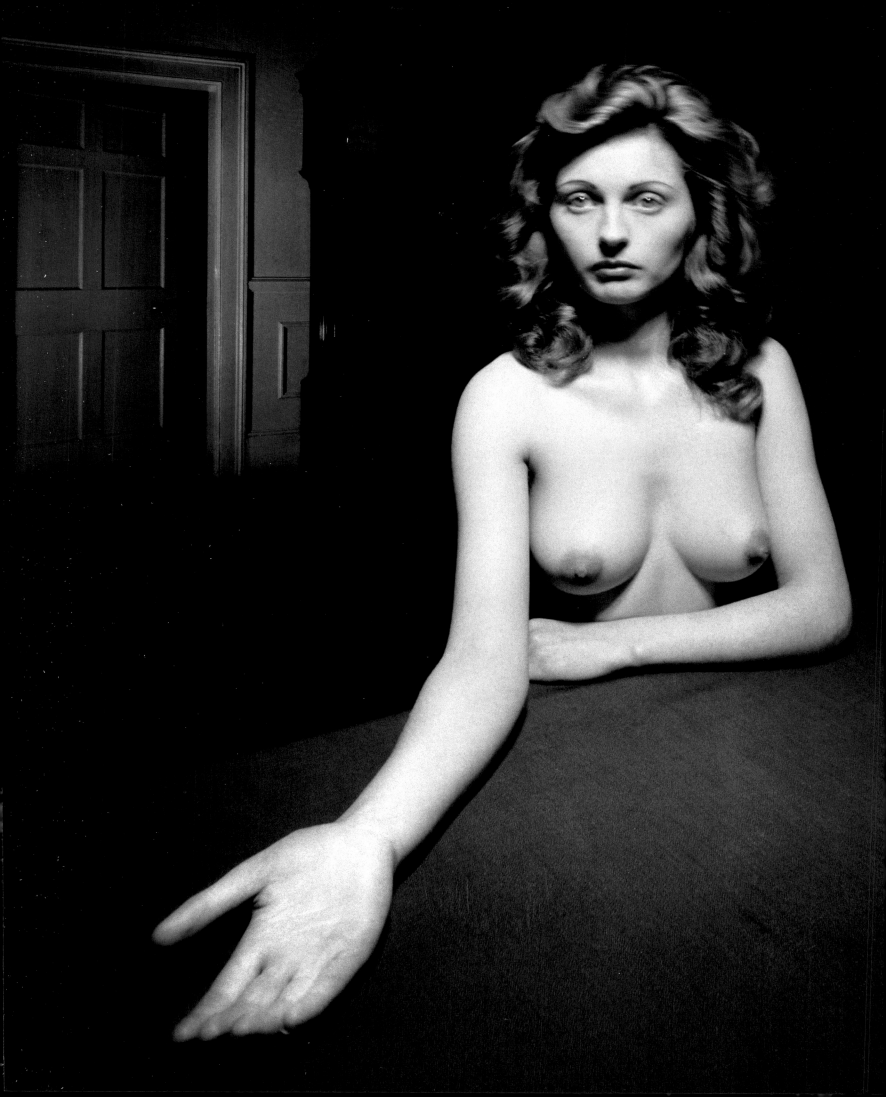

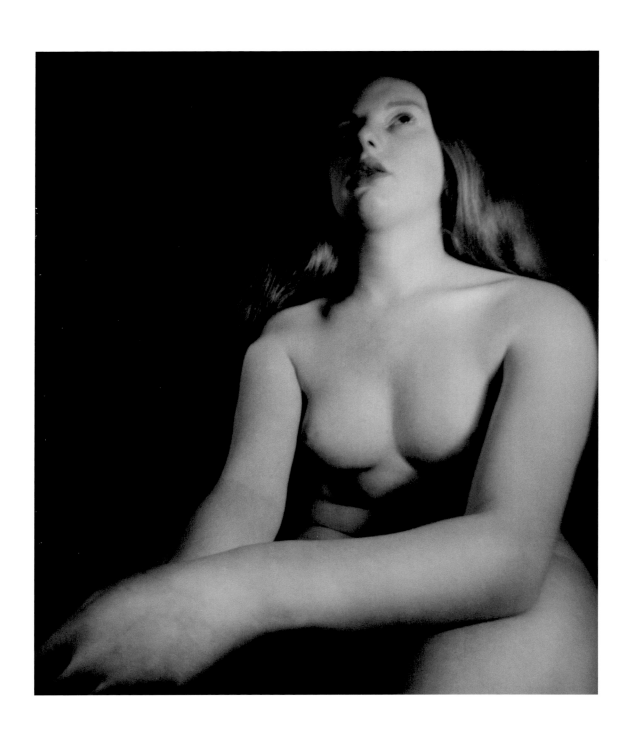

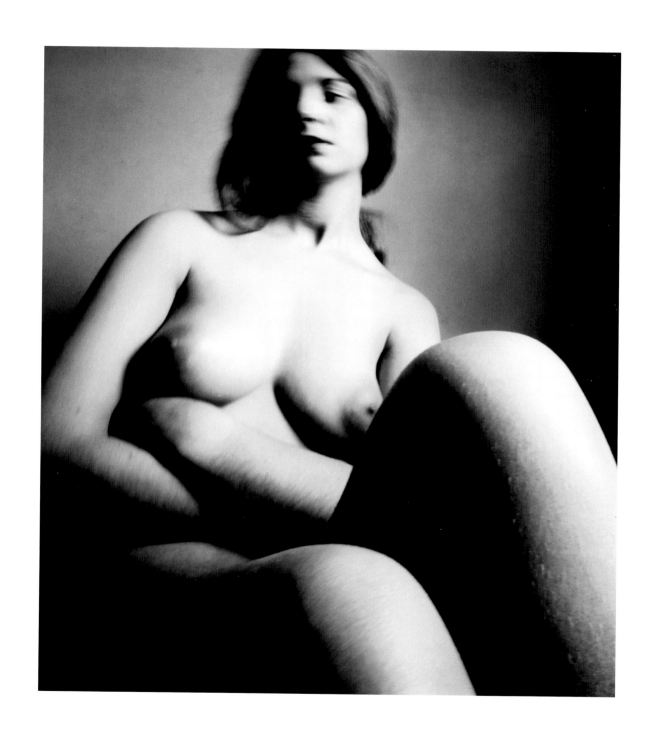

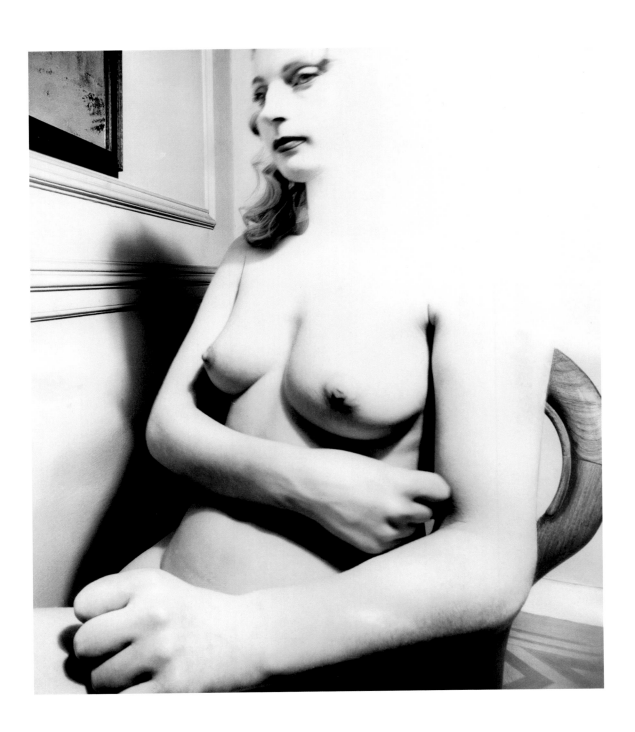

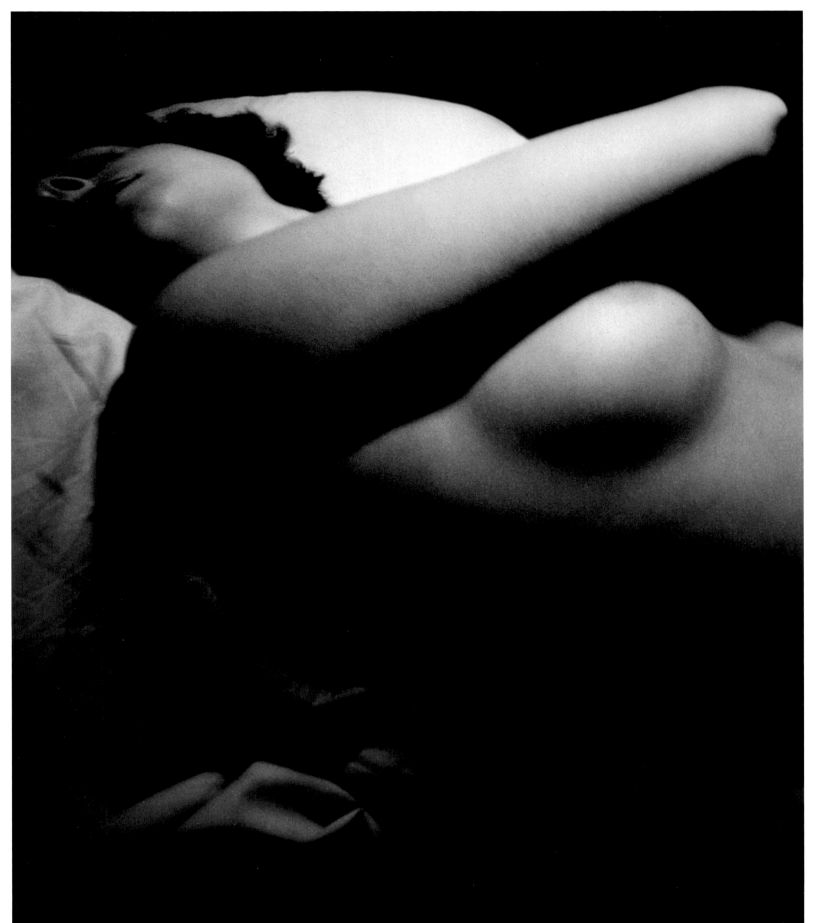

42

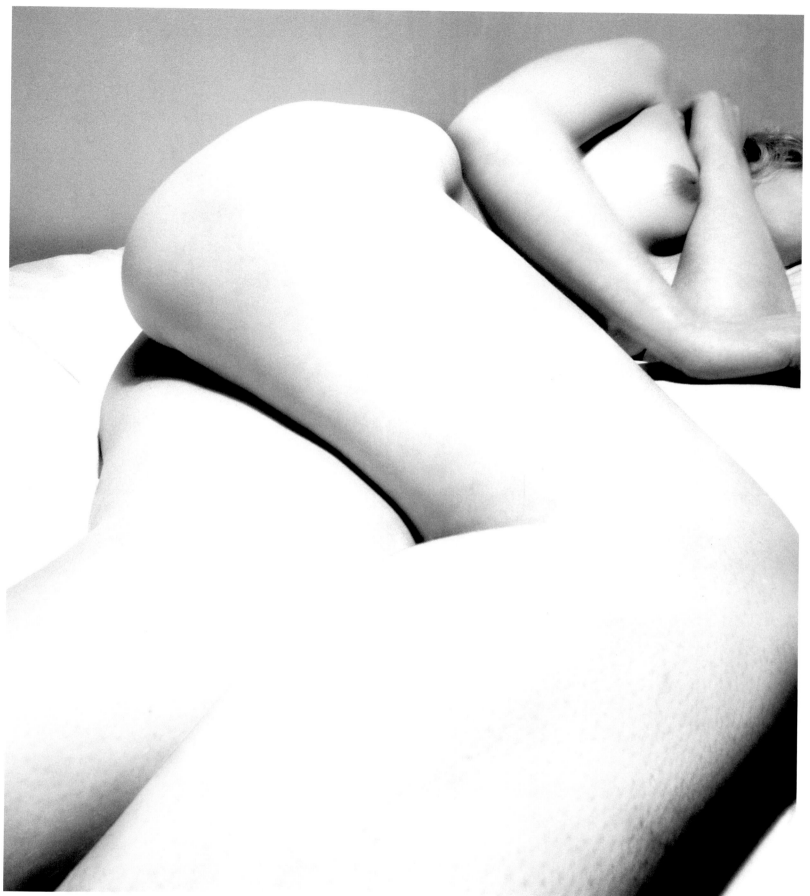

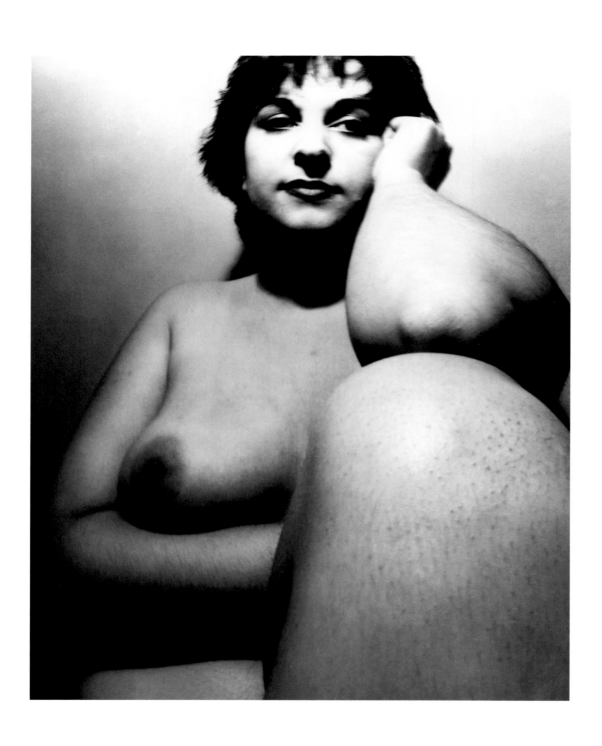

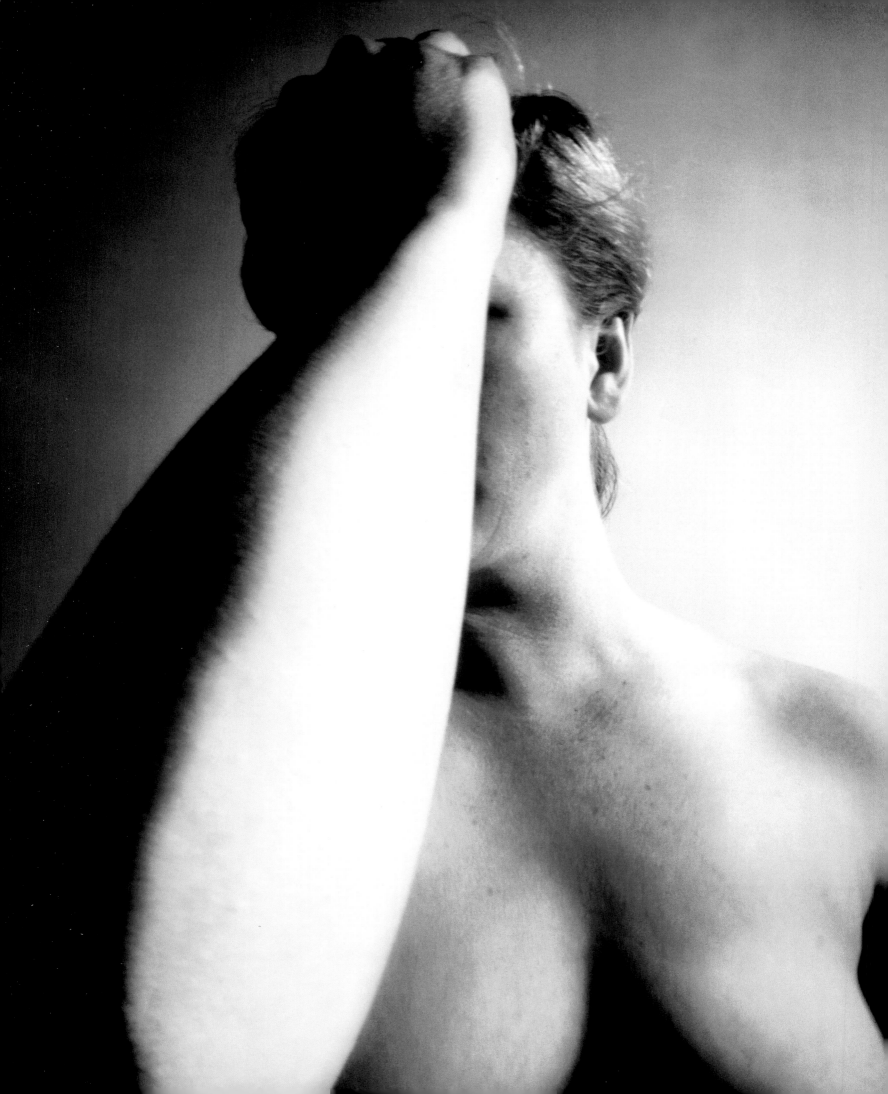

46

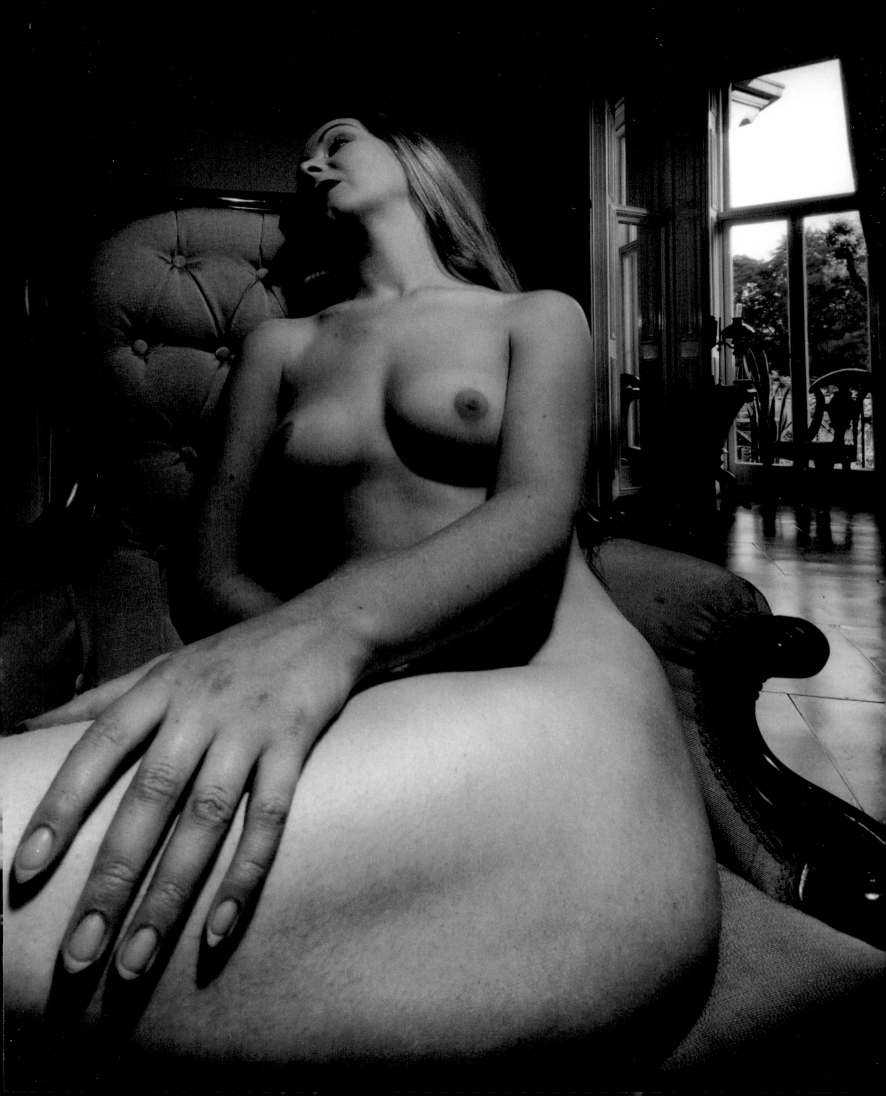

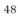

48

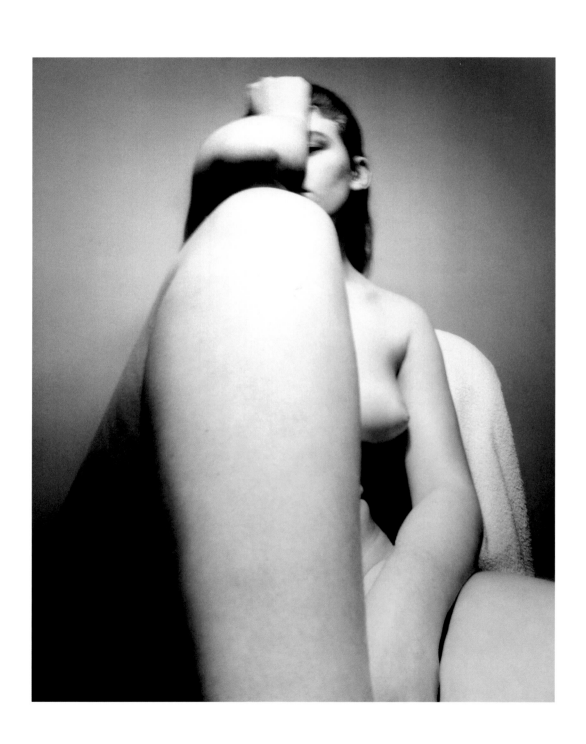

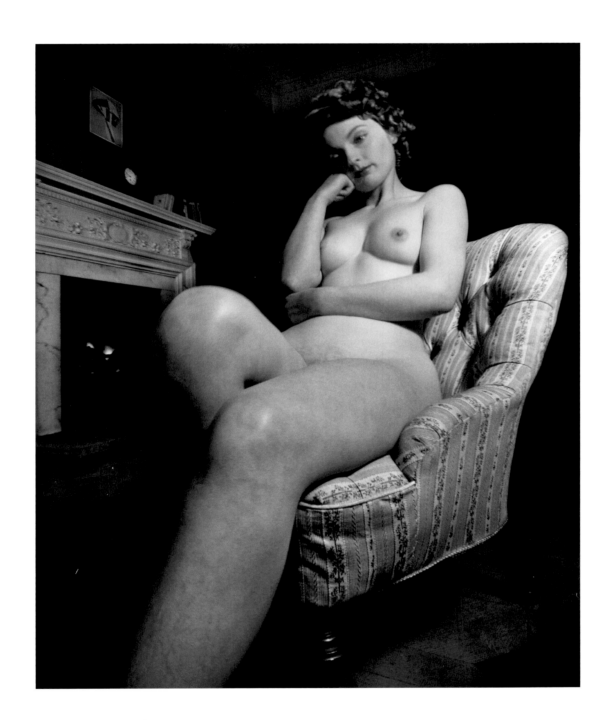

50

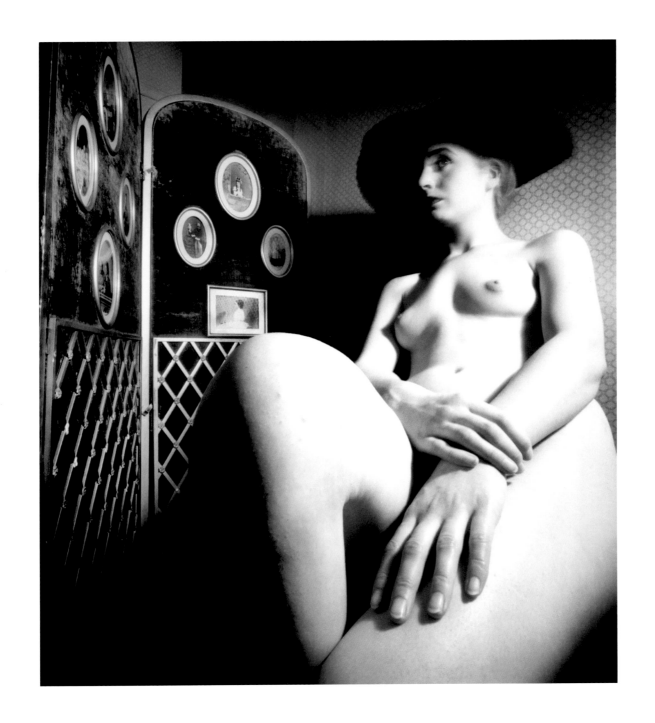

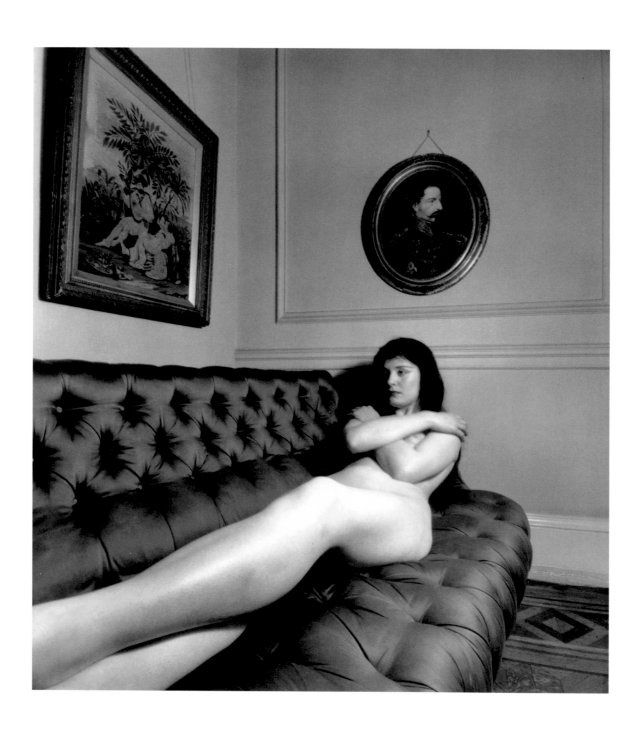

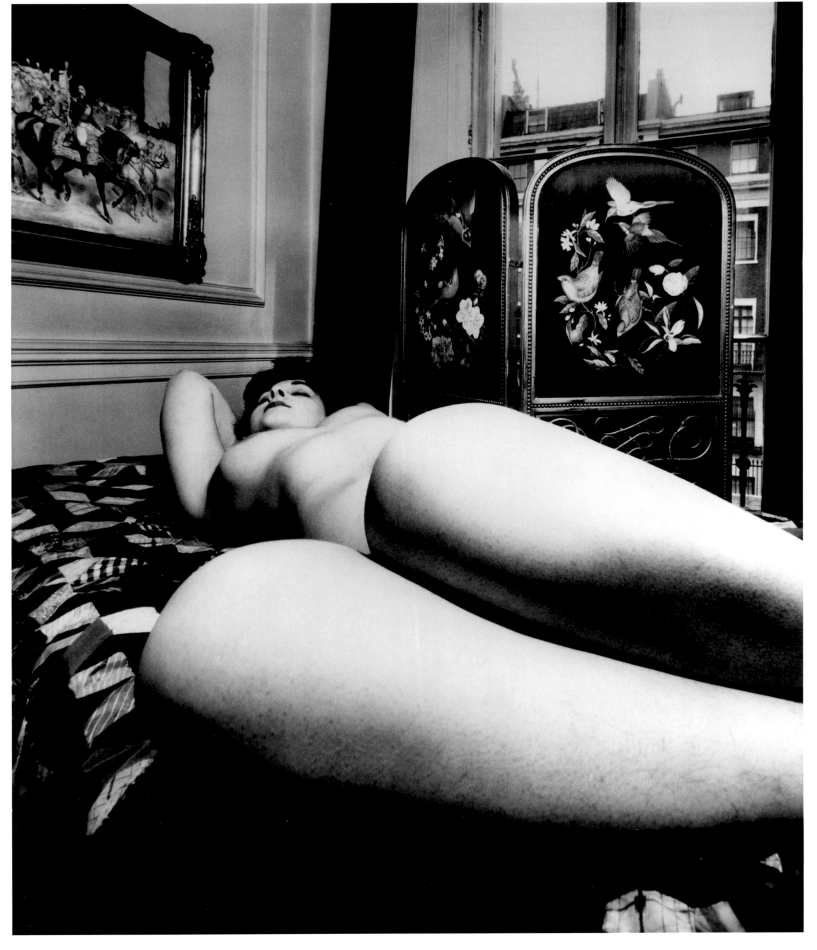

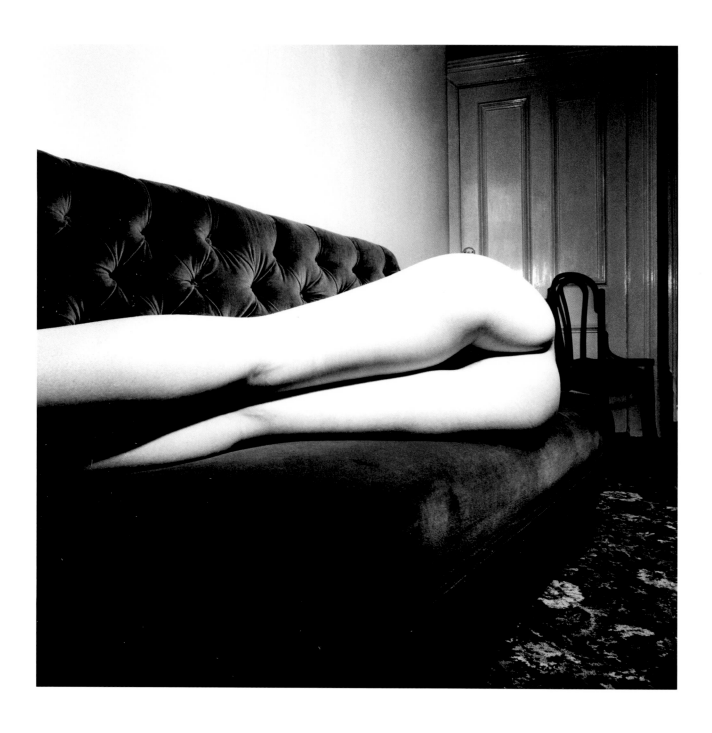

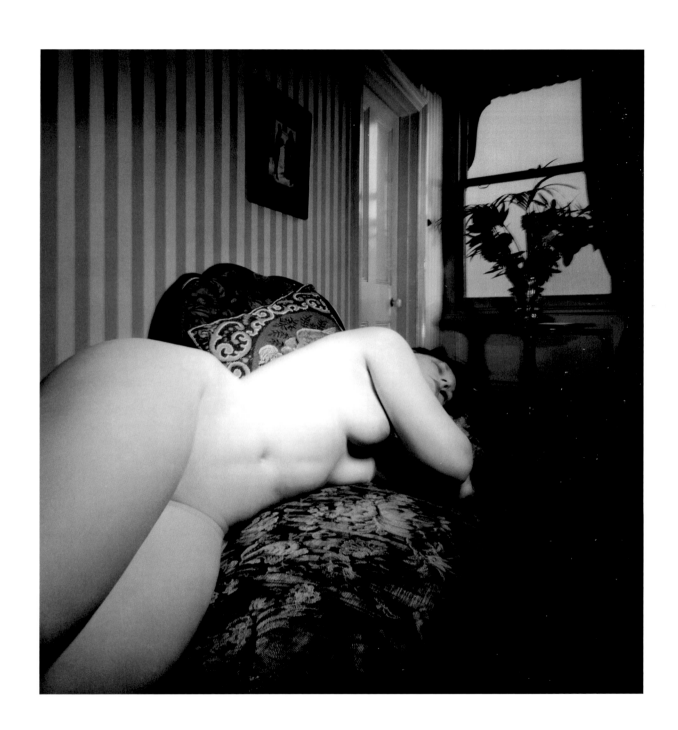

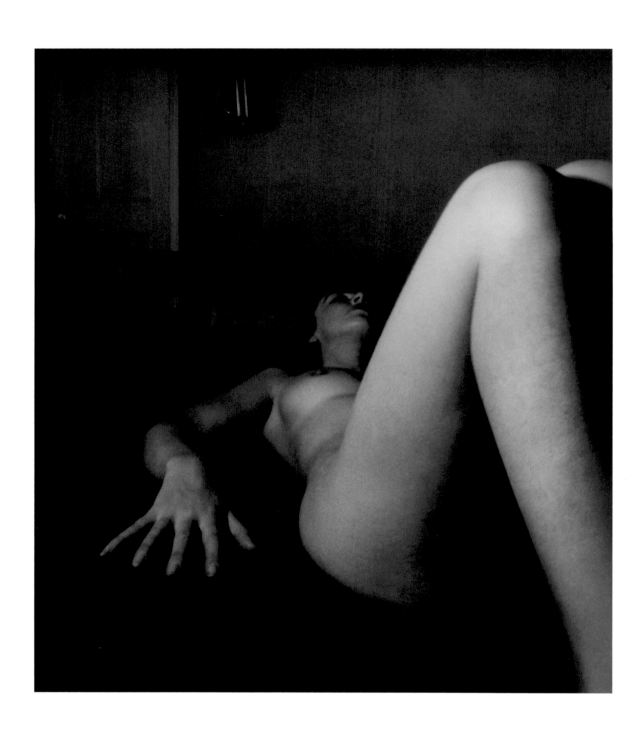

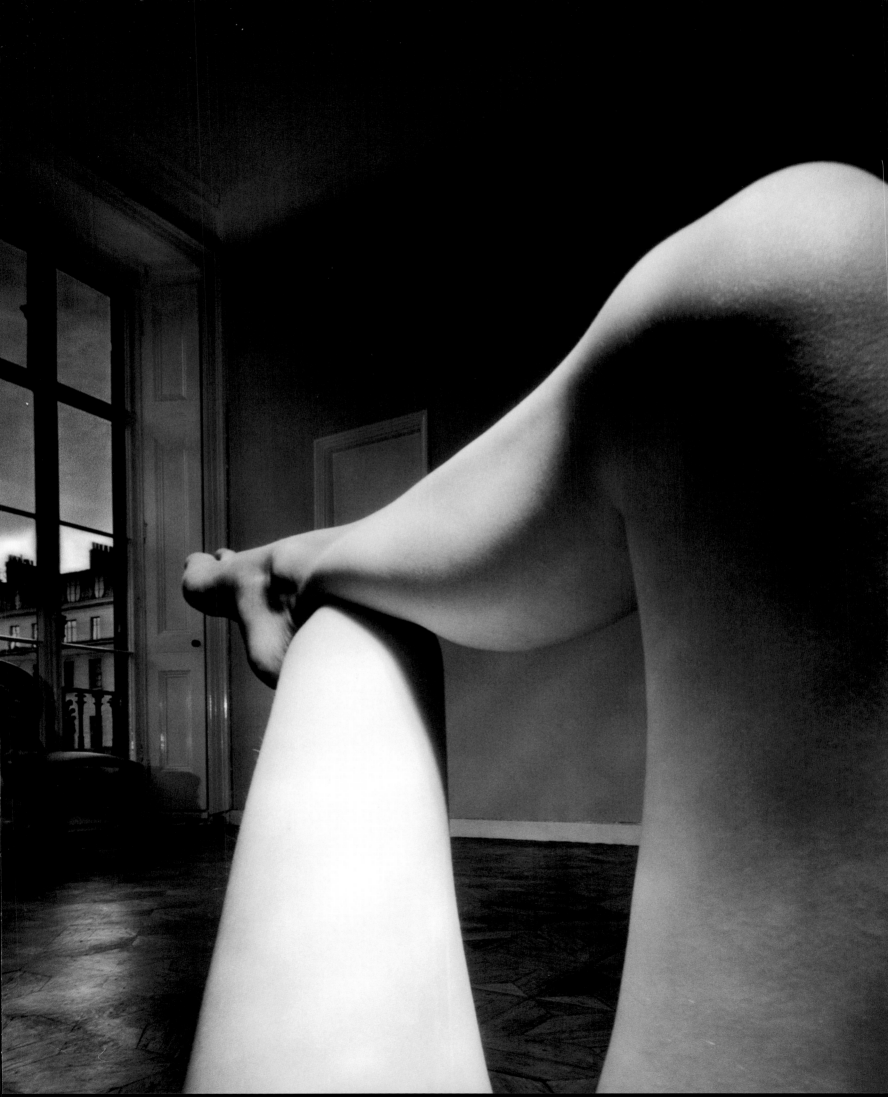

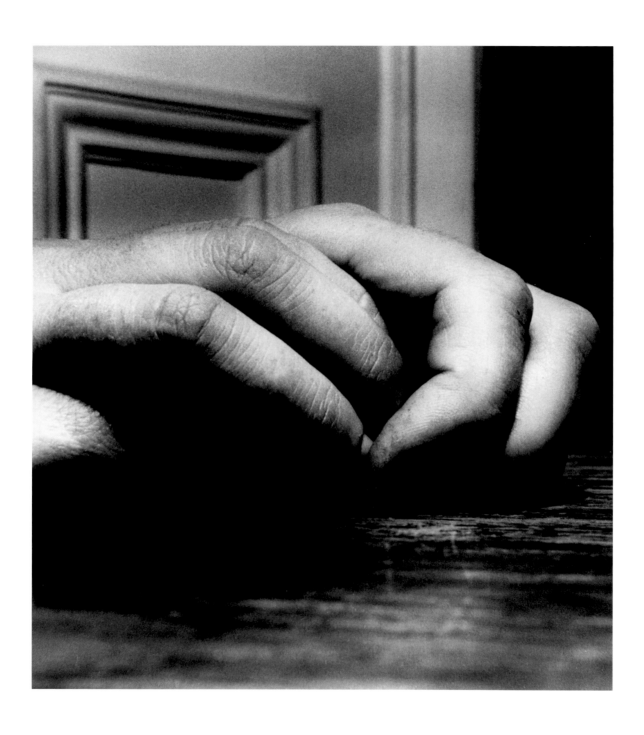

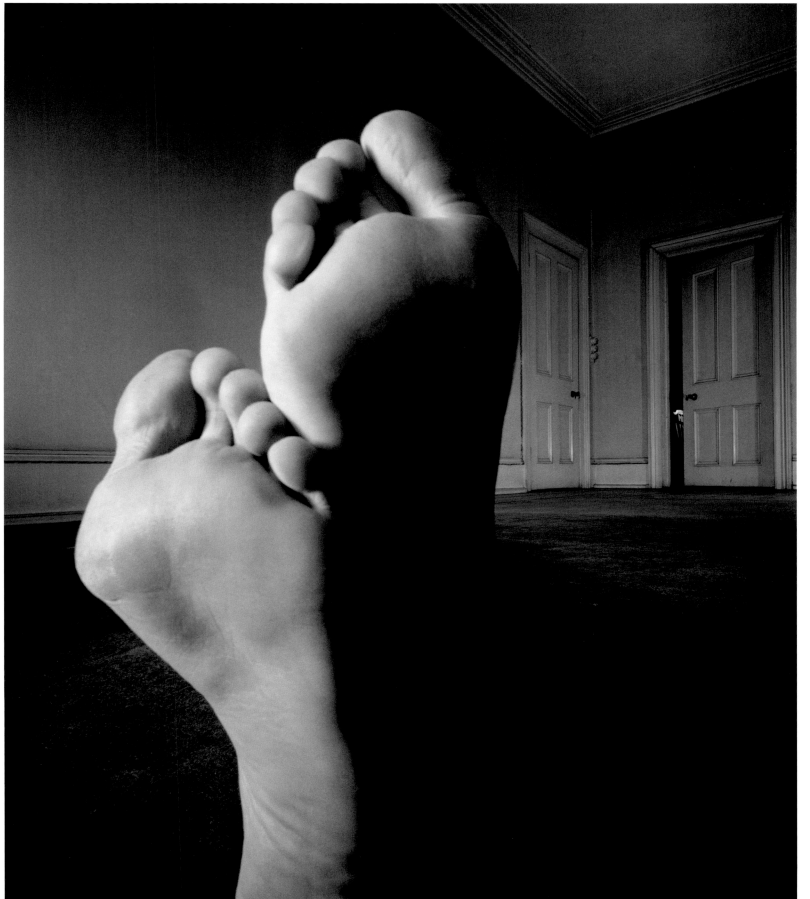

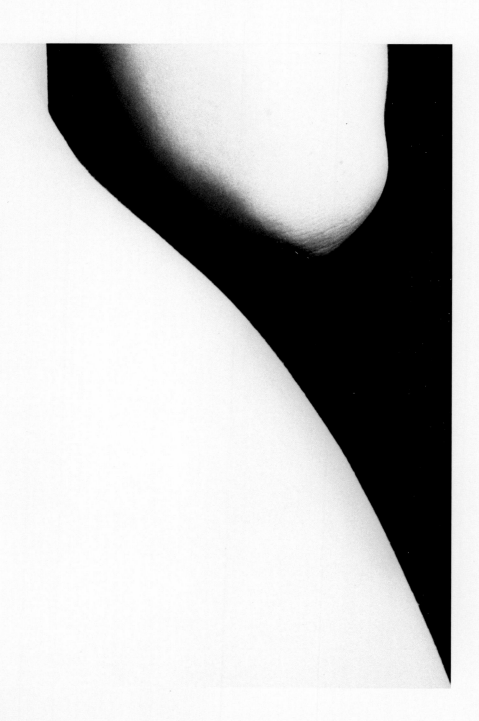

3

Looking back on *Perspective of Nudes* in 1970, Brandt recalled Edward Weston's remark that 'The camera sees more than the eye, so why not make use of it?' and added: '… instead of photographing what I saw, I photographed what the camera was seeing. I interfered very little, and the lens produced anatomical images and shapes which my eyes had never observed. I felt that I understood what Orson Welles meant when he said: "the camera is much more than a recording apparatus. It is a medium via which messages reach us from other worlds."' [1]

The camera took Brandt to the threshold of the subconscious, allowing him access to forms he might recognise but was unable, consciously, to construct. In this willingness to accept the unknown and unplanned, Brandt followed his master, Man Ray, who compared the artist to 'the scientist who is merely a prestidigitator manipulating the abundant phenomena of nature and profiting by every so-called hazard or law…'. [2] These intimate views of the body owe most to Man Ray's close-up photographs of the female torso, reinforced perhaps by Brandt's knowledge of Picasso's many 'close-up' paintings of the nude of the 1930s (and Jean Arp's equally 'close-up' sculptures, his

'Human Concretions'). The most famous of these photographs (number 63) surely owes something to the juxtaposition of face and mask in Man Ray's celebrated photograph *Noire et blanche* (1926). However, in contrast to Man Ray's sleeping muse, Kiki de Montmartre, and an ebony African mask, Brandt offers a suggestion of dynamic movement, the body barred by an arm, and crowned by the hooded gaze of sexual power. The intense contrasts of black and white here result from Brandt's substantial darkroom intervention, which was often considerable but rarely as emphatic as here. Brandt cut masks from card to shield parts of a print from exposure to light during printing. He often enlarged fragments of his negatives and used grain to graphic effect – techniques characteristic of Man Ray. Brandt's grain, achieved by using high-speed Tri-X film with appropriate development and sometimes considerable enlargement, was employed to splendid graphic effect in number 70.

Elsewhere he used photographic grain to echo the granularity of stone. In number 81 Brandt has accepted the graphic benefits of camera-movement. This suite of nudes combines radical abstraction of form with the intimate mysteries of sexual discovery.

61

1. N. Warburton op cit, p-32
2. Man Ray, 'The Age of Light', *Photographs 1920-1934* (1934), not paginated

62

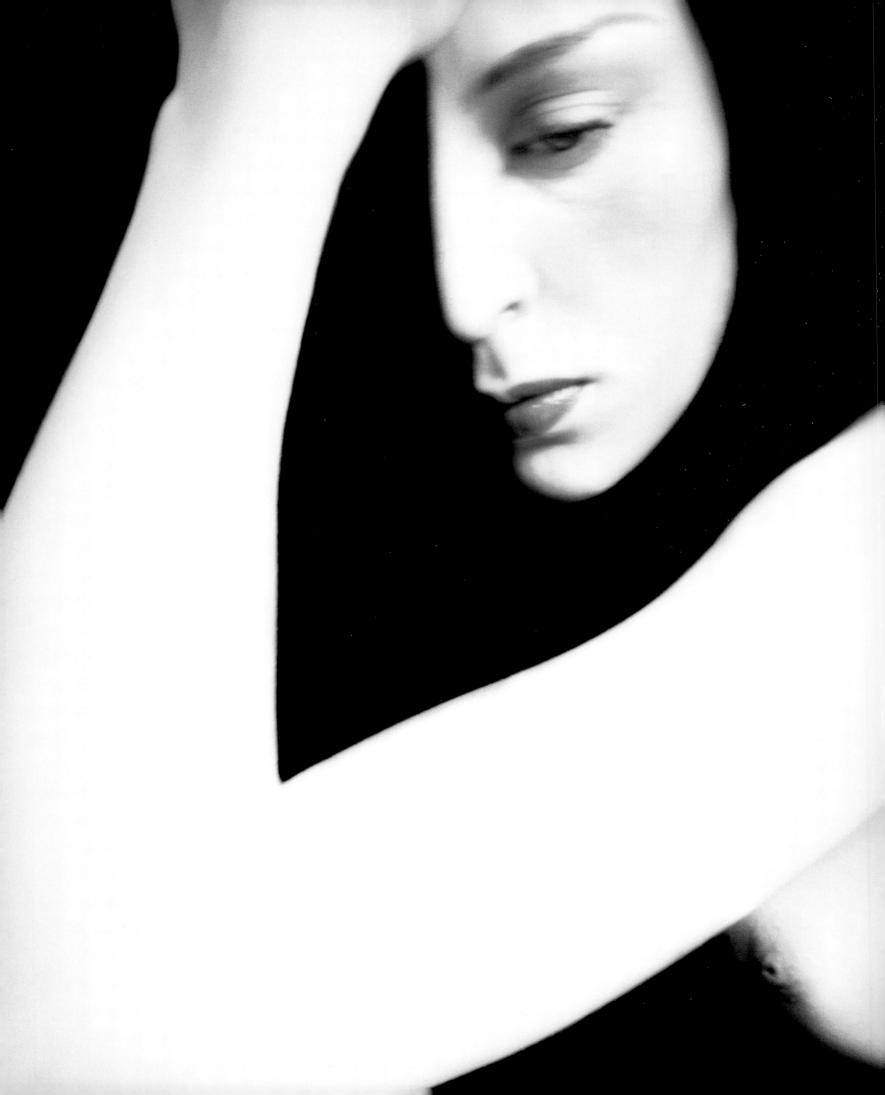

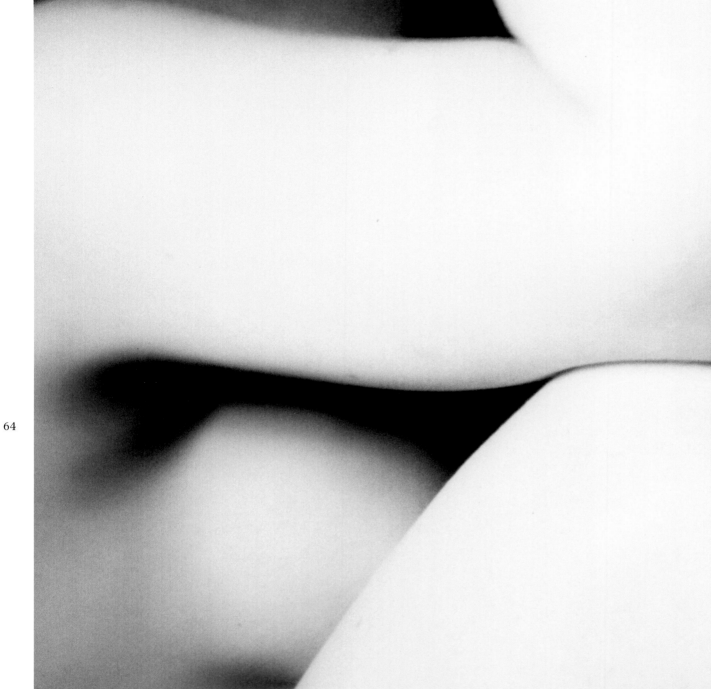

64

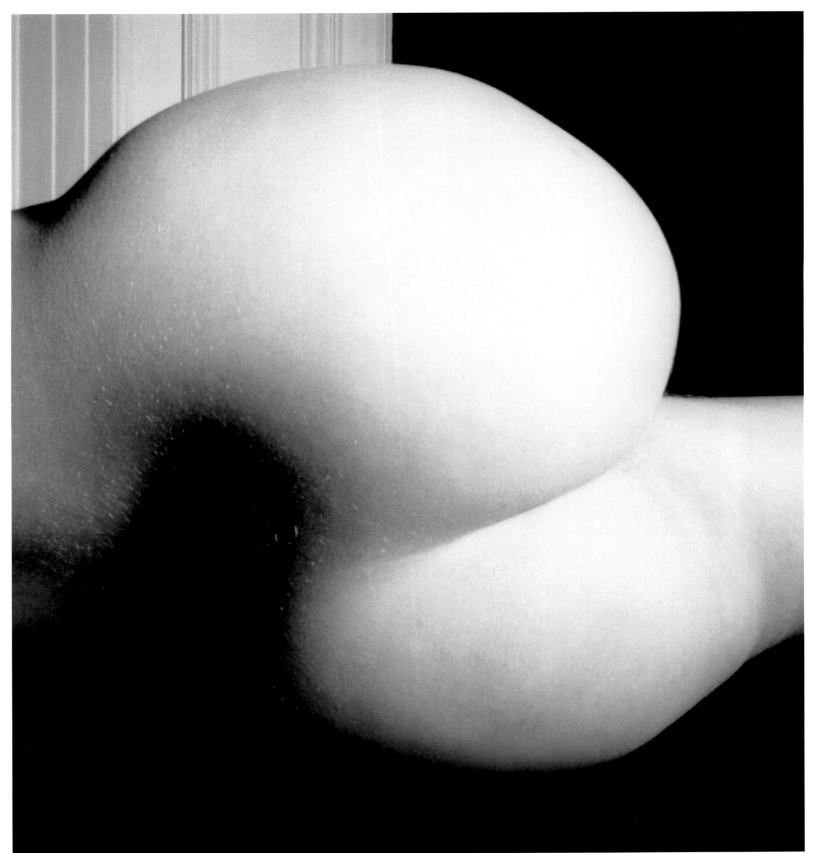

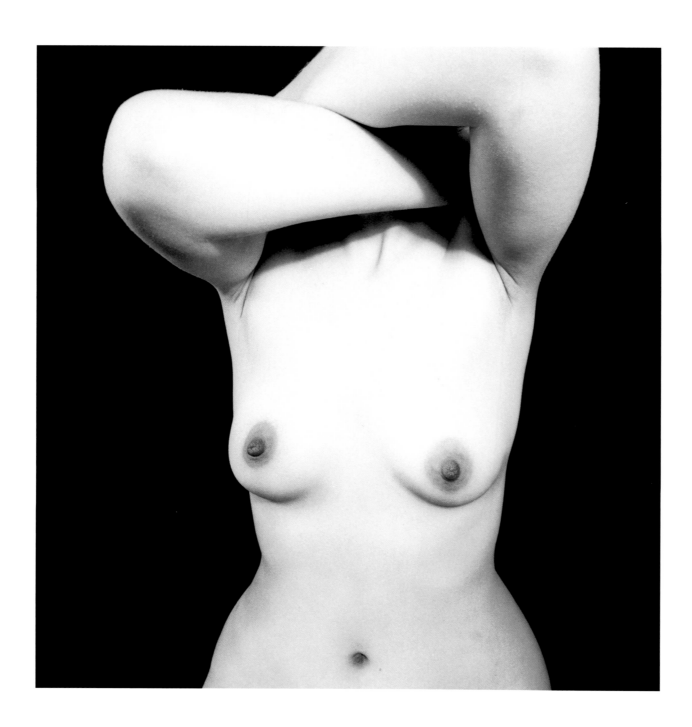

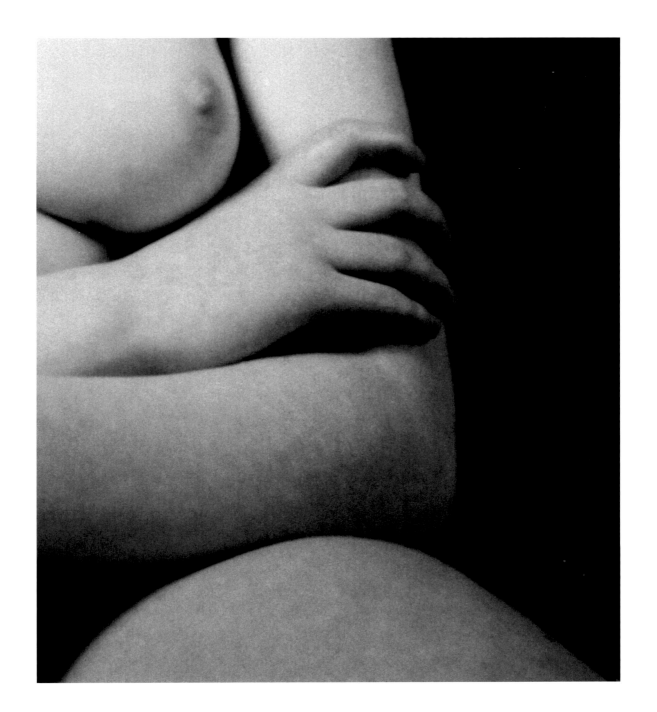

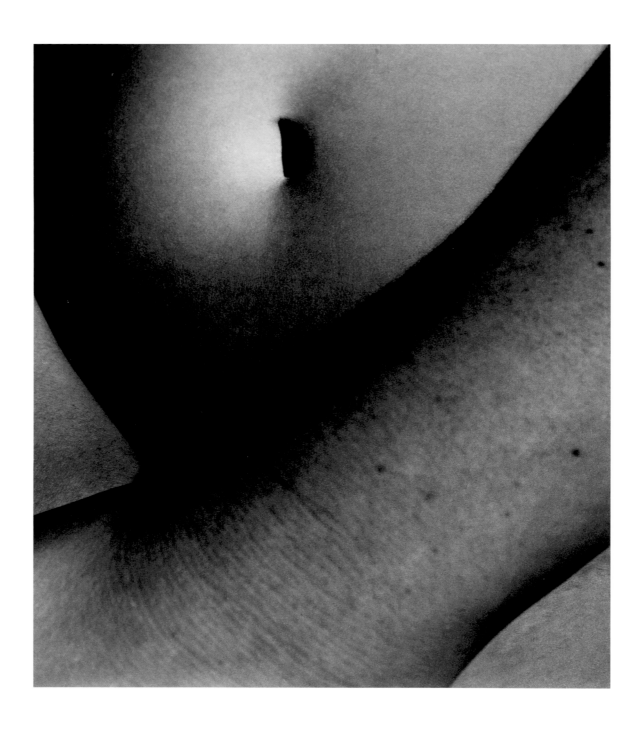

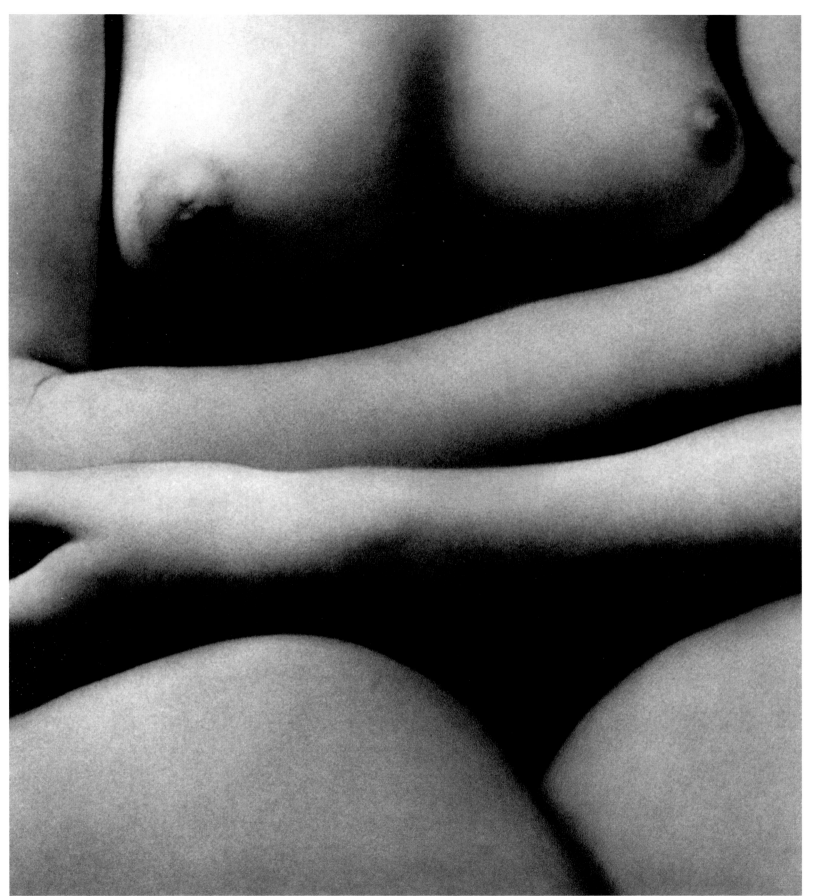

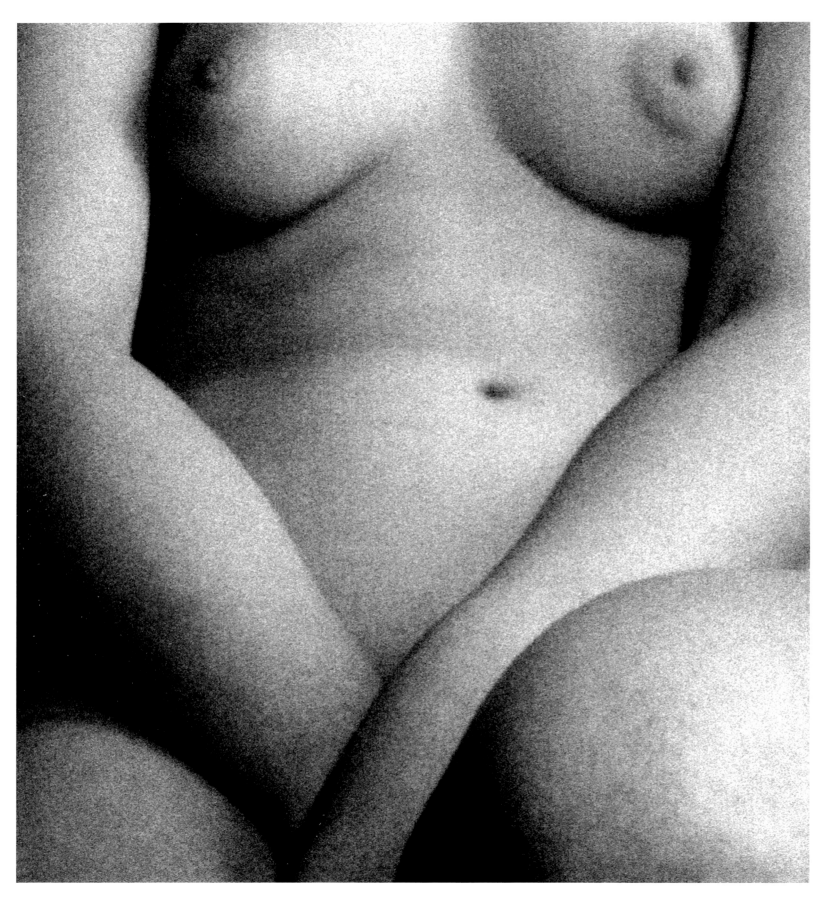

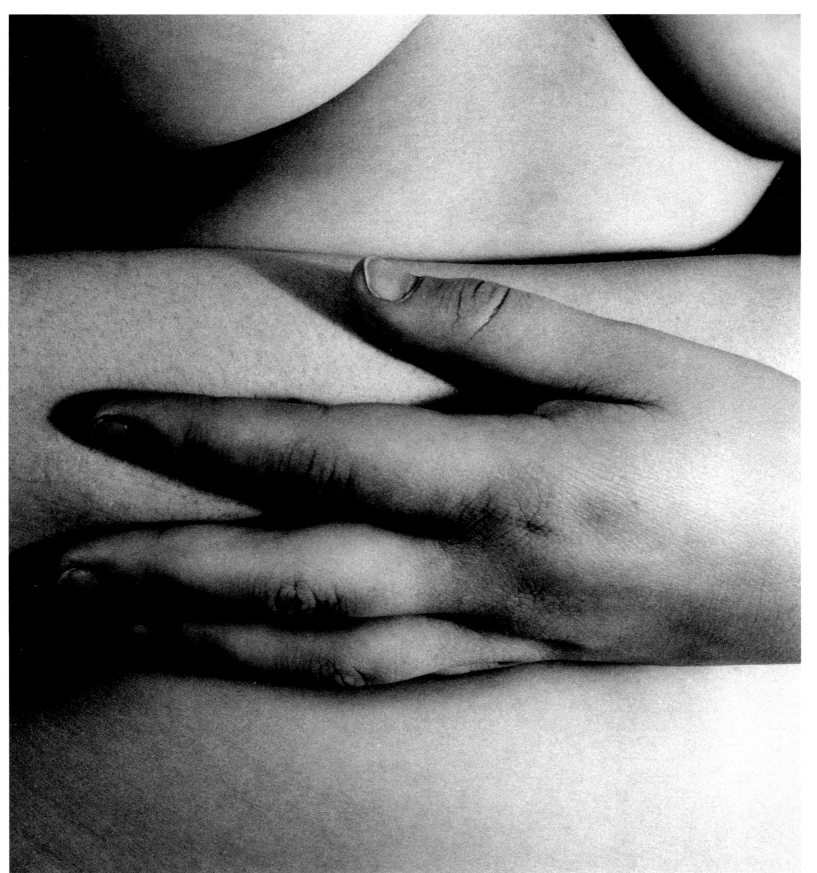

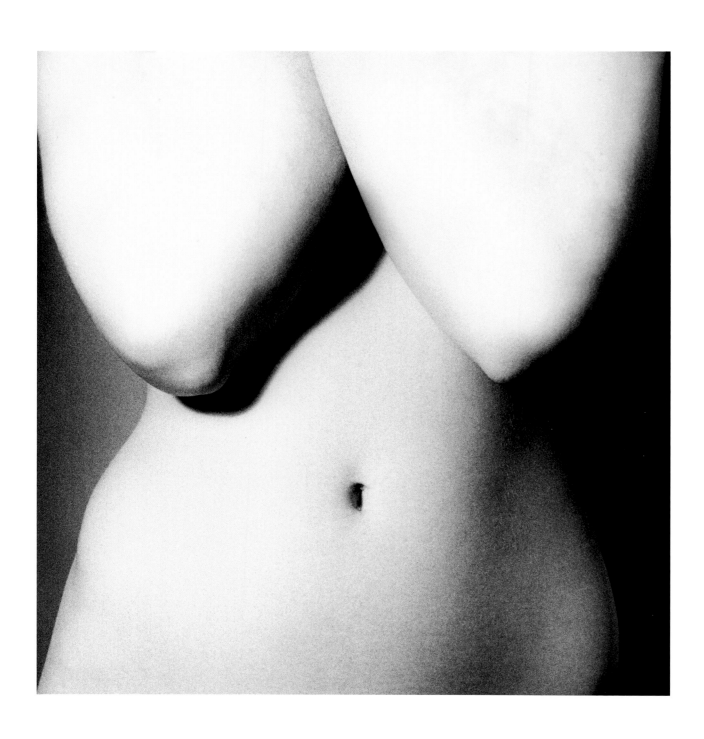

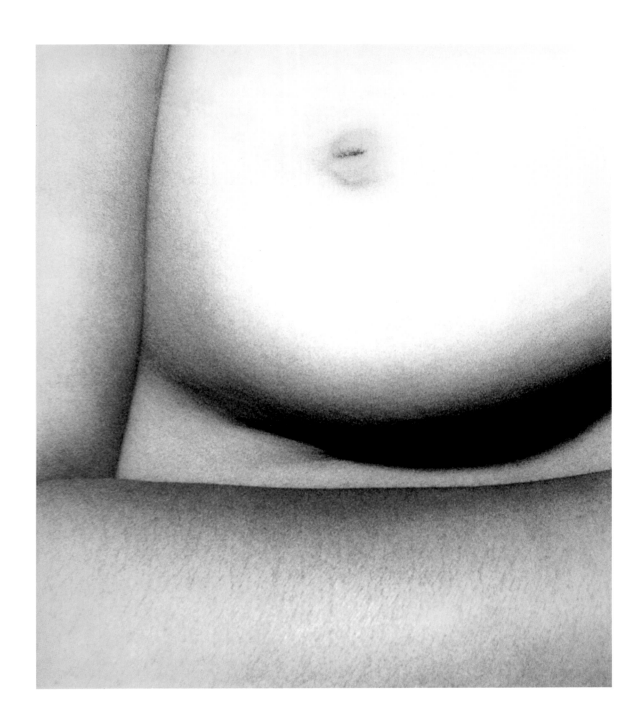

73

74

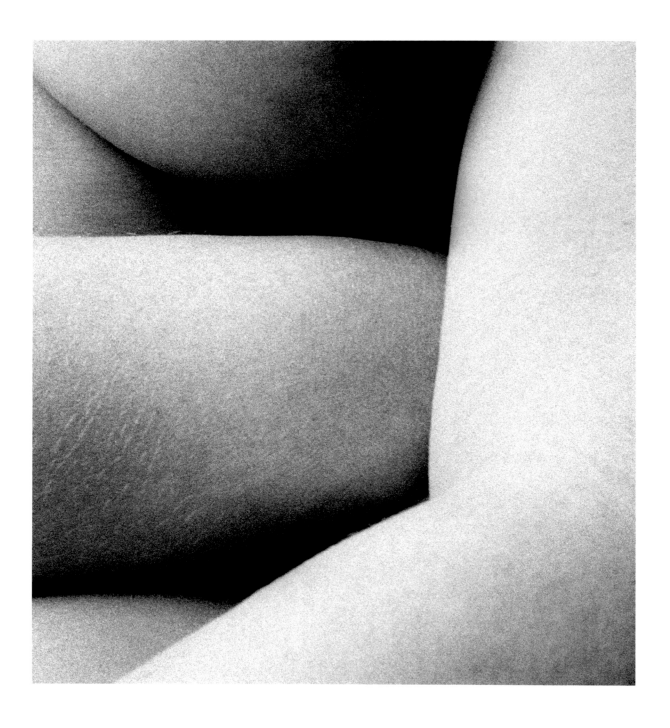

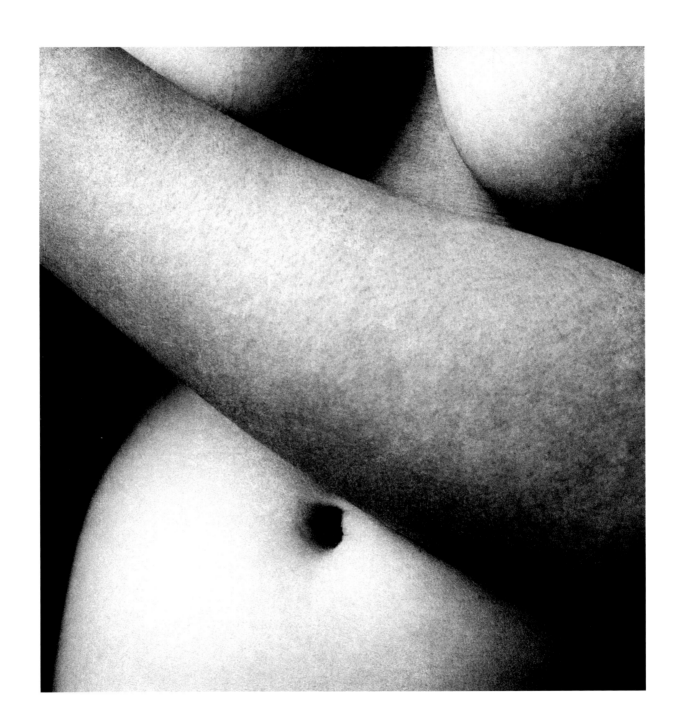

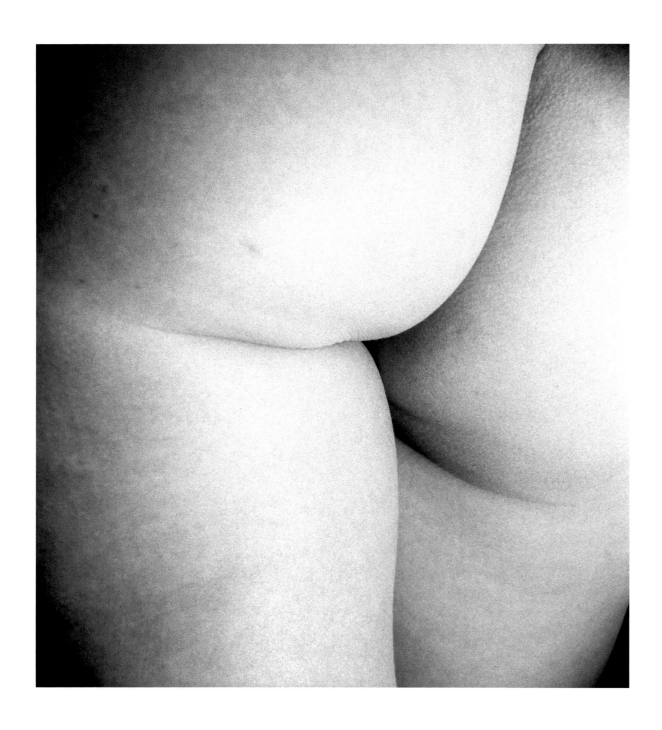

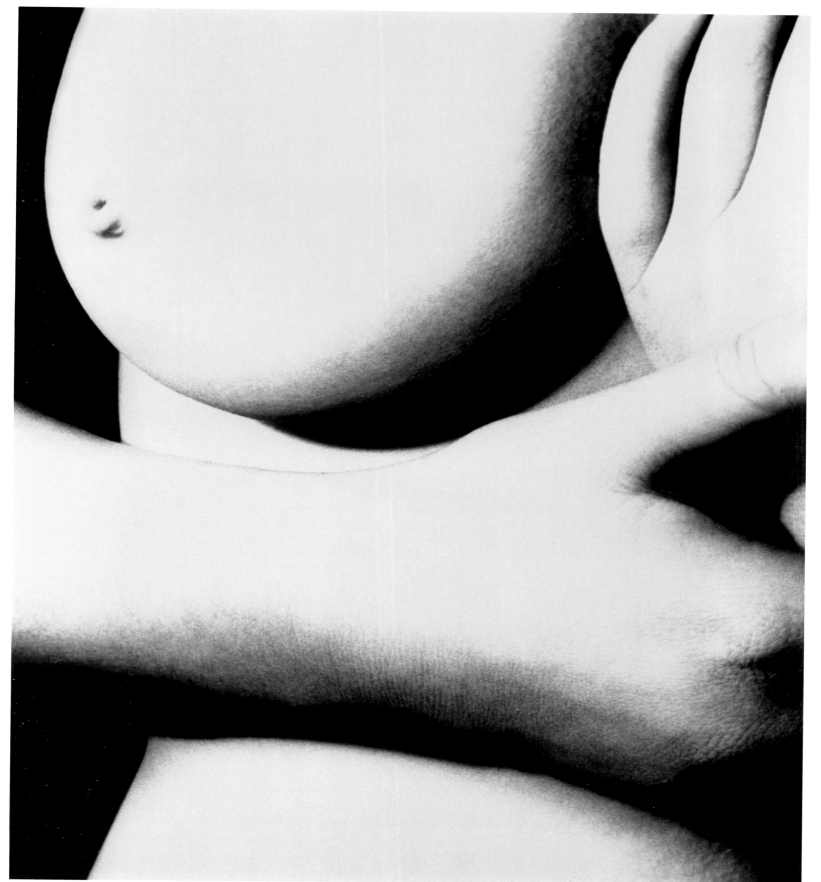

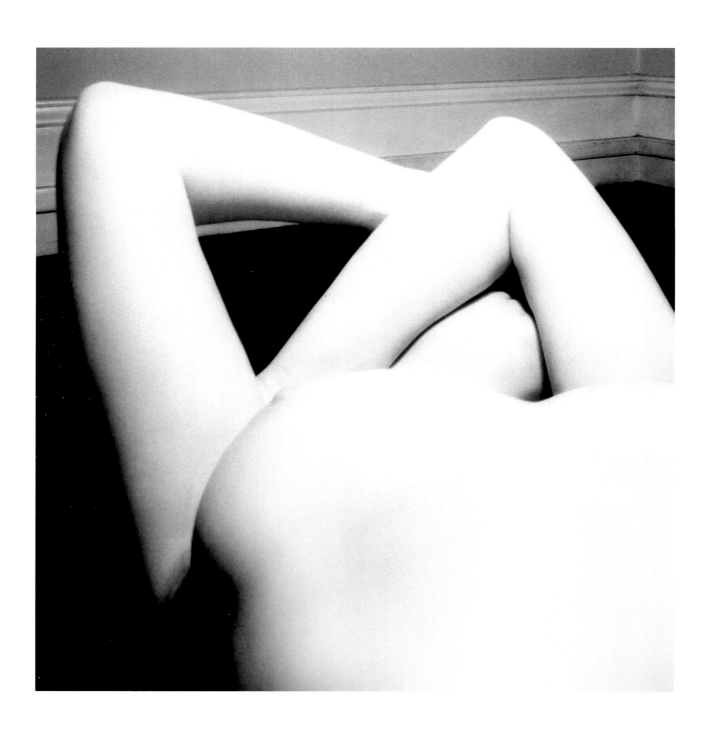

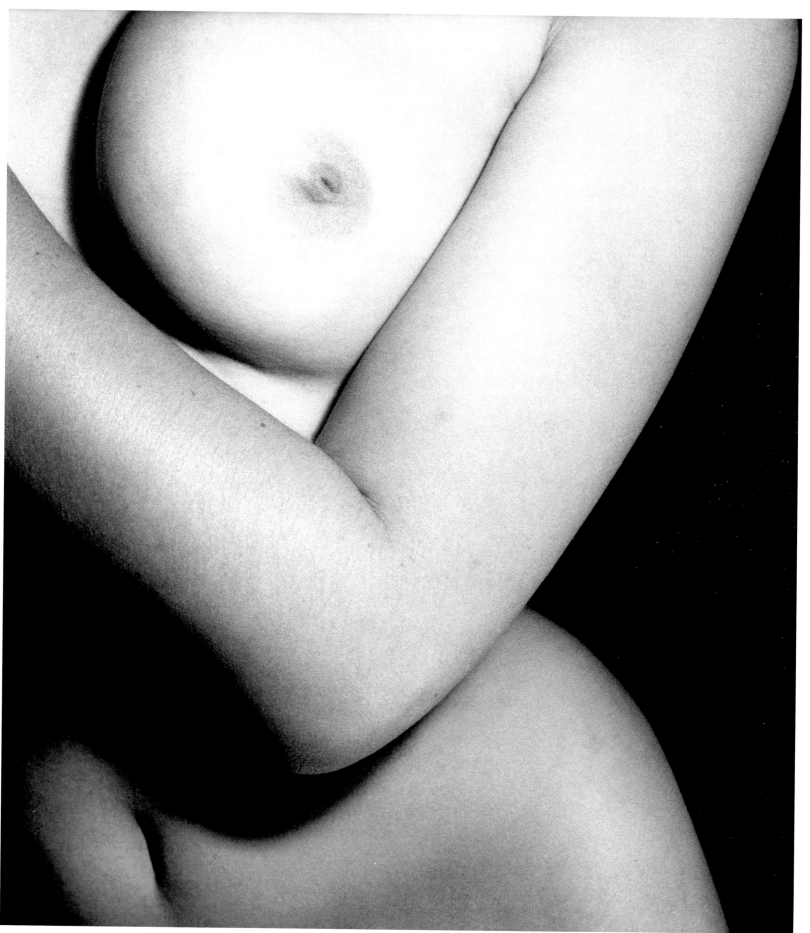

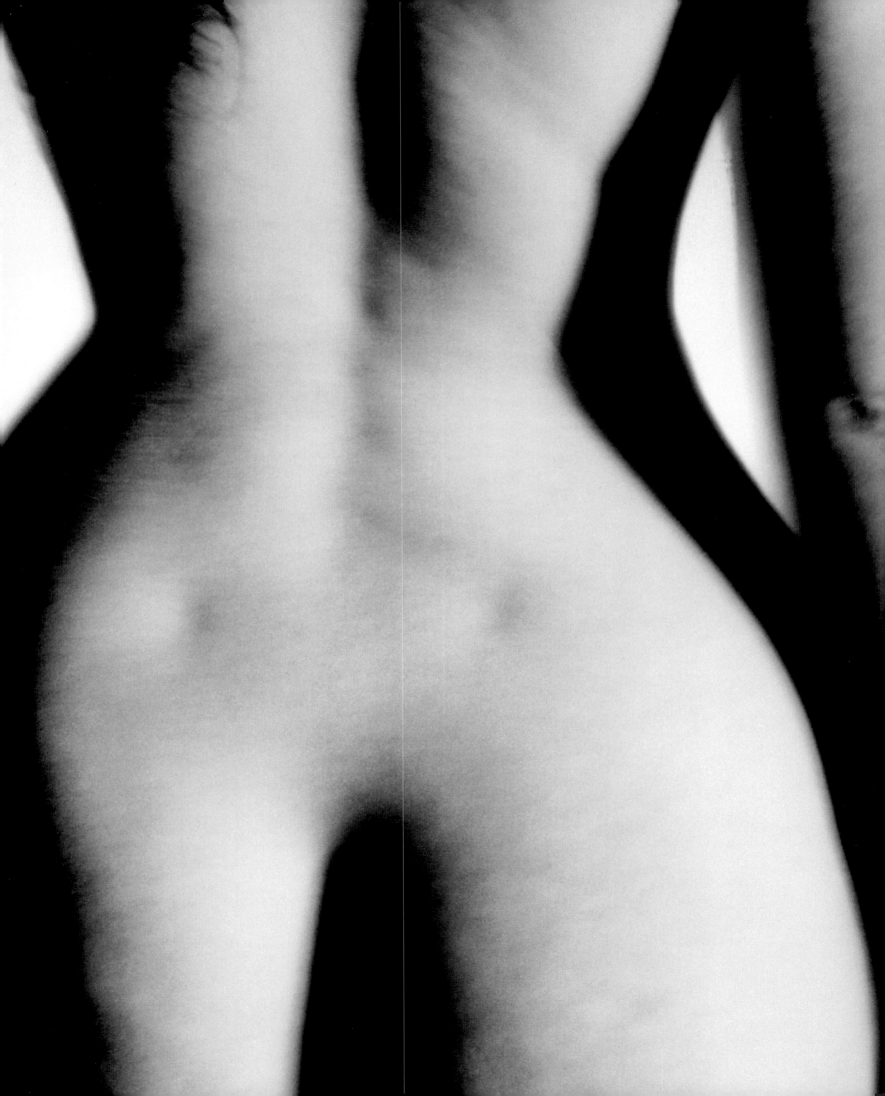

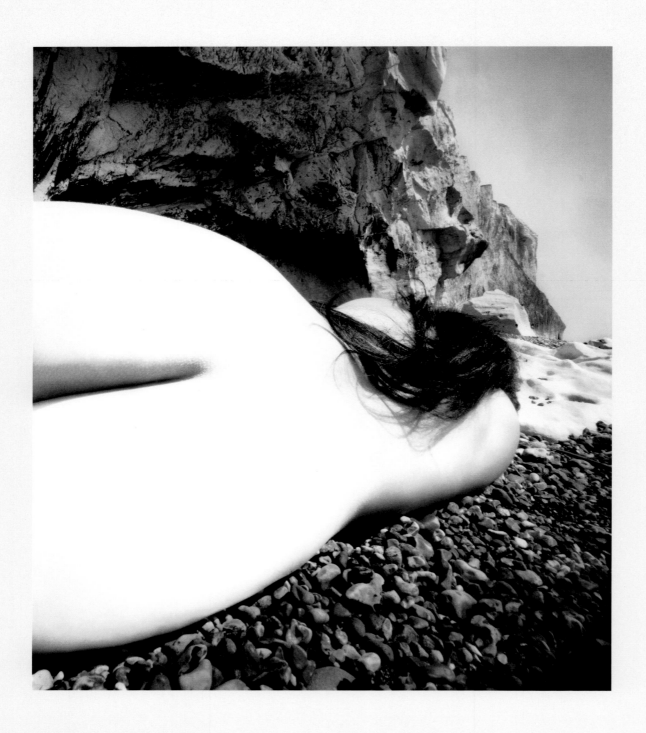

4

It is likely that when Brandt was working with Man Ray in 1930 he came across copies of a magazine in which his master played a major role. In the first issue of *La Révolution Surréaliste* (1 December 1924) he would have seen a page full of portraits of 29 founding Surrealists and noted that a space was left for an honorary 30th member – Charles Baudelaire. The poet was not represented by a portrait but a quotation:

La femme est l'être qui projette la plus grande ombre ou la plus grande lumière dans nos rêves. (Woman is the being who projects the greatest shadow or the greatest light on our dreams). This remark could stand as an epigraph for Brandt's whole series of nudes. His friend Chapman Mortimer noted [1] that Brandt himself attached the first stanza of Baudelaire's poem, 'La Géante' to a specific image (number 82). The whole poem, originally published in *Les Fleurs du Mal* in 1861, appears at the end of this book.

If the young Brandt had looked at *La Révolution Surréaliste* for March 1926, he would have seen one of Picasso's paintings of nudes playing on a beach – *Femmes Devant la Mer*. Picasso painted the nudes as sculptural figures. Even more interesting is the way in which he represented the right hand figure in this work: her nearer leg looms expansively towards us while the far one shrinks sharply towards the horizon. This is the geometry of the wide-angle lens and thus remarkably akin to Brandt's exploration of the nude on the beaches of England and France in the 1950s. During this decade he abandoned the Kodak in favour of a more manoeuvrable Hasselblad camera with a Superwide lens.

Whereas Edward Steichen disliked Brandt's nudes, John Szarkowski (his successor as director of the Department of Photography at The Museum of Modern Art, New York) wrote of them with both understanding and panache in 1970: 'These pictures – at first viewing, strange and contorted – reveal themselves finally as supremely posed and untroubled works. It has been said that these pictures concern the world of pure form and space, but surely they also concern the bodies of women... Not abstract but depersonalised, their content is I think after all a transcendent eroticsm – a suspended, euphoric celebration of the flesh. In photography only Edward Weston has made nudes of equal power.' [2]

83

1. B. Brandt. L. Durrell and C. Mortimer, *Perspective of Nudes* (1961), p. 13
2. J. Szarkowski, 'Bill Brandt', *Album*, vol. 1, No. 1, 1970, p. 12

84

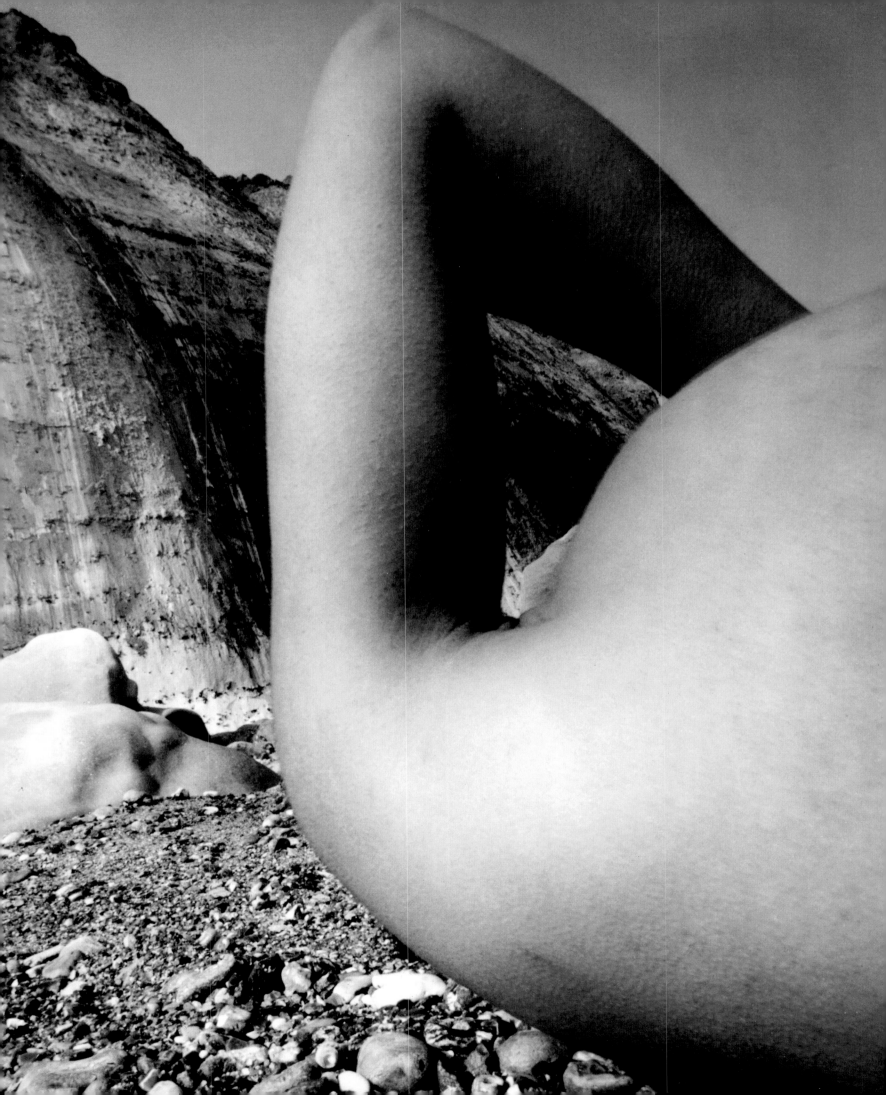

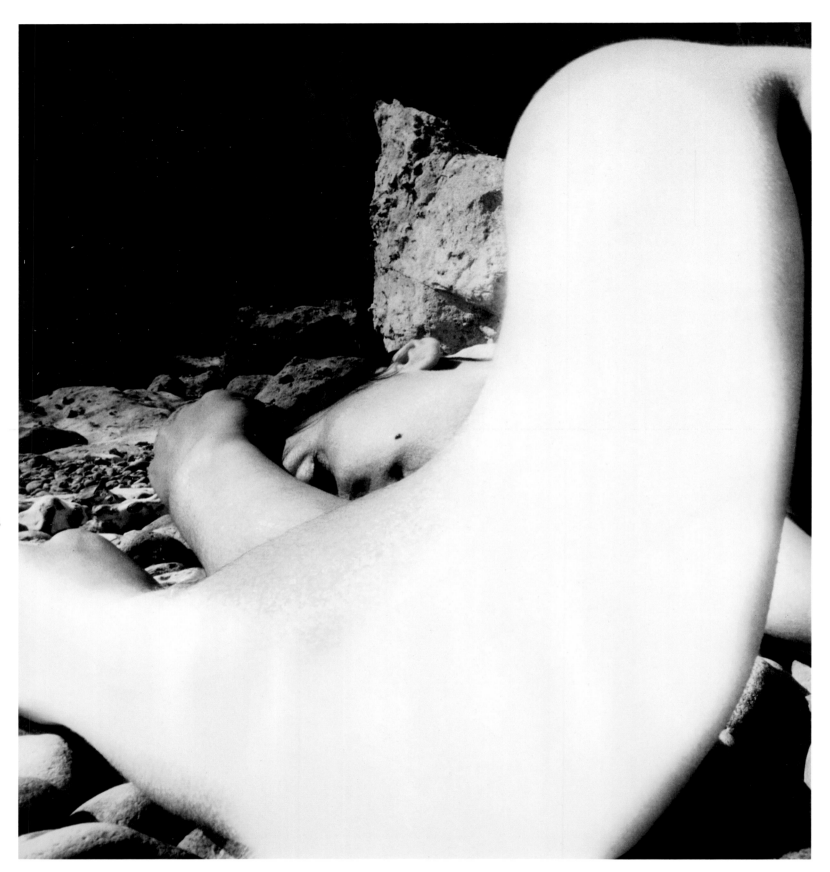

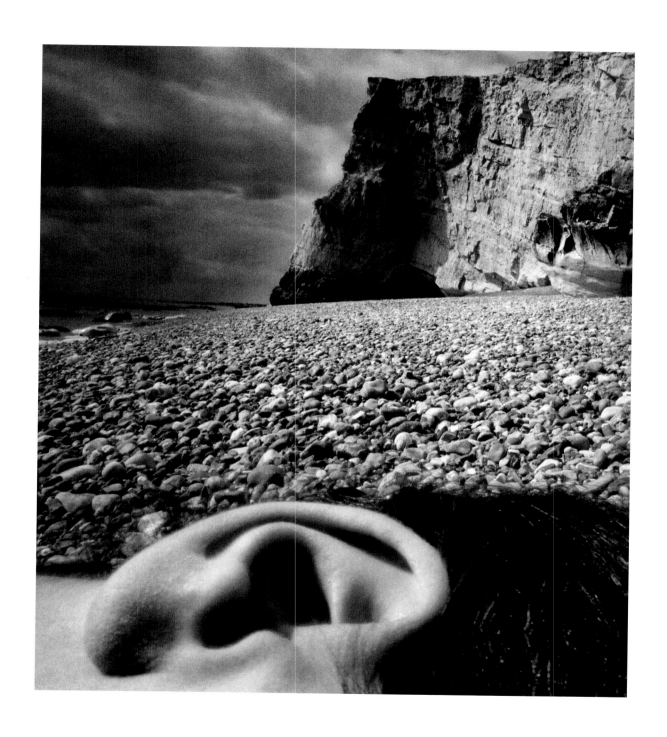

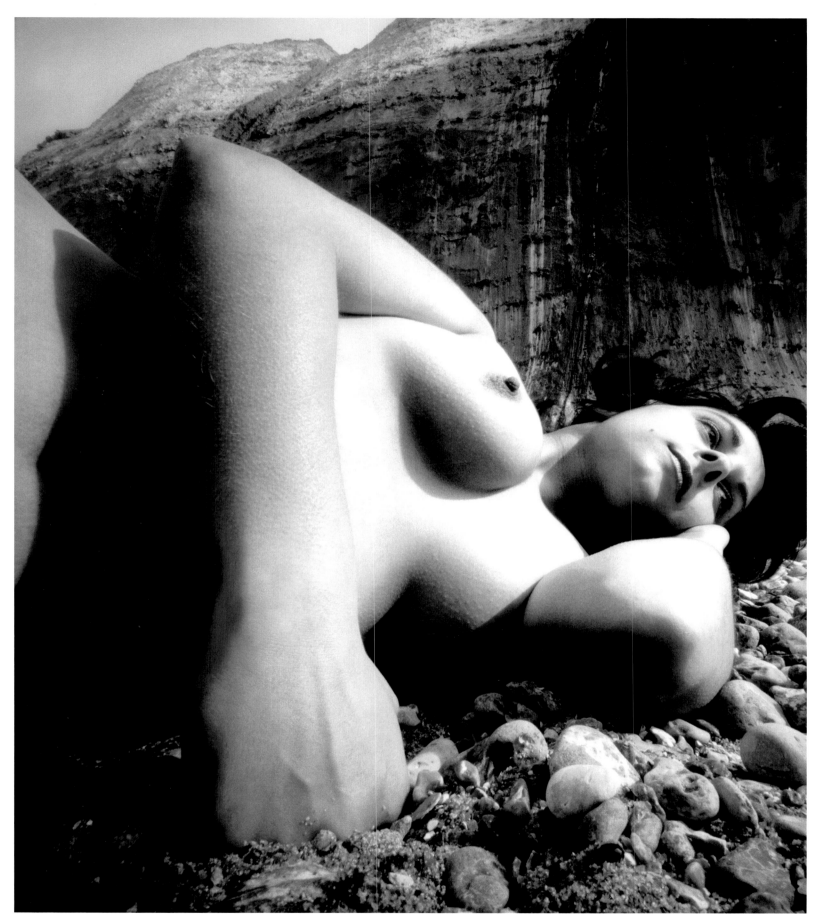

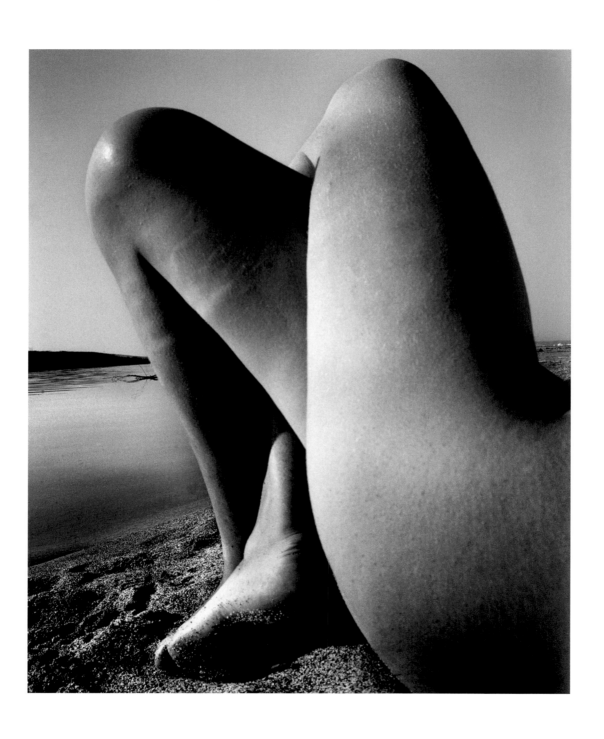

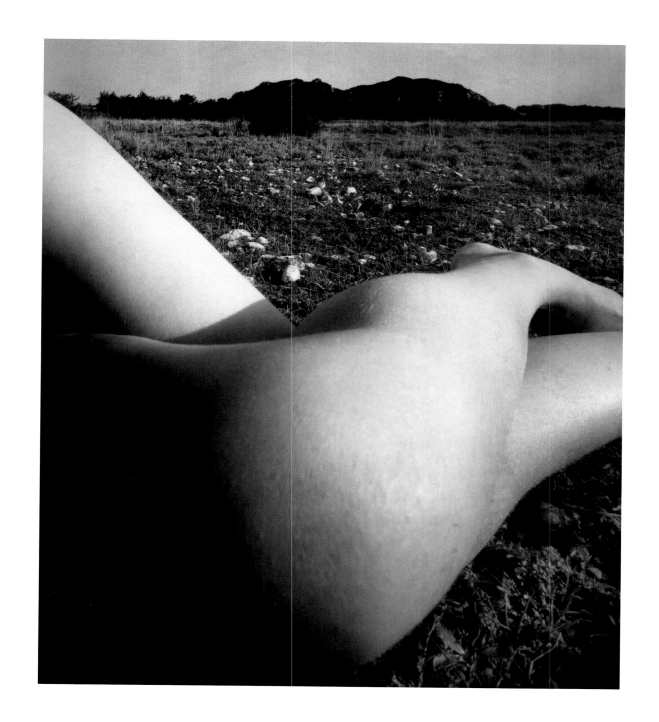

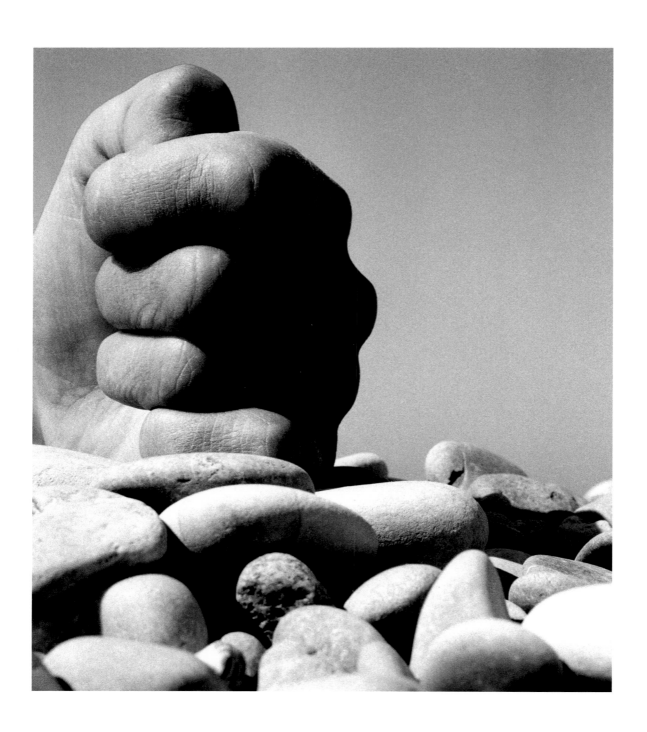

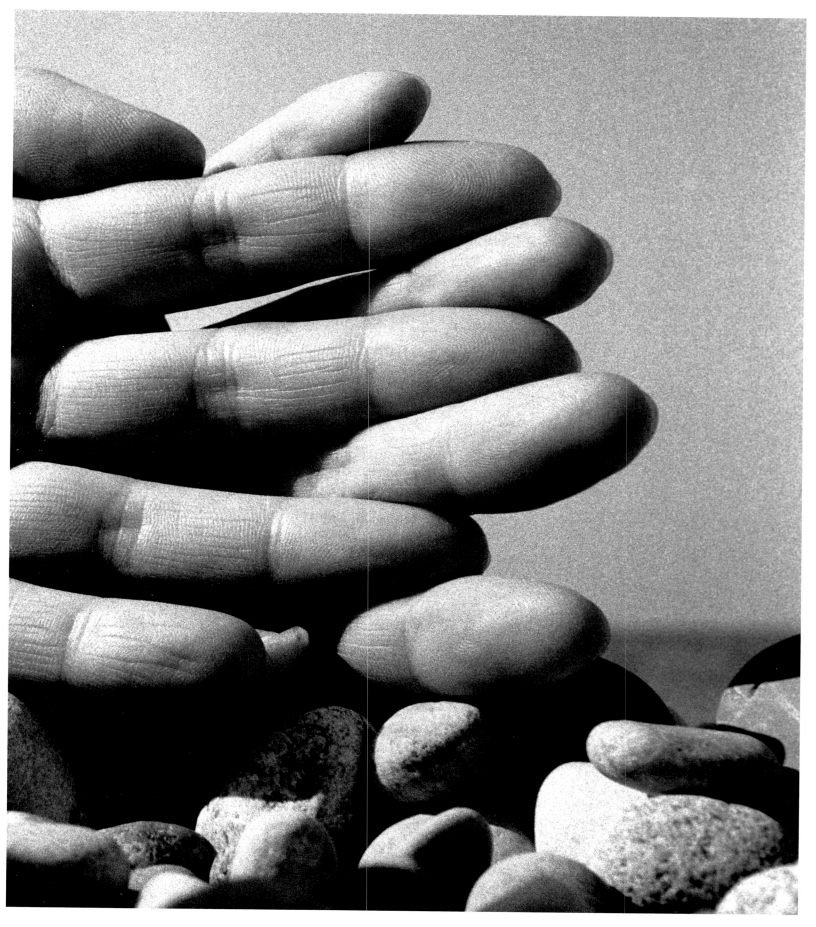

93

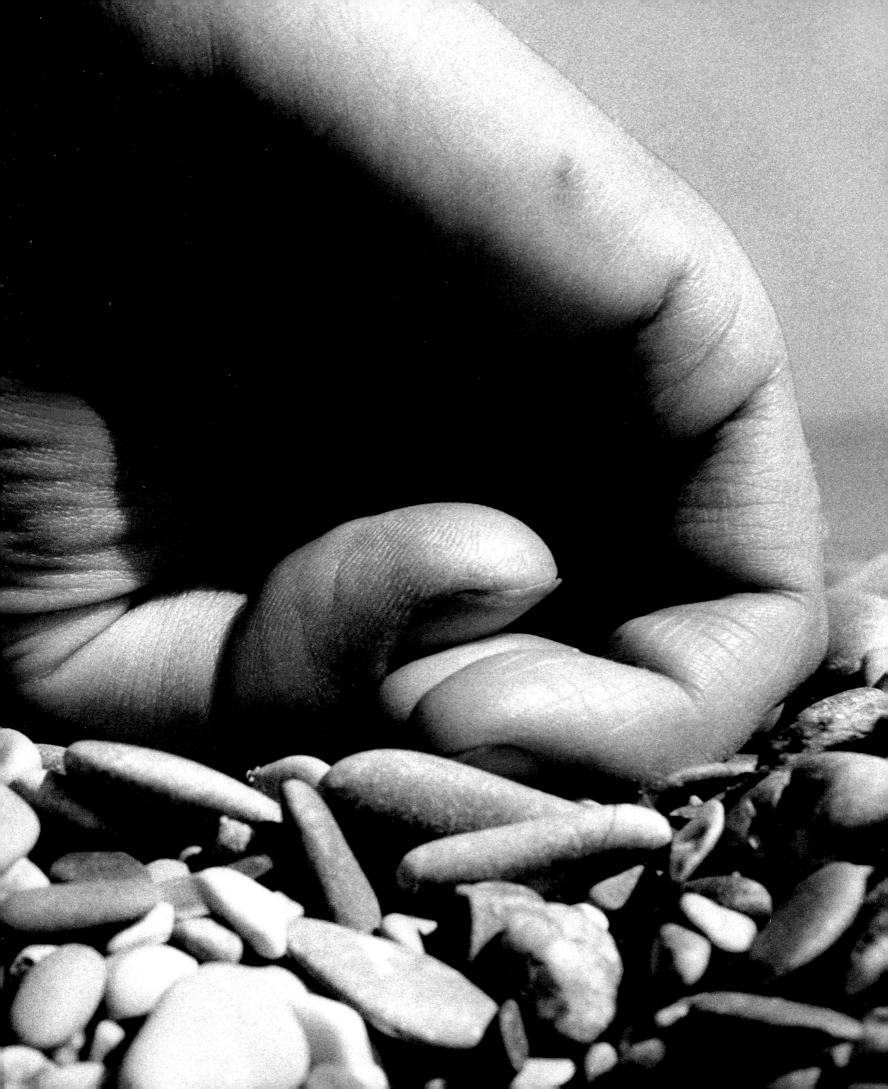

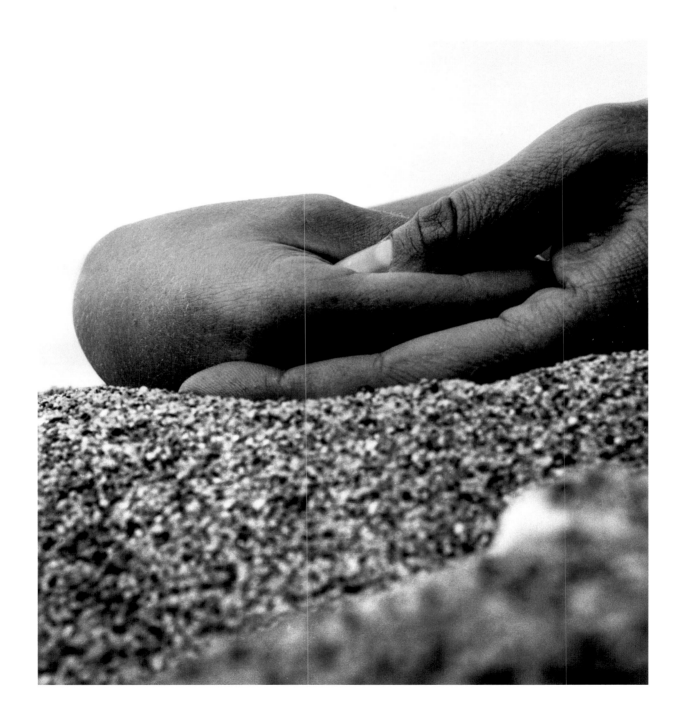

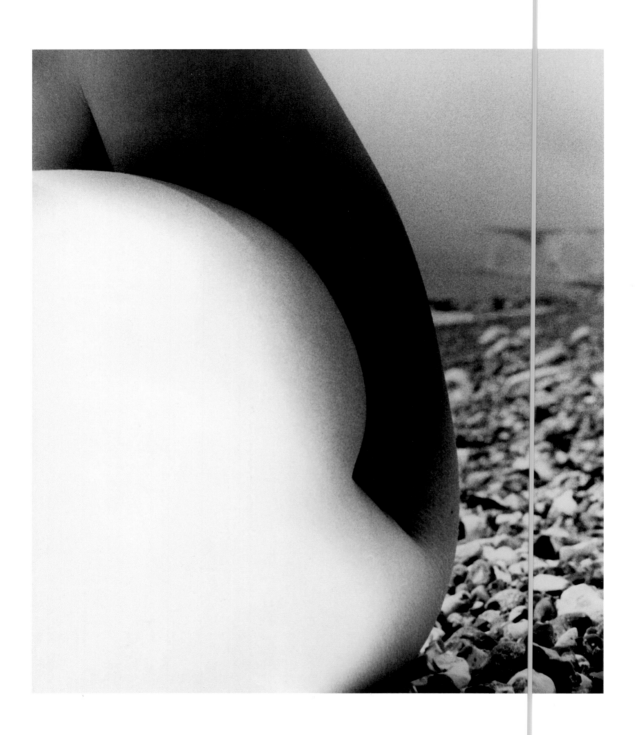

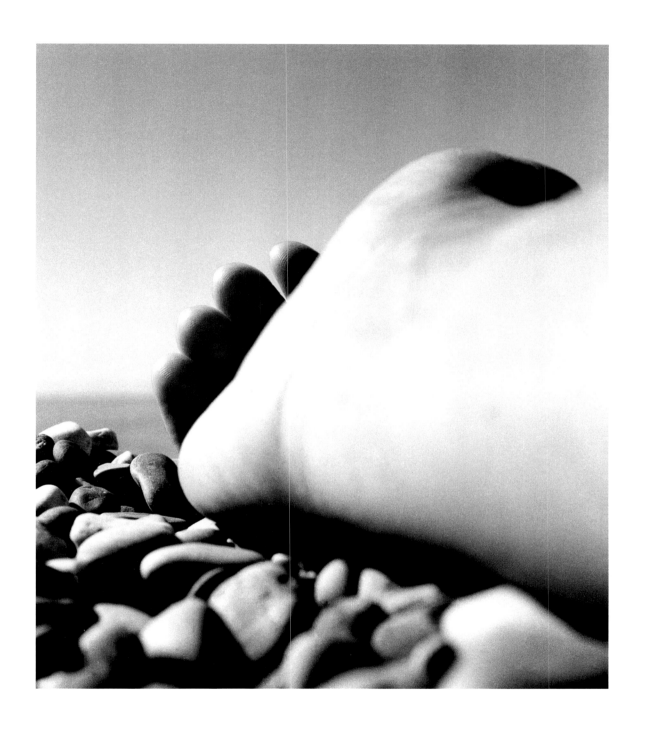

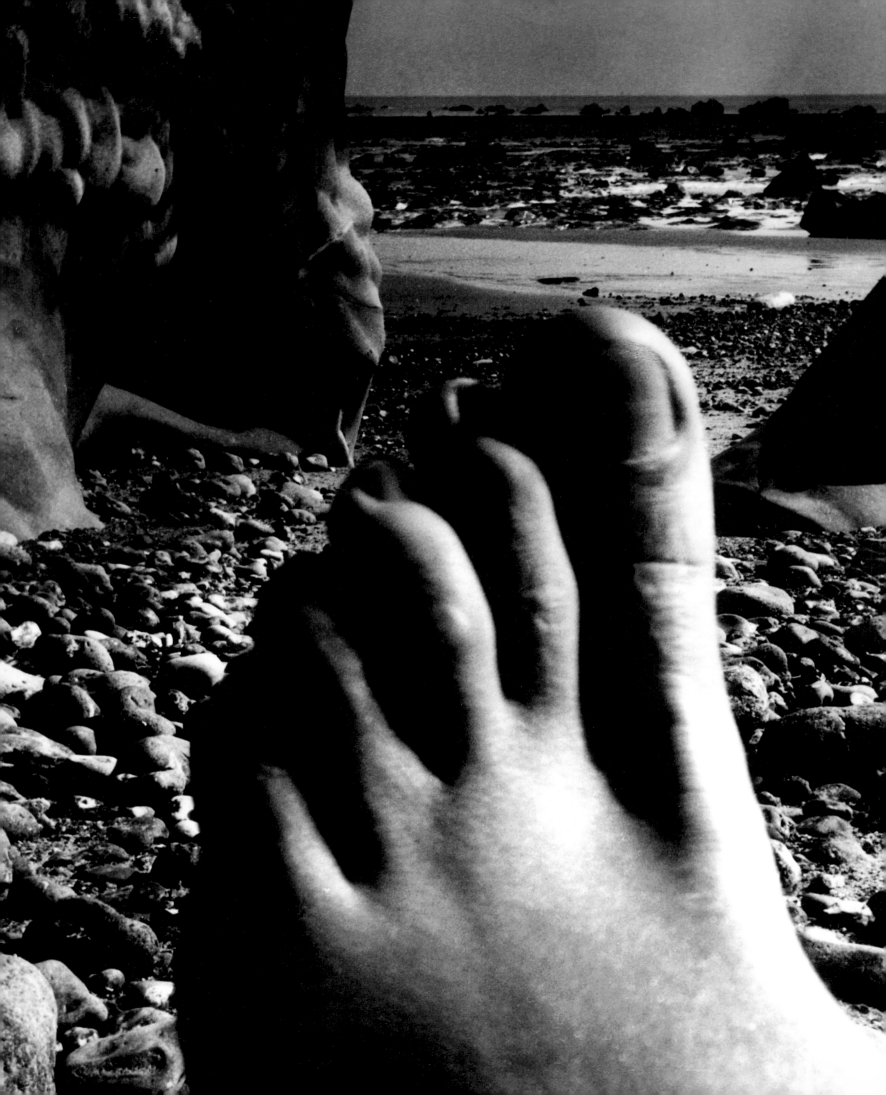

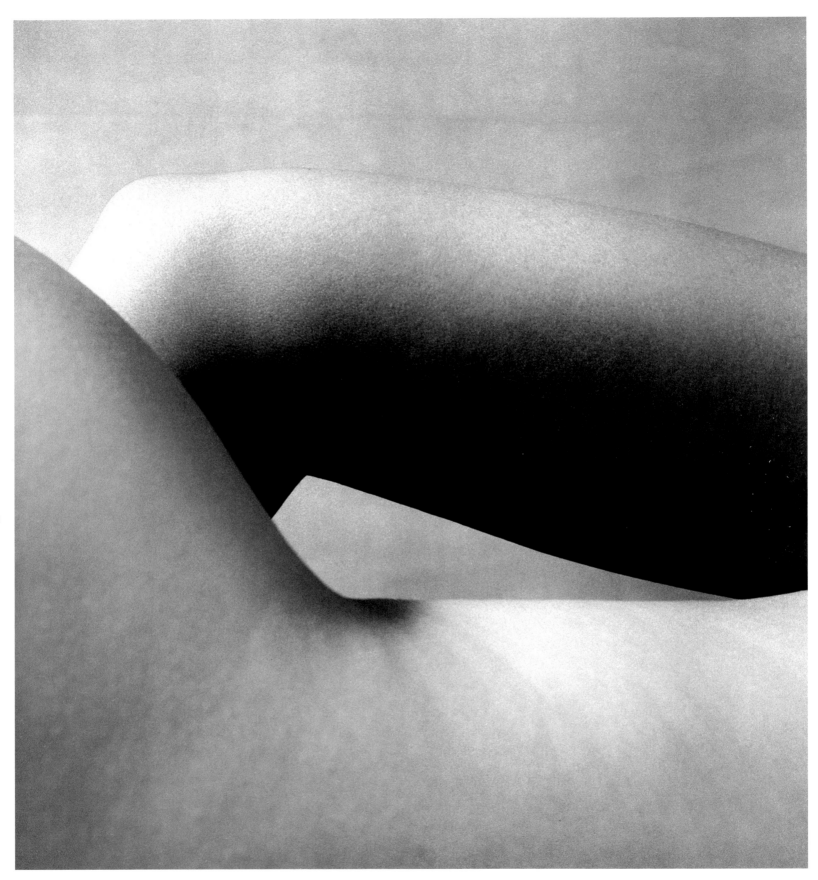

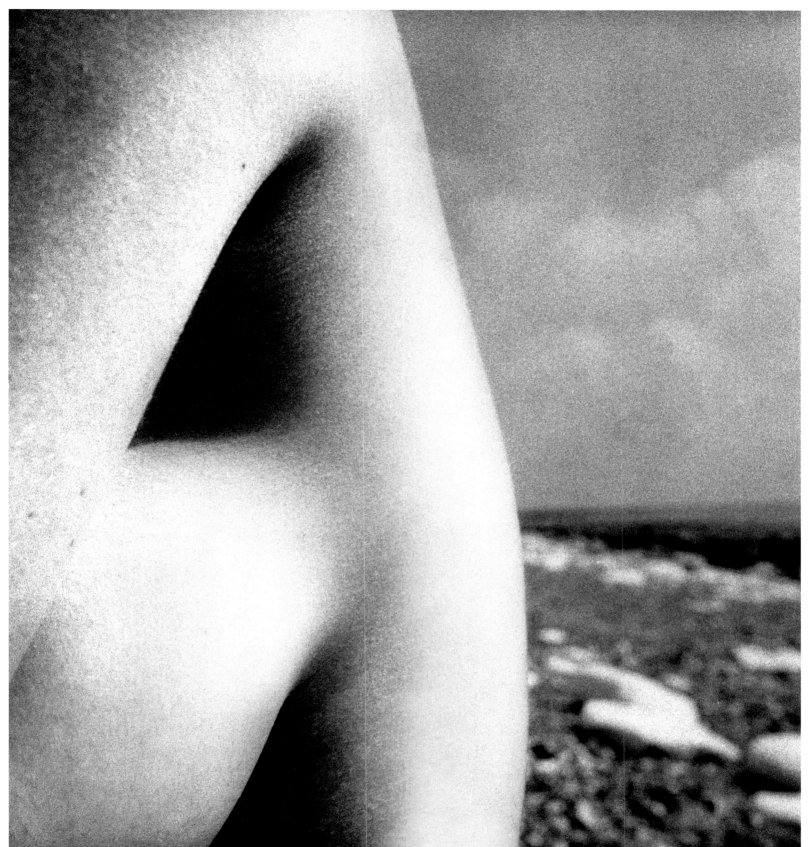

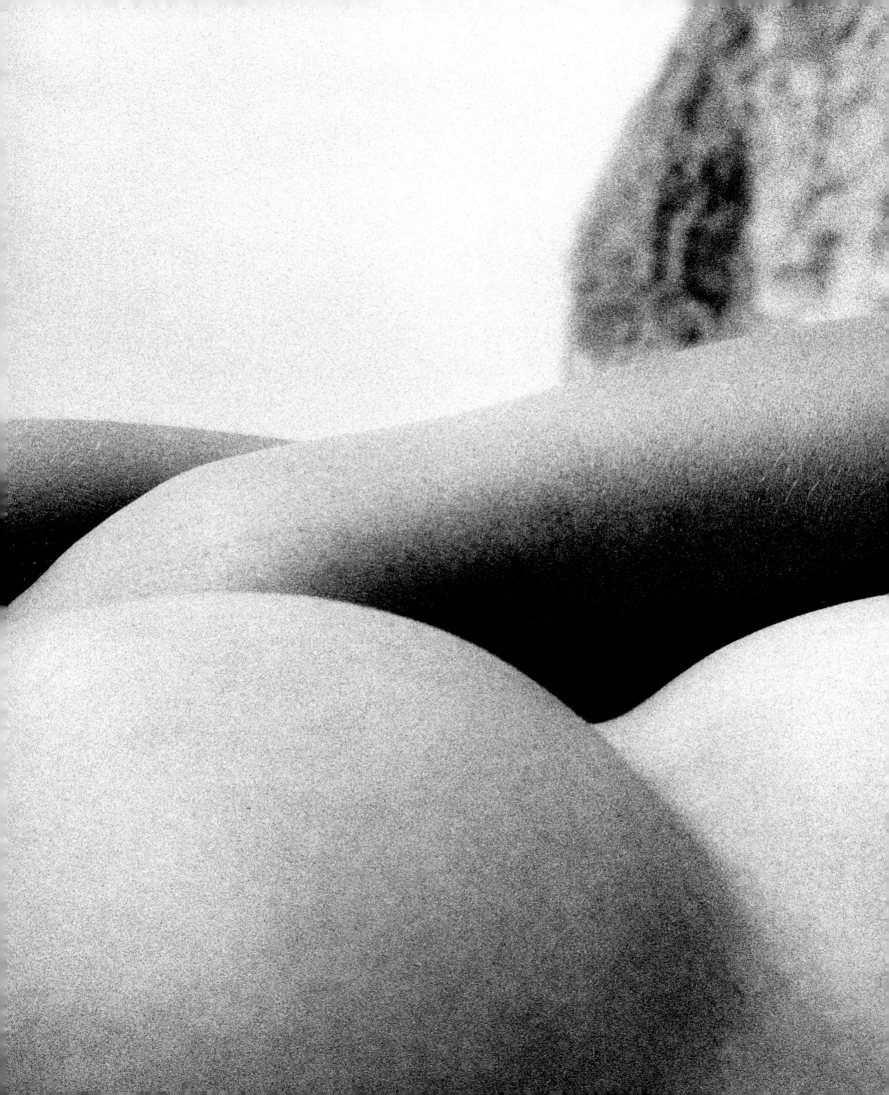

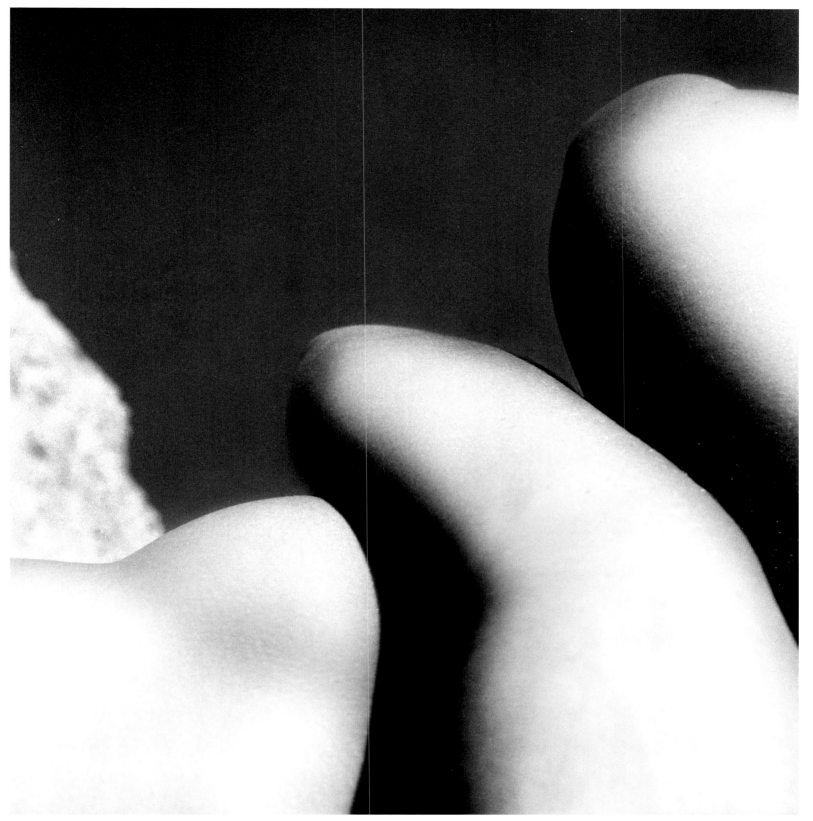

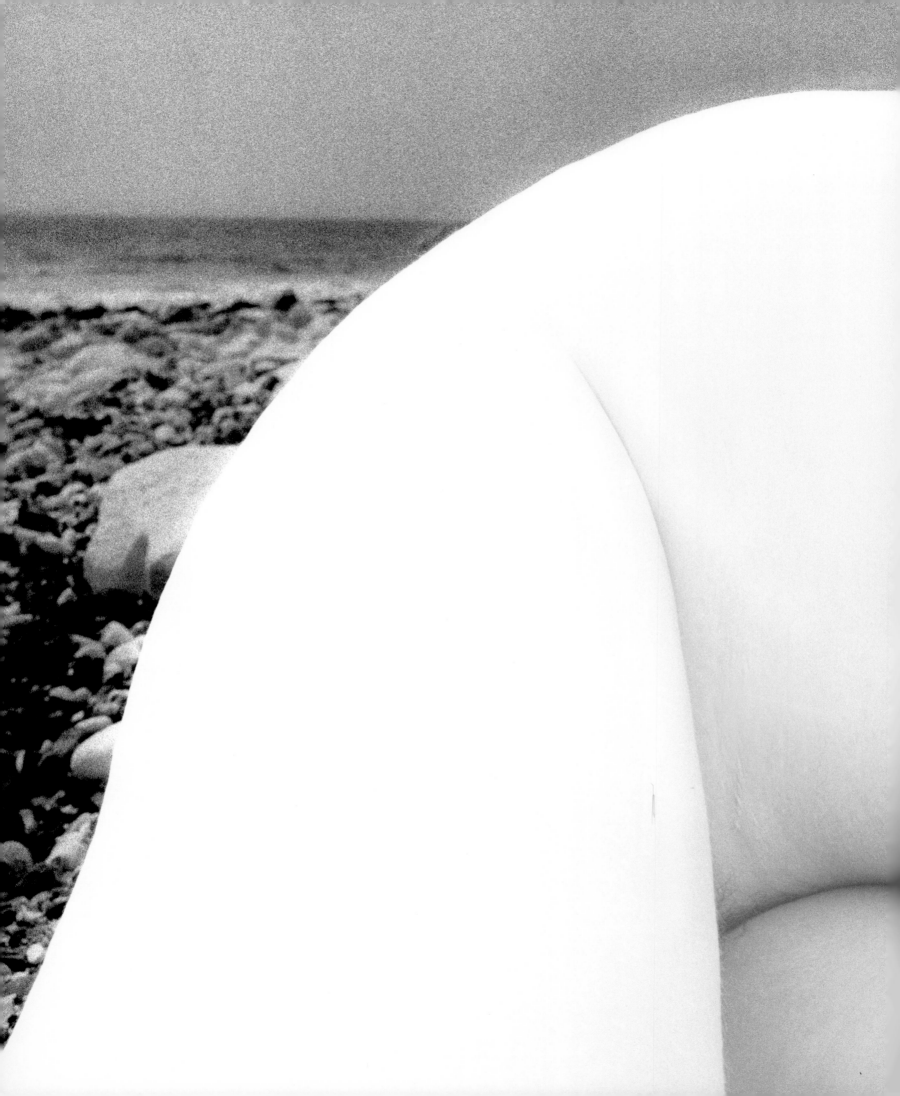

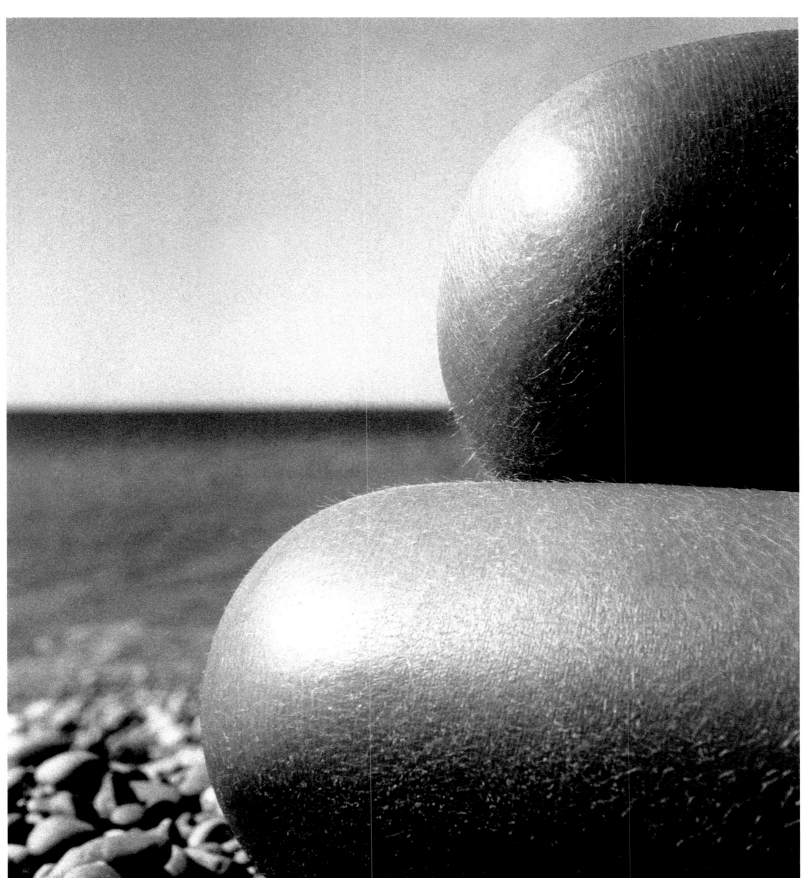

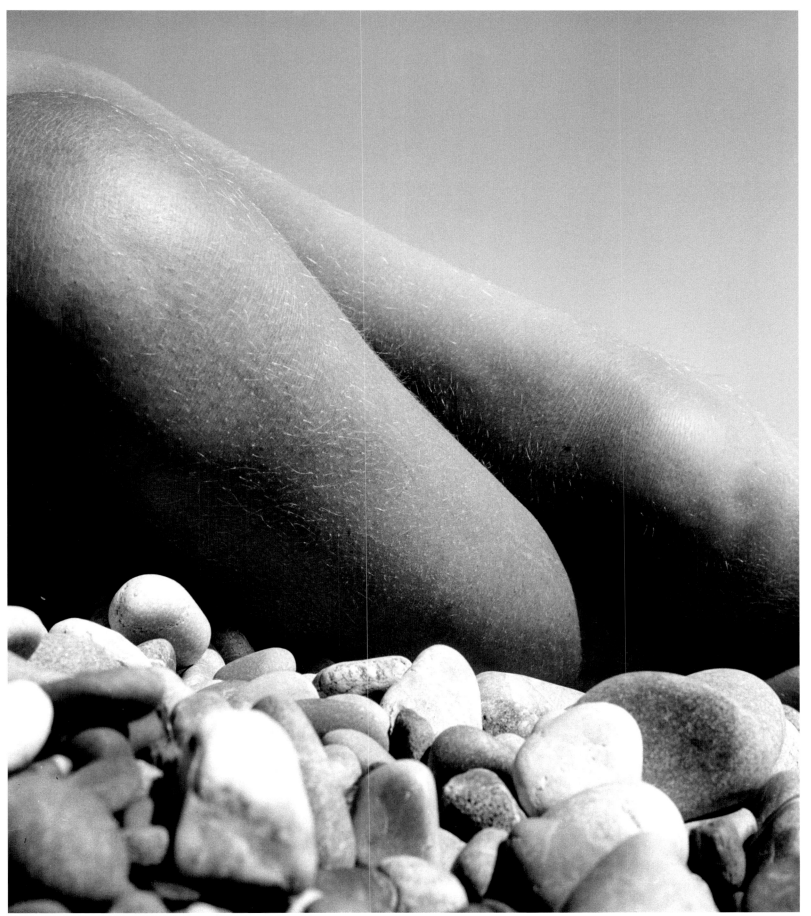

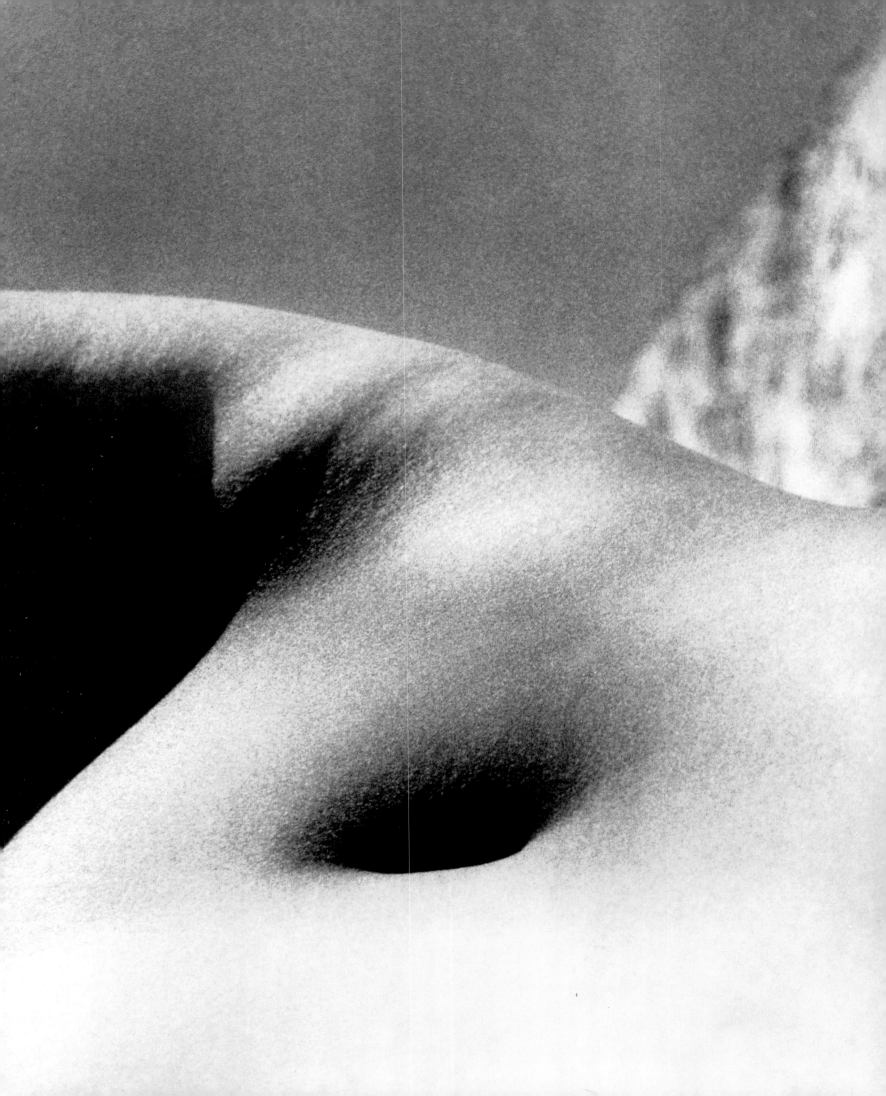

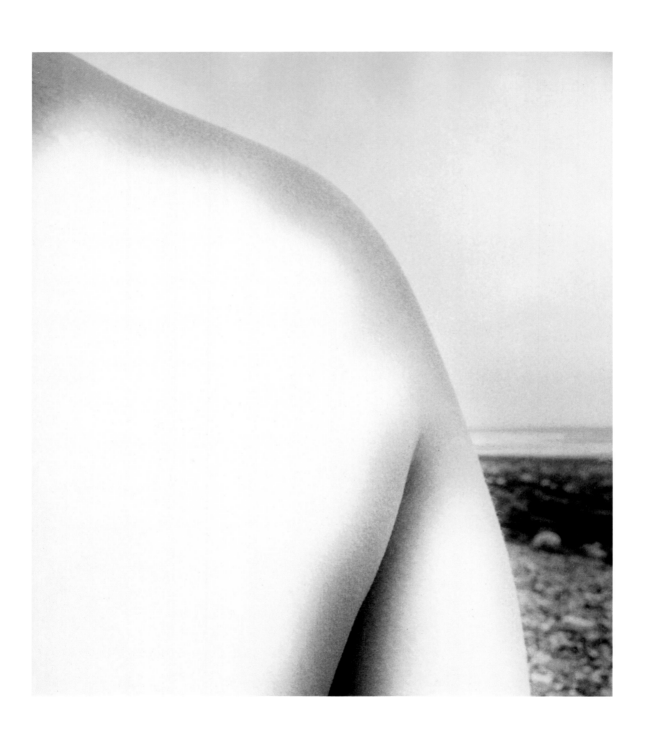

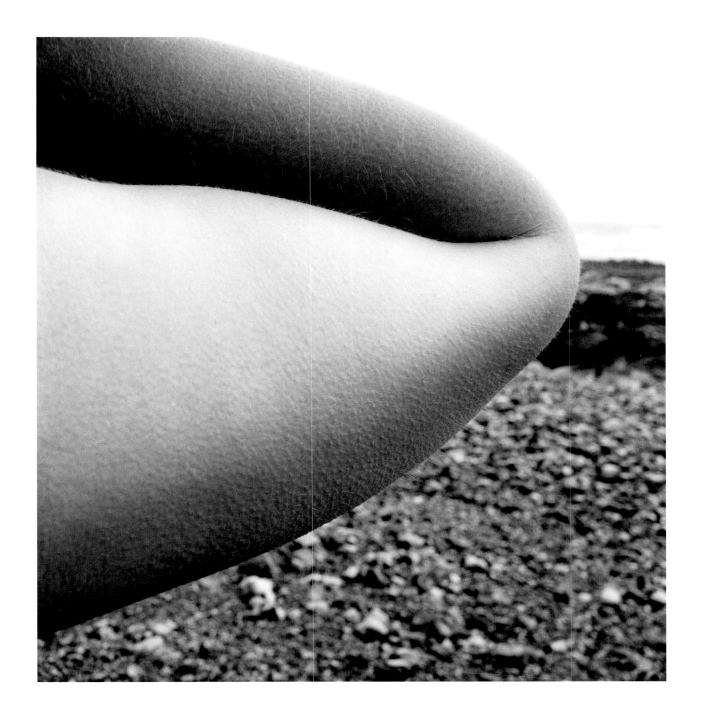

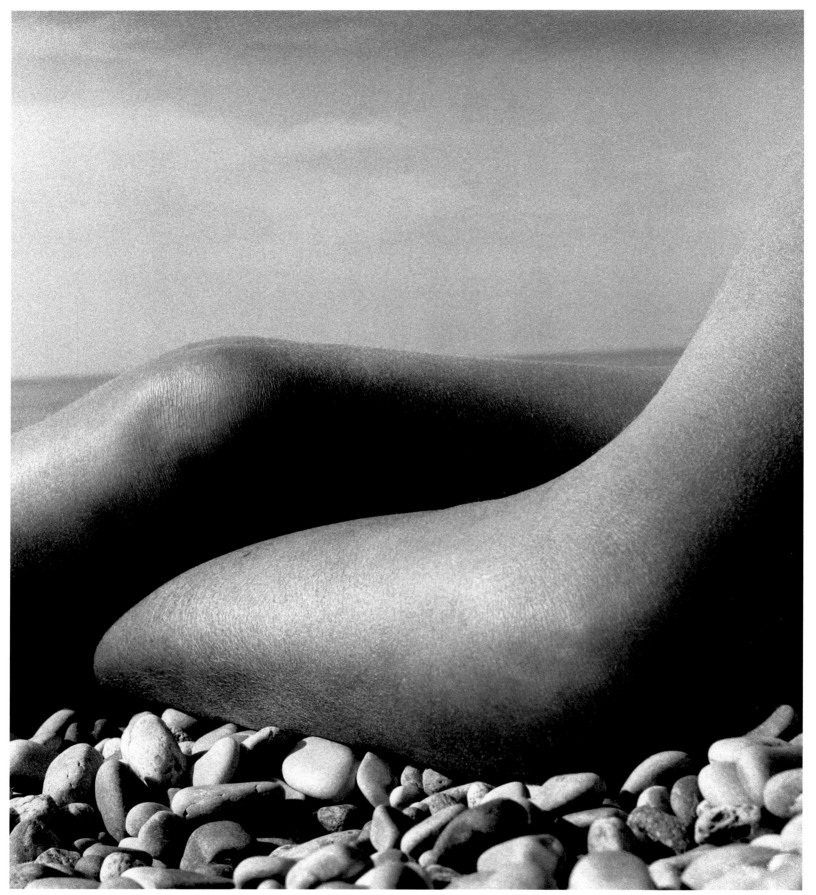

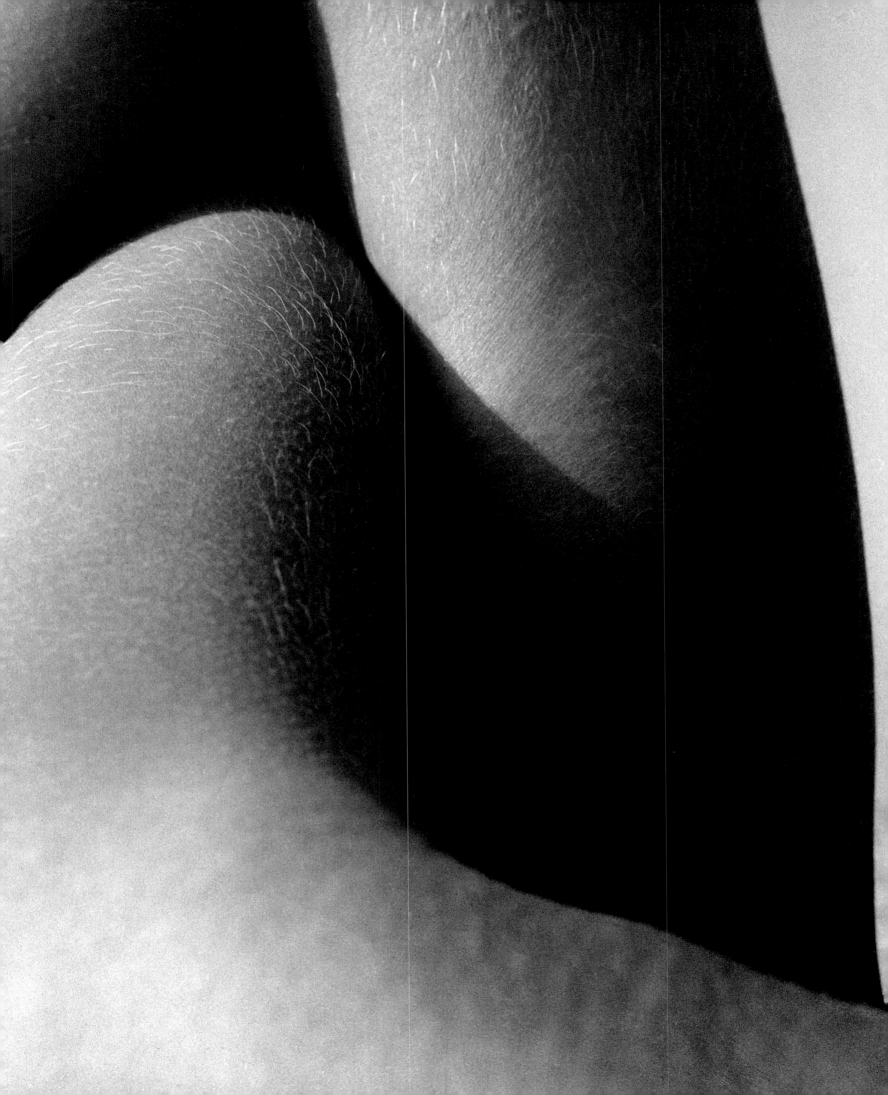

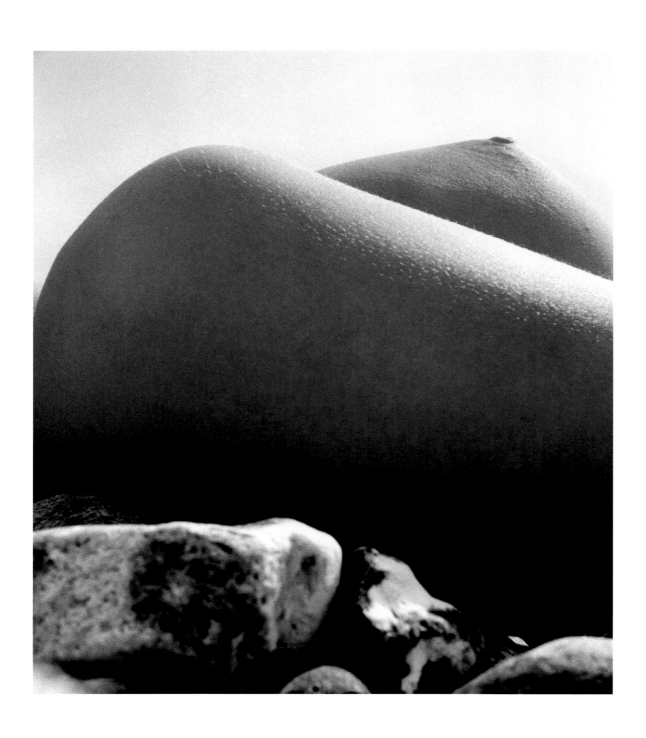

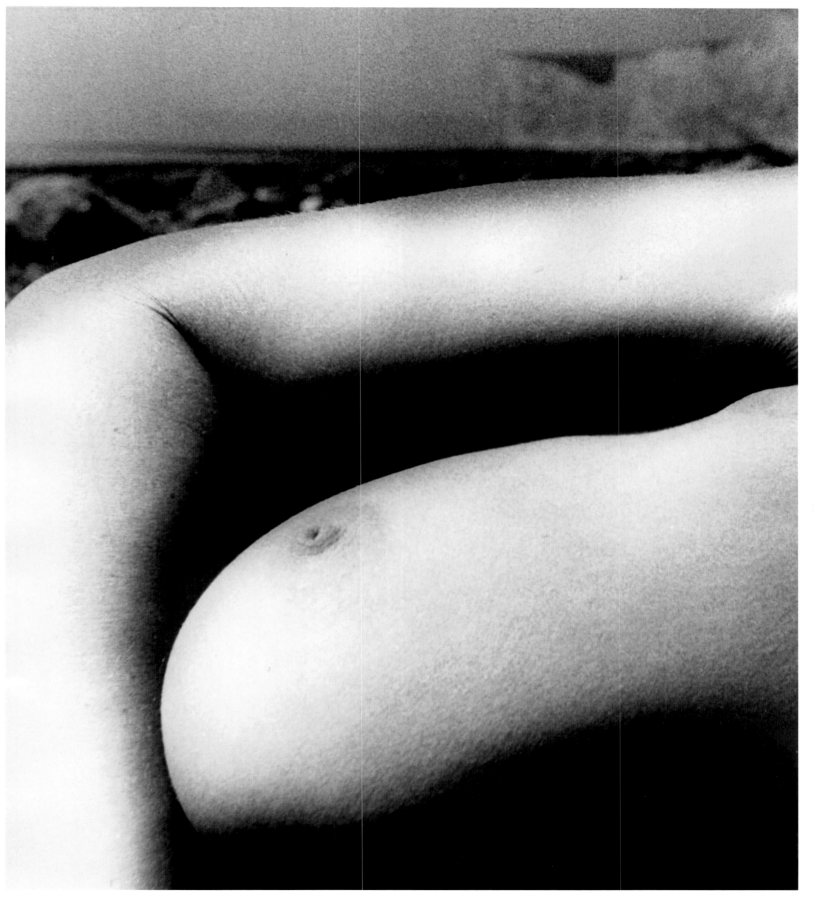

115

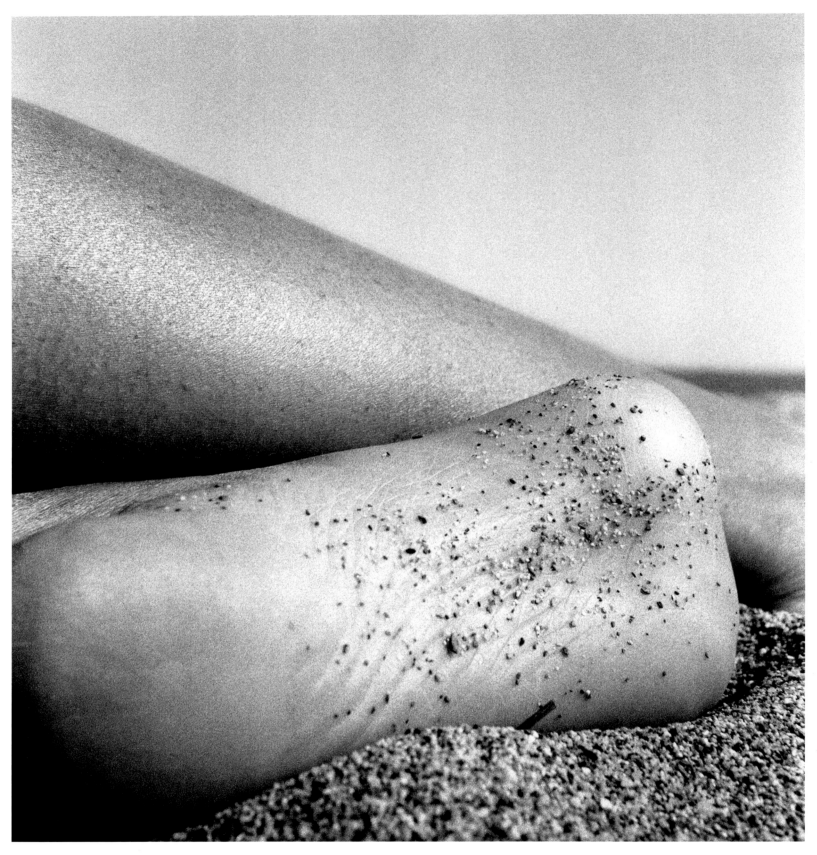

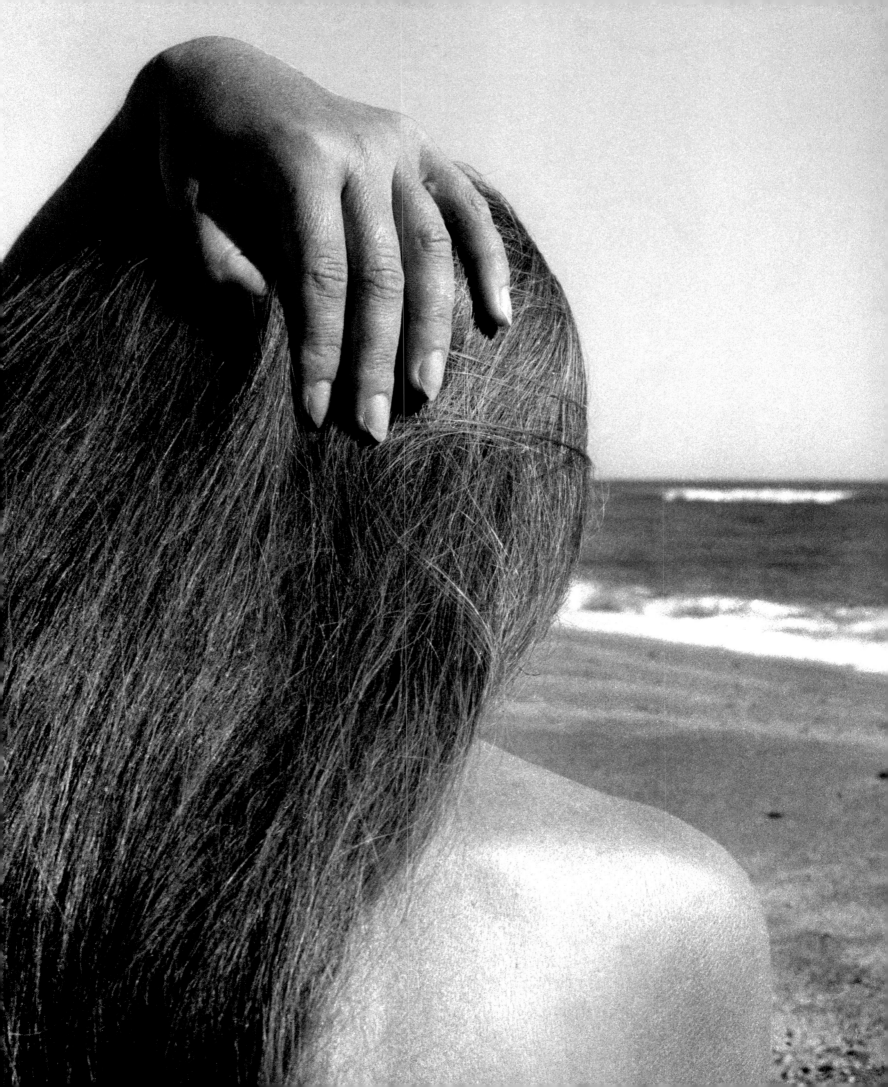

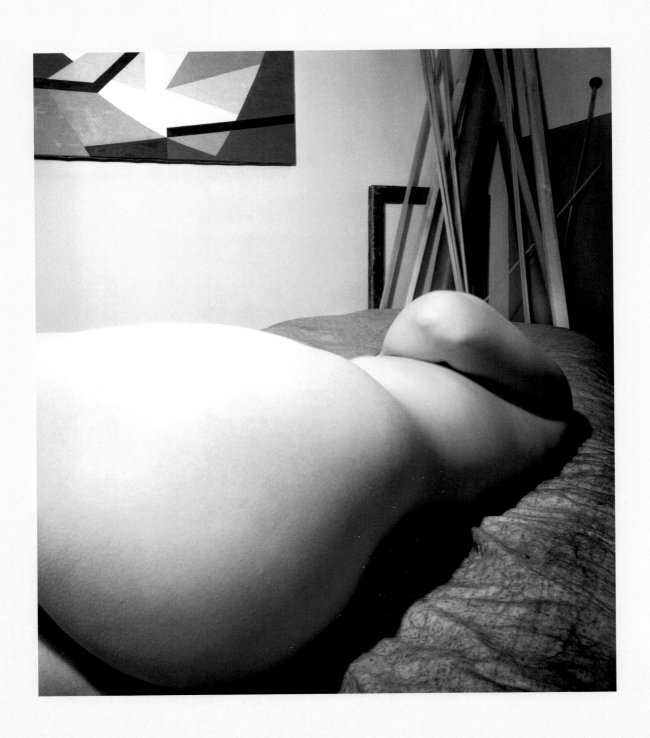

5

This series returns to interiors and shows us the body juxtaposed with objects, a preoccupation of Brandt's from the early 1950s to the late 1970s. The early interiors conjured an atmosphere of twilight, the time also variously known as 'the violet hour', 'the magic hour' or 'l'heure entre le chien et le loup'. In these interiors, however, the lighting suggests the bright expectancy of a studio. We find ourselves first, in fact, in the studio of Brandt's younger brother Rolf – with its hard-edged paintings – and then in Brandt's own studio with its photographic equipment and carefully arranged curiosities. Rolf Brandt (1906-1986) was close to his brother and appeared in various roles (from East End villain to West End toff) in Brandt's *The English at Home* (1936), *A Night in London* (1938) and *Camera in London* (1948). At the time Rolf was, in any case, an actor: he was part of Max Reinhardt's Deutsches Theater, Berlin until 1933 and continued his acting career in England. His hard-edged abstract paintings (now being exhibited once more in London galleries) gave Bill Brandt a new kind of context for his nudes – no longer the dream-like and melancholy

Victorian spaces of the first series but a place in which new work is being done.[1] Brandt's own studio is more reflective of his interest in Victoriana, but includes (number 126) photographic equipment: a studio clock, rolls of background paper and even (on a tripod) a Kodak Wide-Angle camera. (By then Brandt had acquired a second one.) He uses a photo-flood to cast angular shadows, creating a series of harmonics with the triangle of the model's elbow.

The hard-edged paintings connect with the dramatic change in Brandt's printing style during the 1950s, seen most emphatically in the hard-edged nude included in number 126. The change occurred after Edward Steichen included four photographs by Brandt in his famous exhibition *The Family of Man* (1955). On receiving the prints Steichen complained that they were too grey.[2] Brandt's later printing style – also evident in his books from *Perspective of Nudes* onwards – used harsh tonal contrast to emphasise the graphic structure of his pictures. This series pulls Brandt's nudes forwards in time towards the glittering hard-edged 1960s, when they were published (in 1961).

119

1. Rolf Brandt, *Apparitions*, an exhibition of paintings and drawings (1988)
2. Mark Haworth-Booth and D. Mellor, op. cit, p71

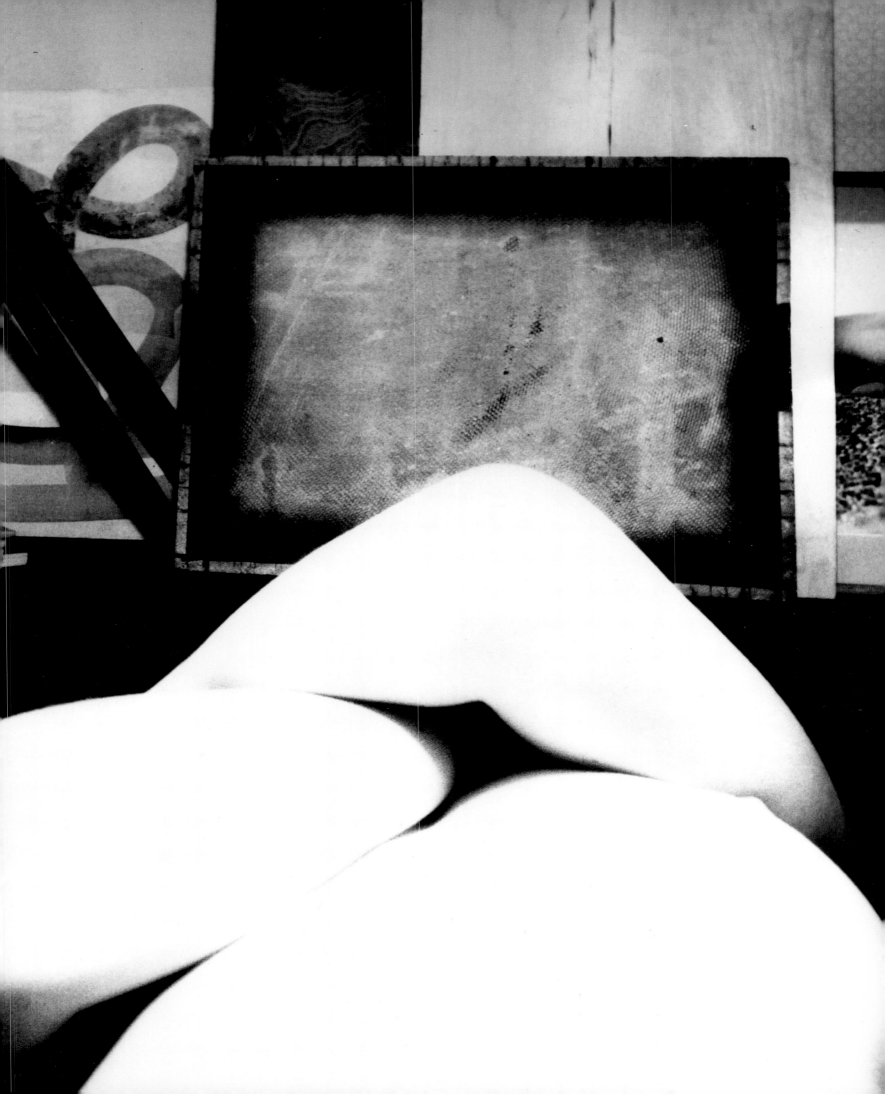

122

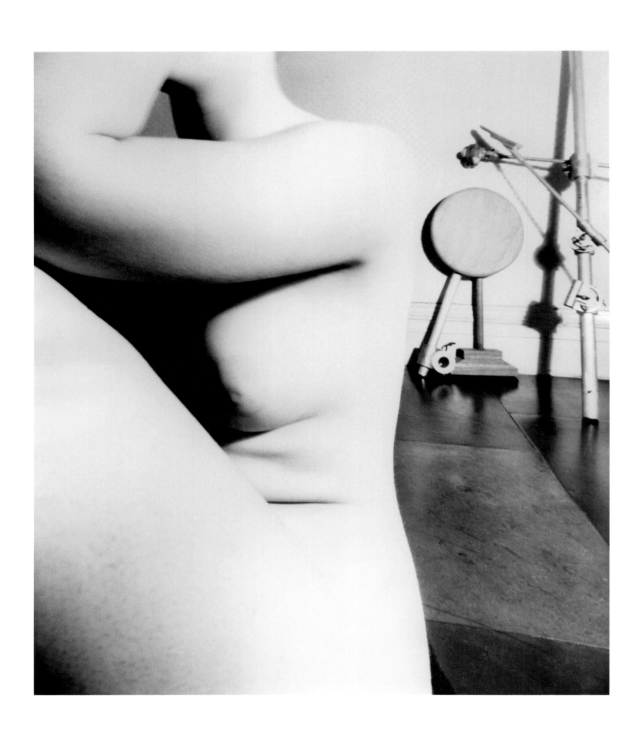

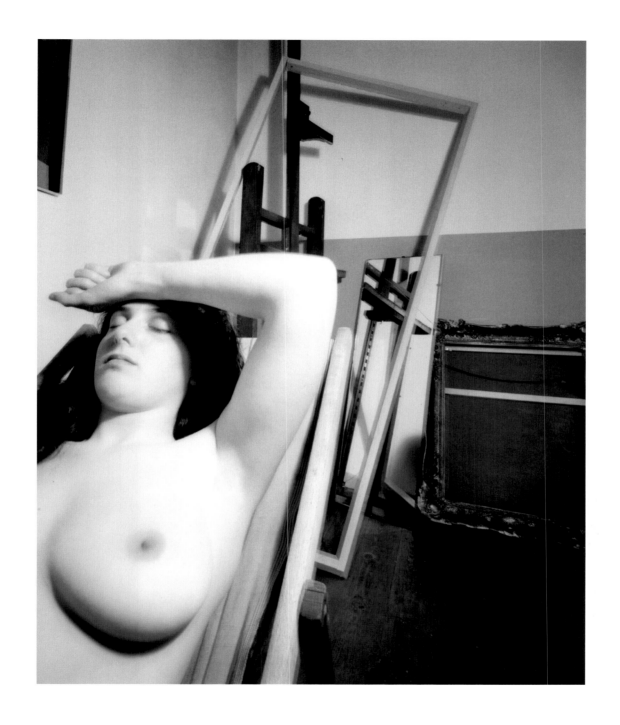

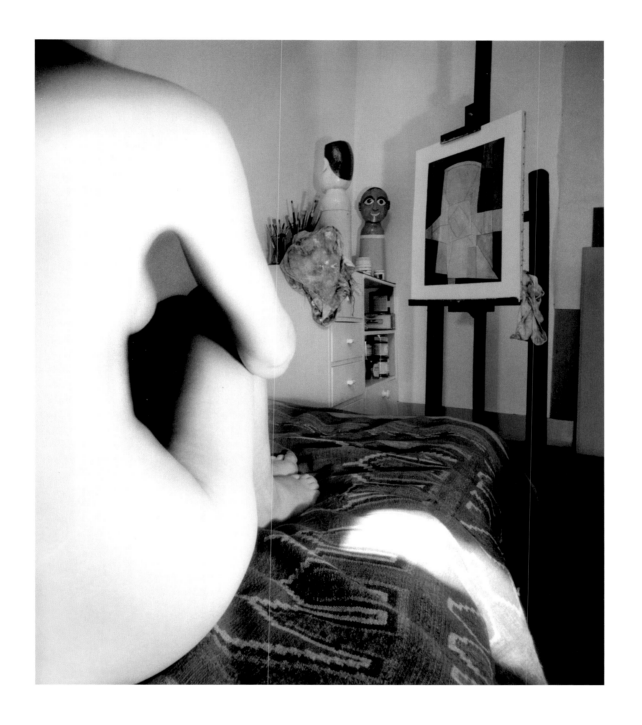

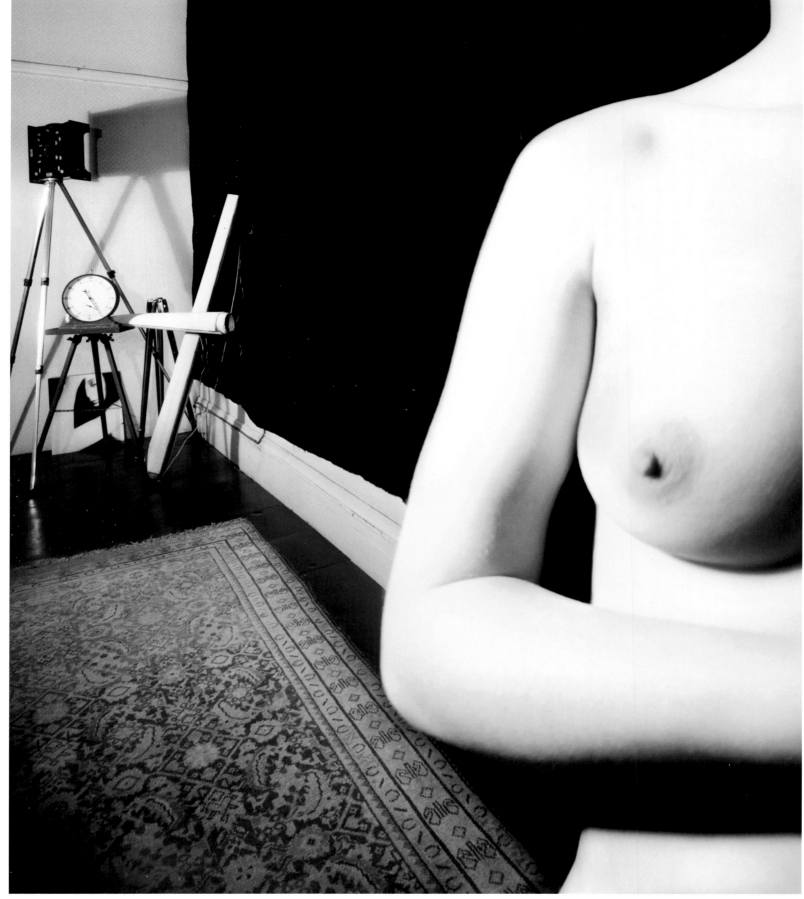

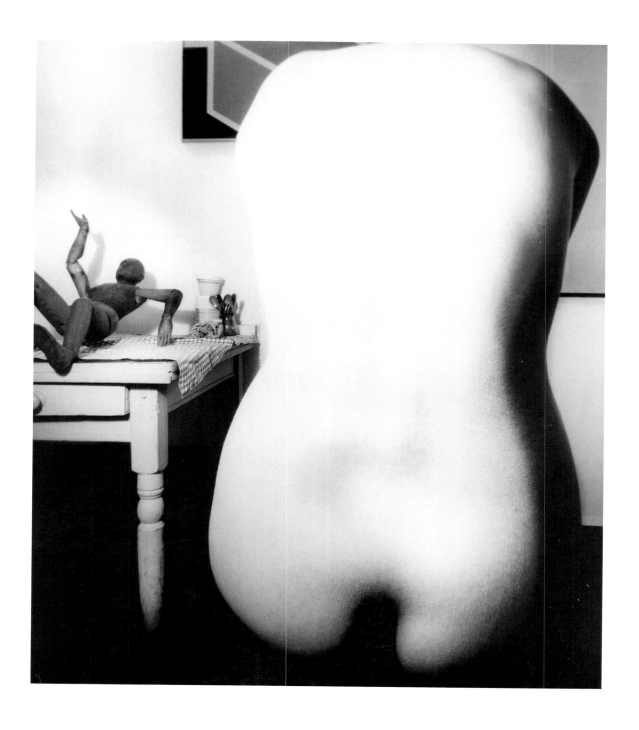

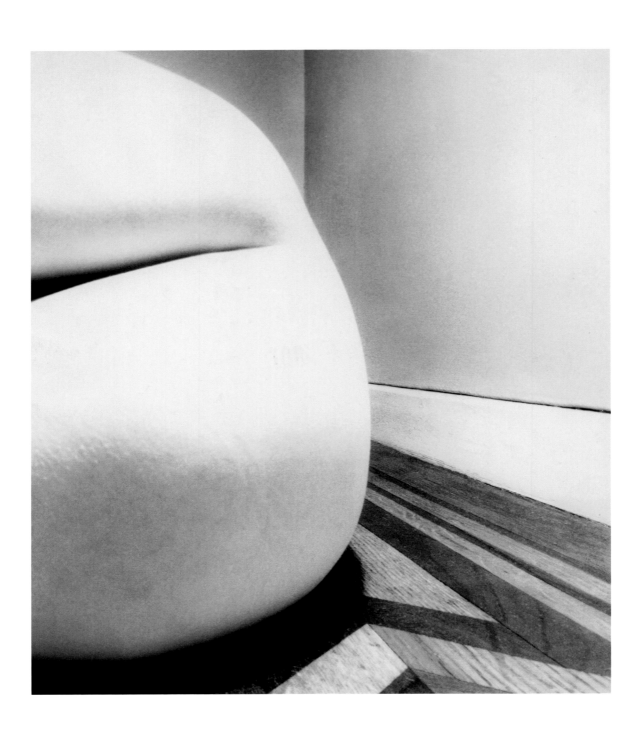

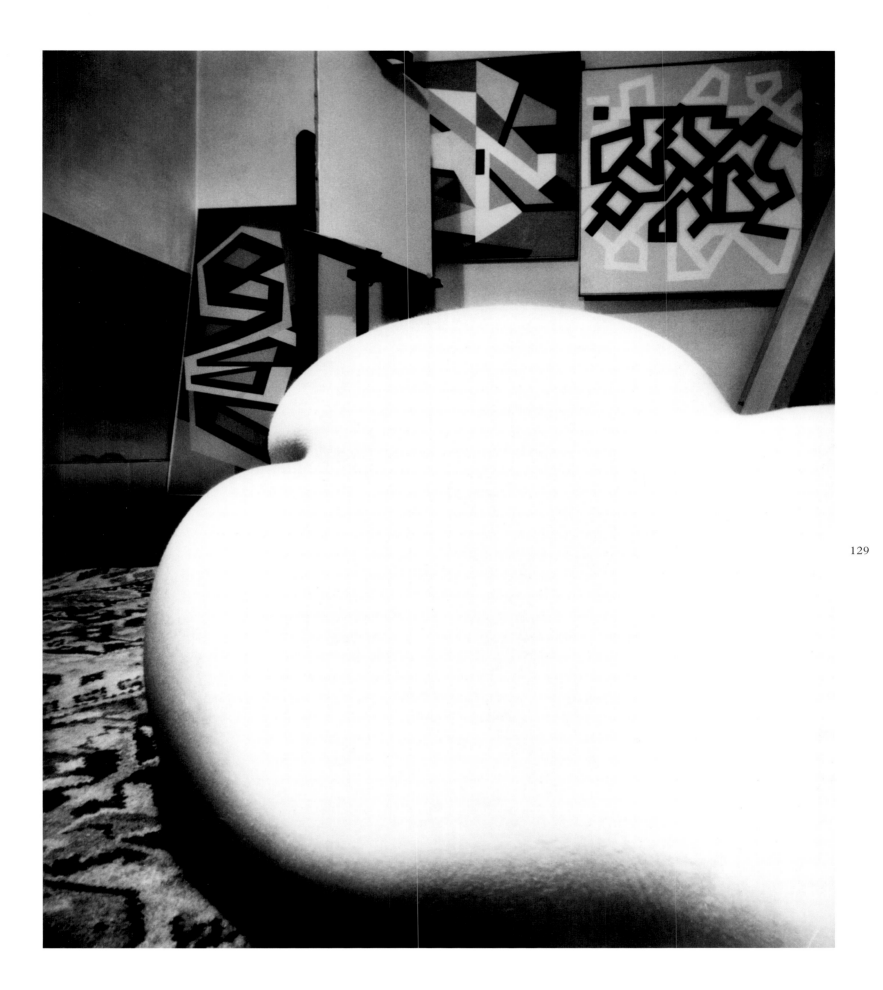

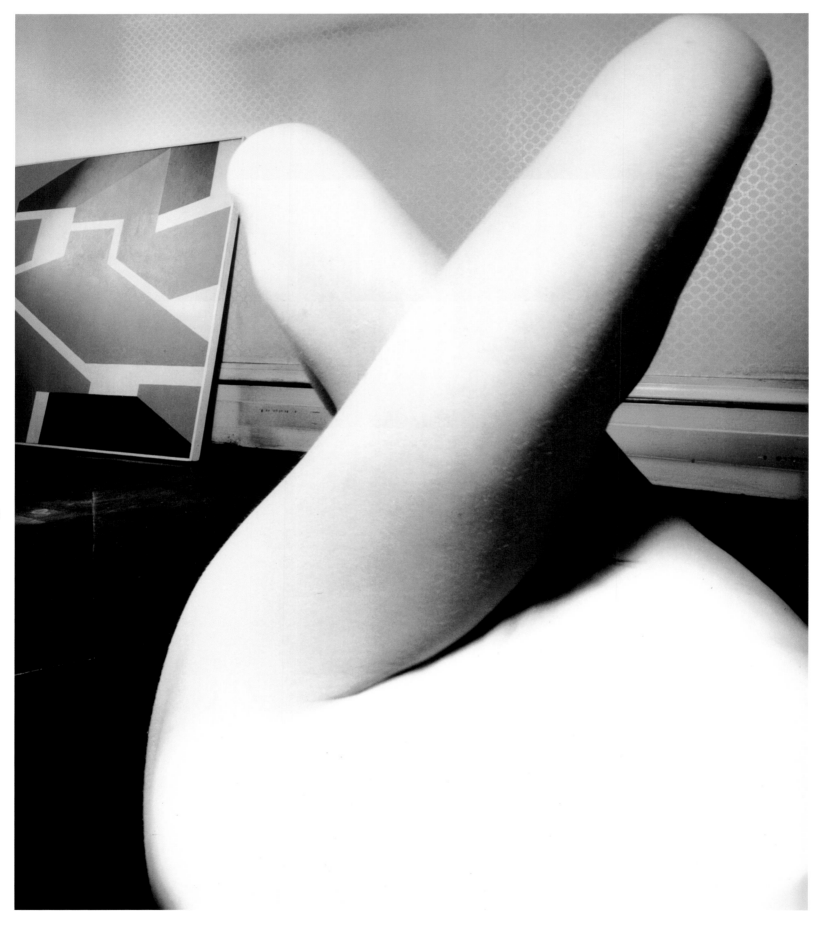

130

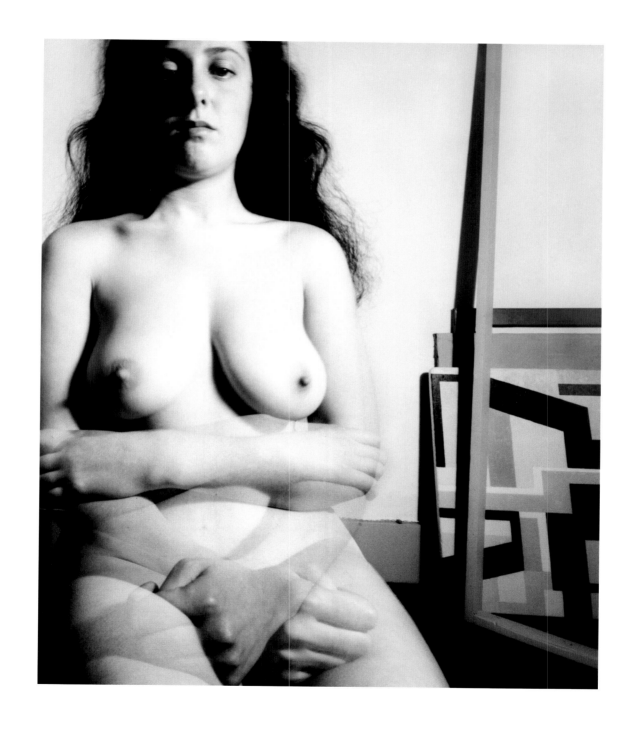

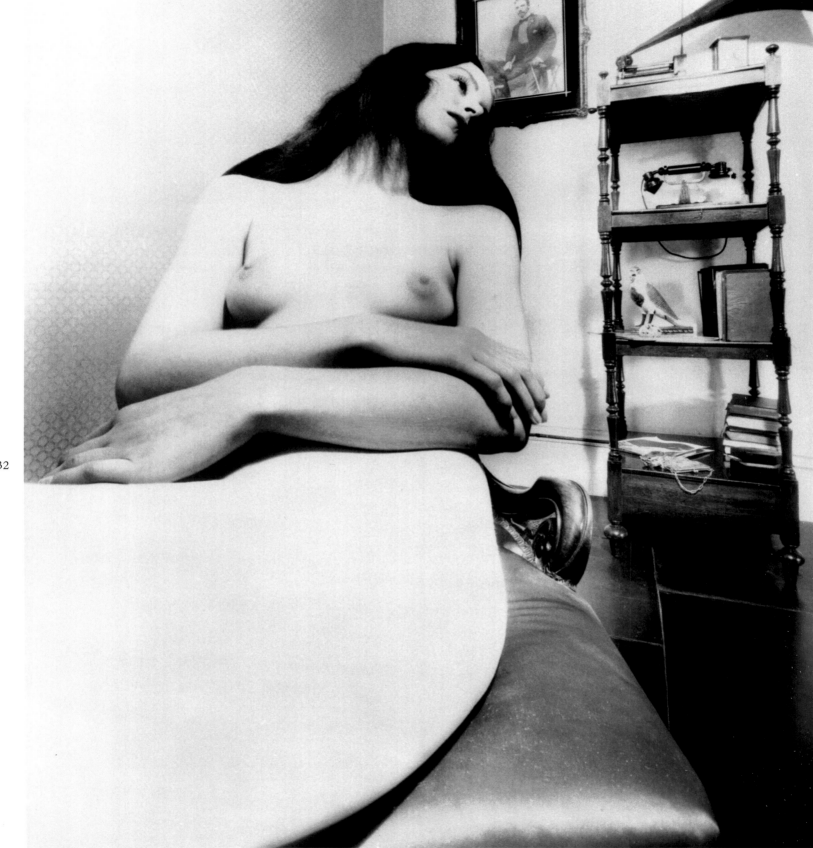

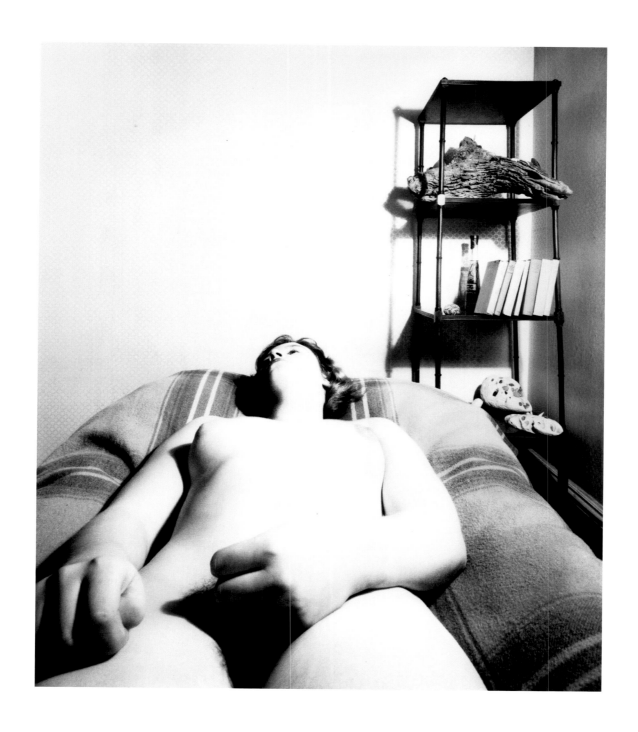

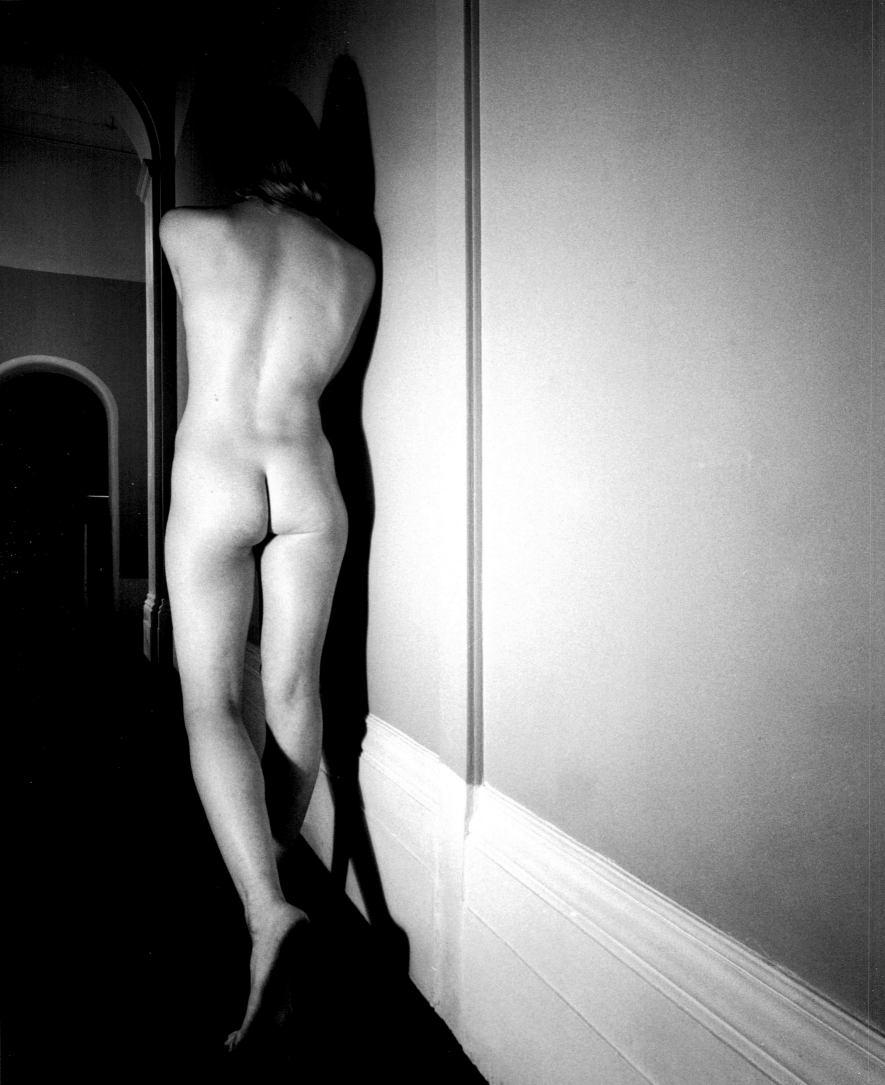

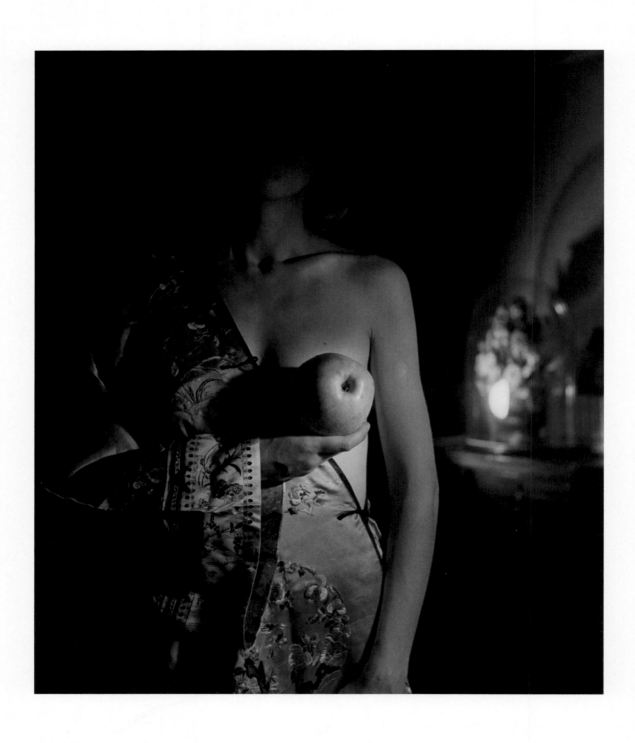

6

Brandt's *Perspective of Nudes* (1961) sold slowly, especially in the US, where it appears to have been remaindered. By the mid-1970s the book's status as a major work was established and it had become relatively hard to find and expensive even second-hand. When Brandt agreed with his publisher Gordon Fraser to produce another book of nudes in the late 1970s, he decided to make new works. He planned *Bill Brandt: Nudes 1945-1980* (1980) as six sections, corresponding to different themes in his work. Section five in that book is the basis of section six here.

The theme – the juxtaposition of bodies and objects – continues from the previous chapter but now the objects move closer to the body, becoming substitutes or symbols. Sometimes they replace parts of the body altogether. There are many substitutes for the breast in this series – an apple (number 136 may date from the 1930s and 1940s), fluttering hands, a bird's wing, a sunflower, a draughtsman's 'French curves' (a motif borrowed perhaps from Magritte). Brandt used the device of objects, including mirrors, held close to the body in the early 1950s (number 145). He expands on the idea here, using mirrors to displace the body and objects partially to conceal it.

Whereas many of the earlier nudes seem expansive, as if replete with erotic energy or sated with sexual intent, the theme of these interiors of the late 1970s – to which twilight has returned – is mutilation and loss.

Michael Hiley, in his introduction to the 1980 book, wrote of these nudes as 'wraiths bearing urgent messages of warning', adding that 'Now the symbolism is savage and even crude… the few images bearing meanings of sureness and permanence which relate back to Brandt's earlier nudes are now juxtaposed with others which hint at a great sadness for things lost, at risk, passing away'.

In some pictures he returned to his own studio (number 141), with its shelves filled with beach-combed objets trouvés and exotic bones and feathers – the items he delighted in making into collages in his later years. He also returned to the studio of his brother Rolf, with its paintings and doll-like sculptures (numbers 155, 157), in which the mood lightens for a moment. He also returned to his well-stored memory, recalling Magritte's *Les Amants* (1928): the hooded lovers of the painting have become a solitary, bound figure (number 158). In the final nude in the section Venus is literally disarmed.

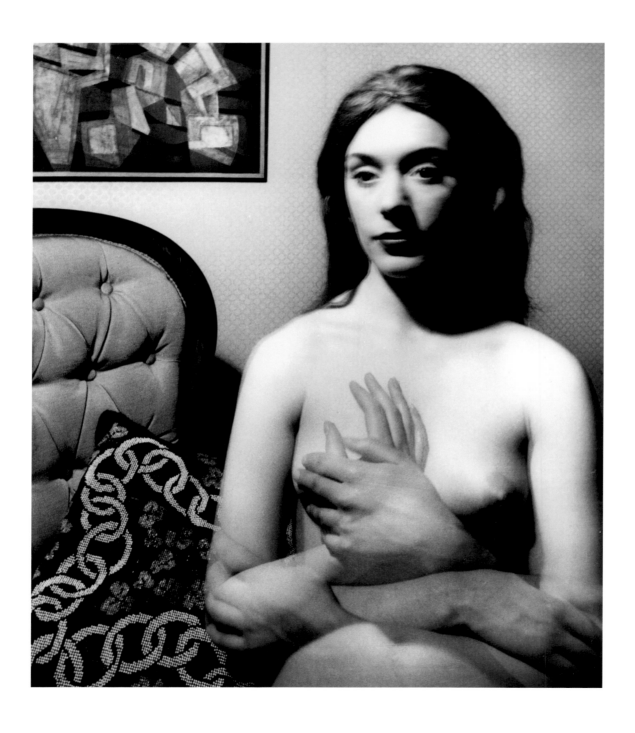

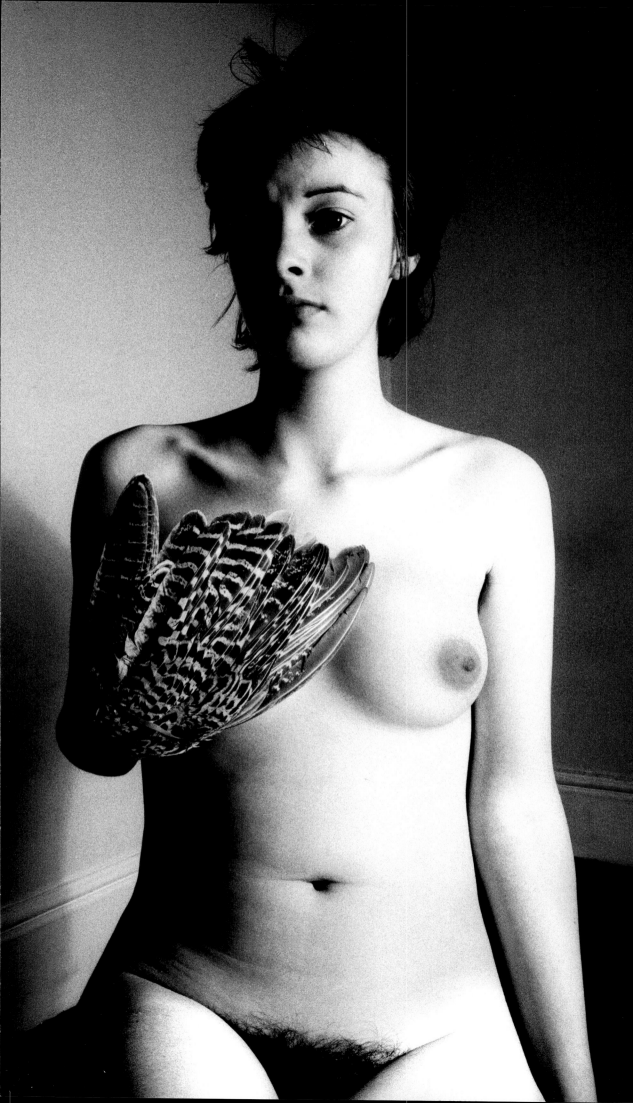

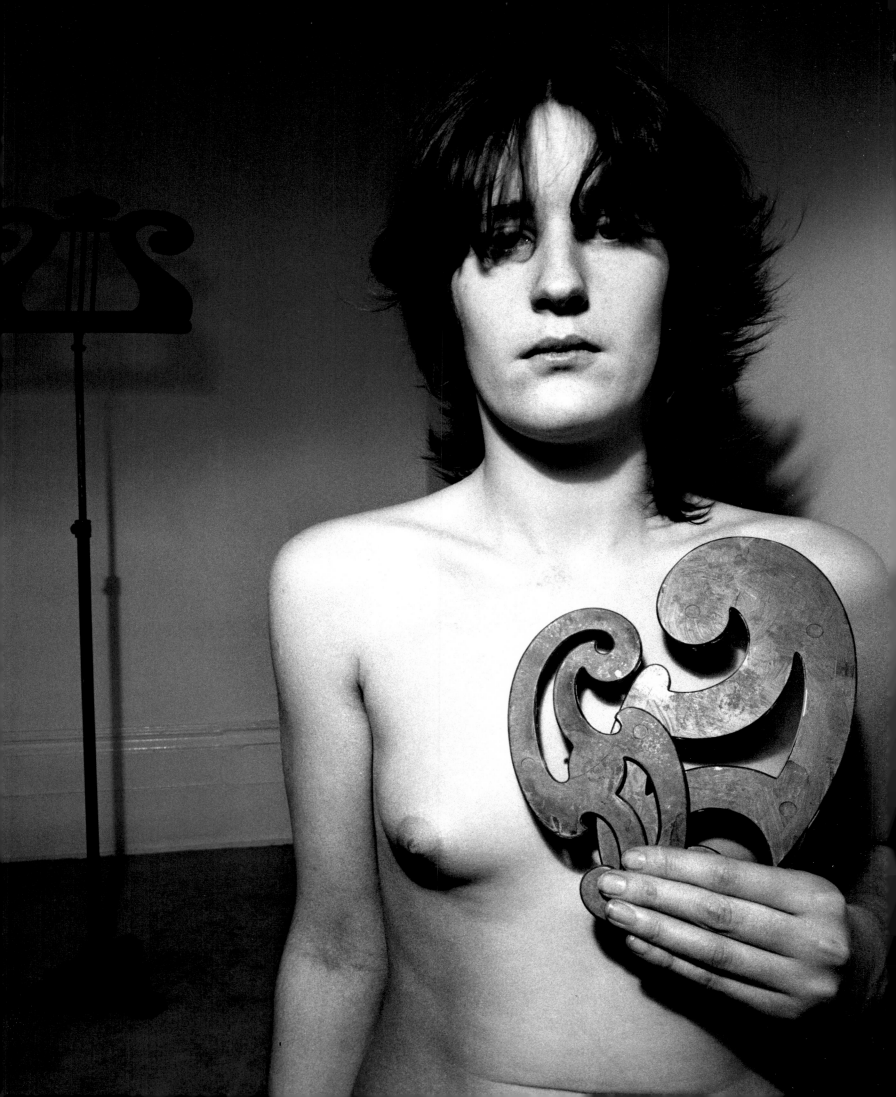

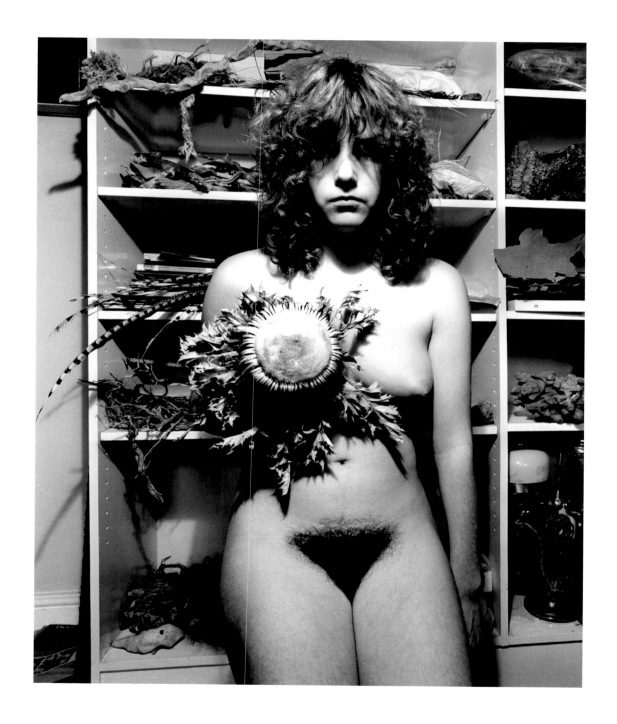

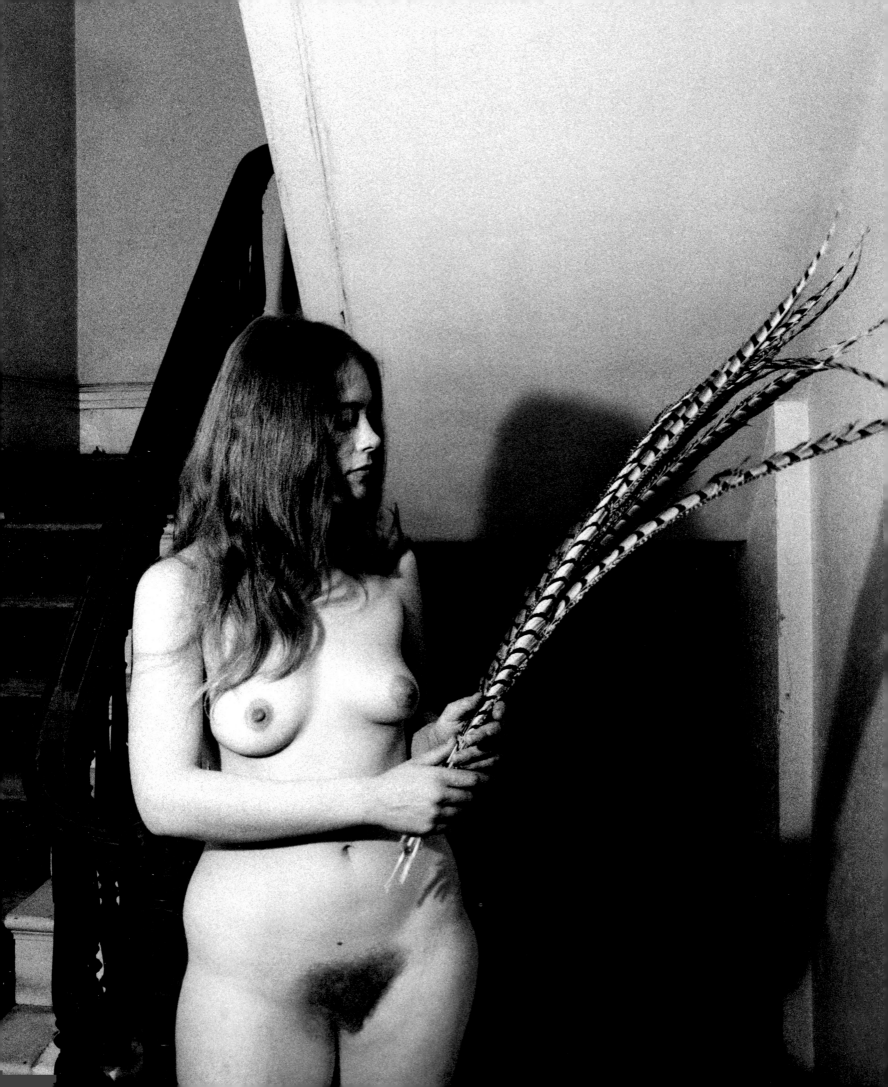

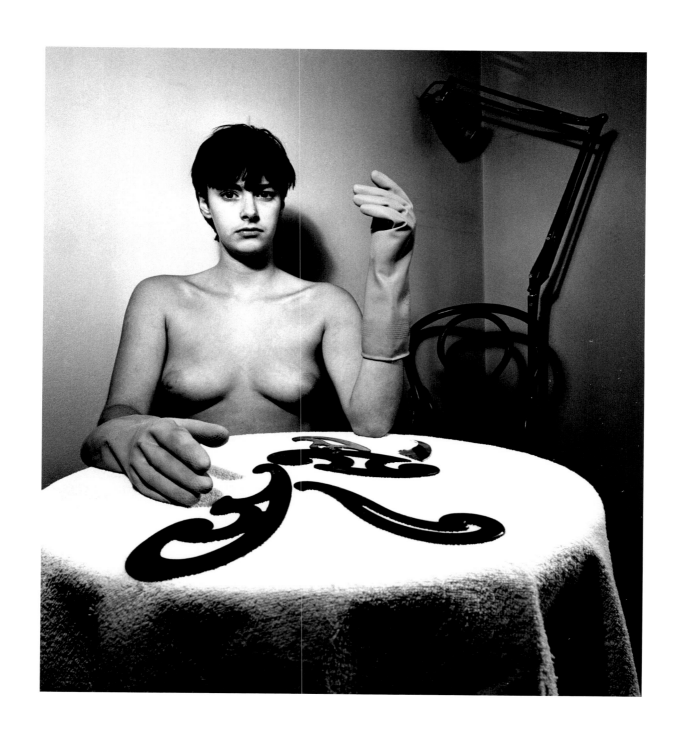

144

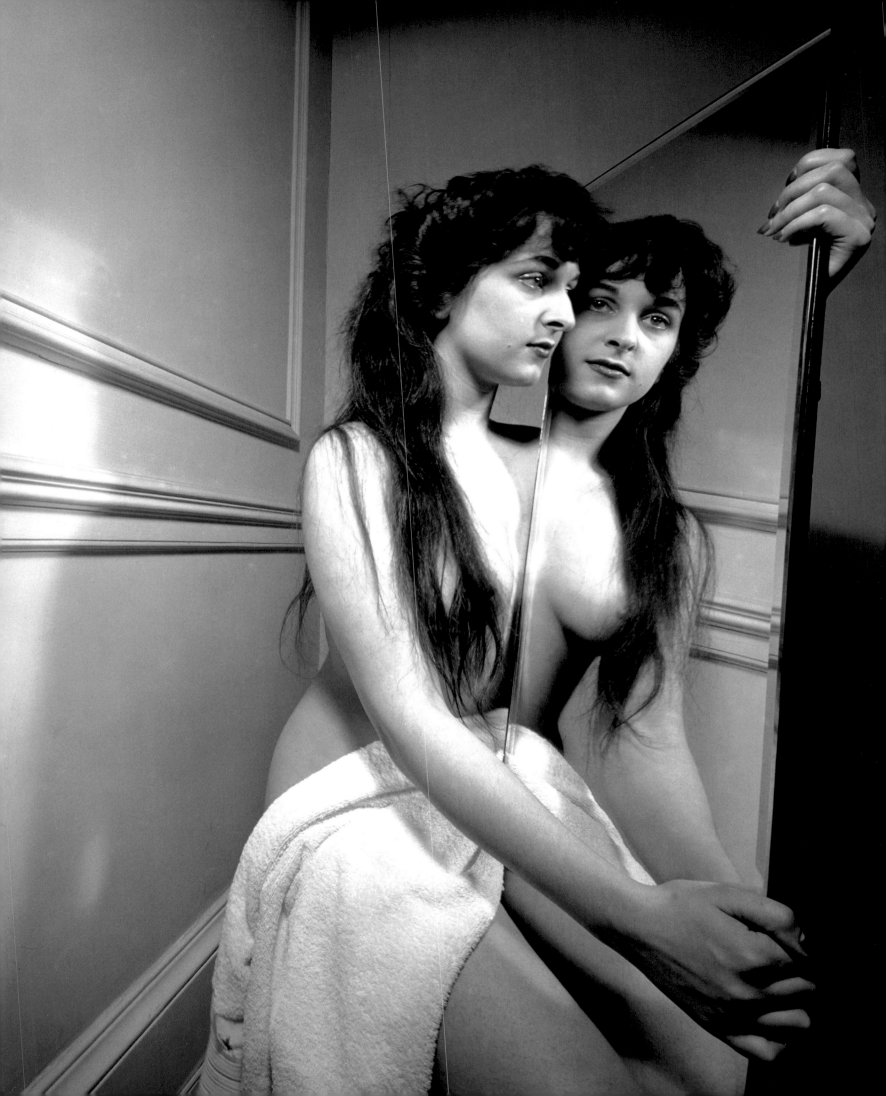

146

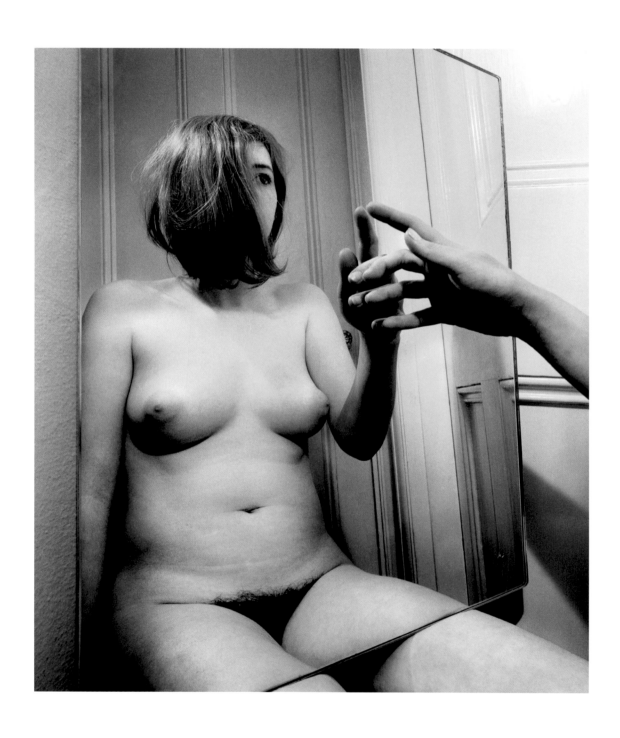

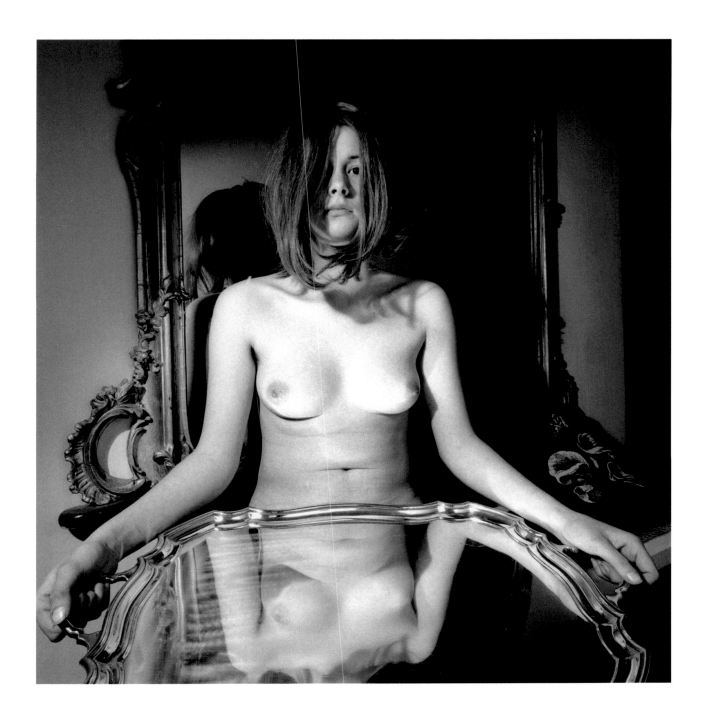

148

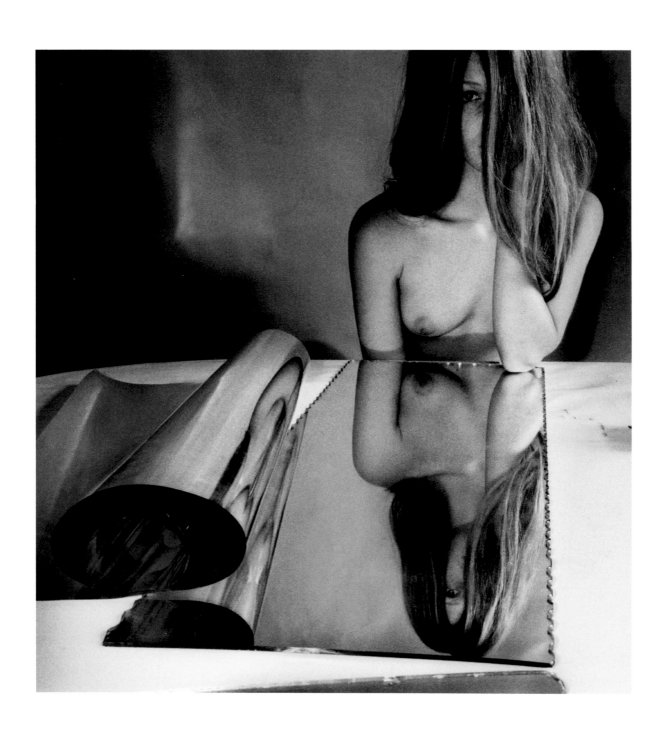

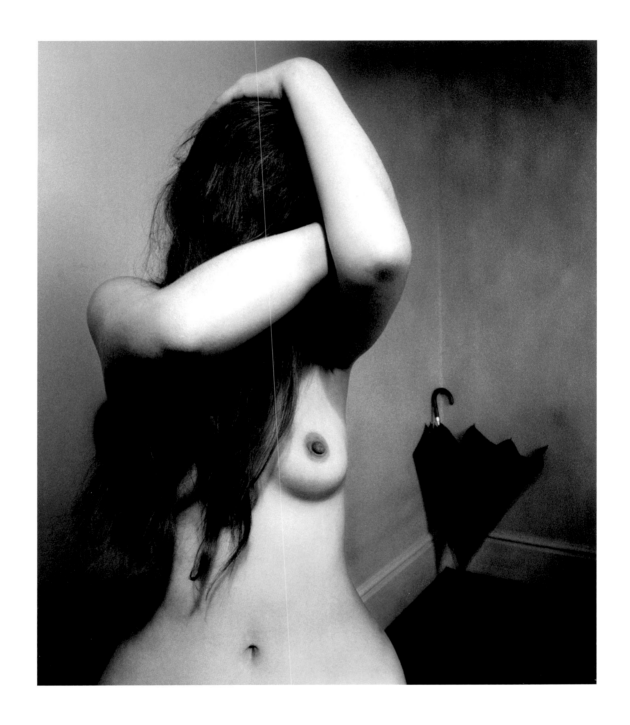

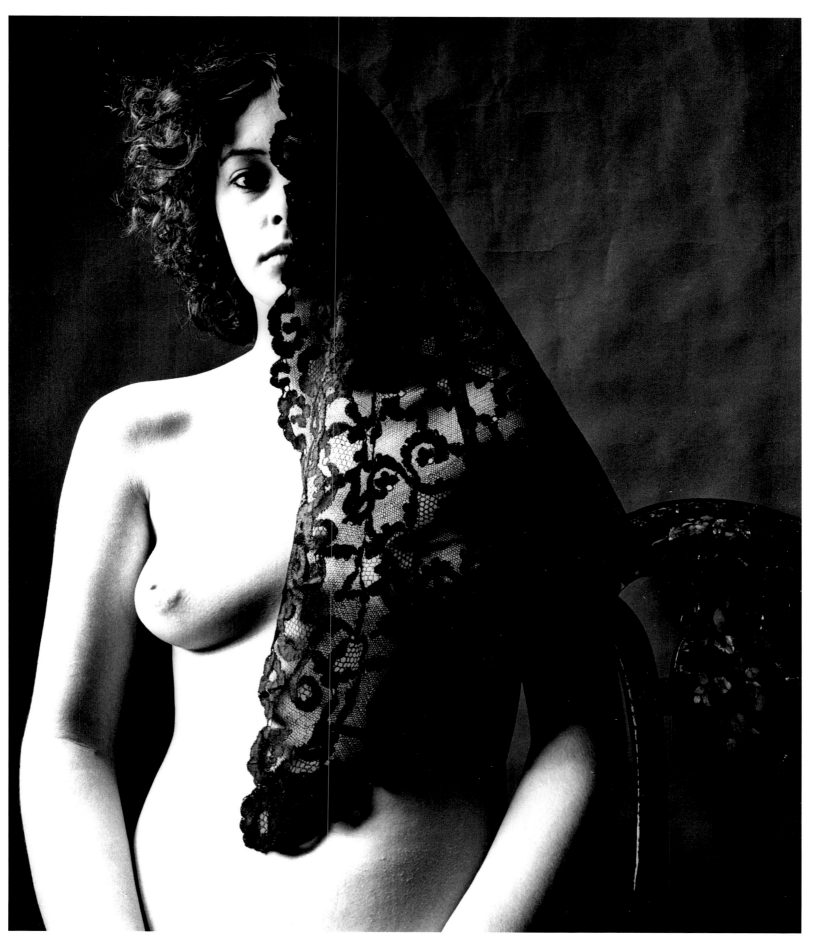

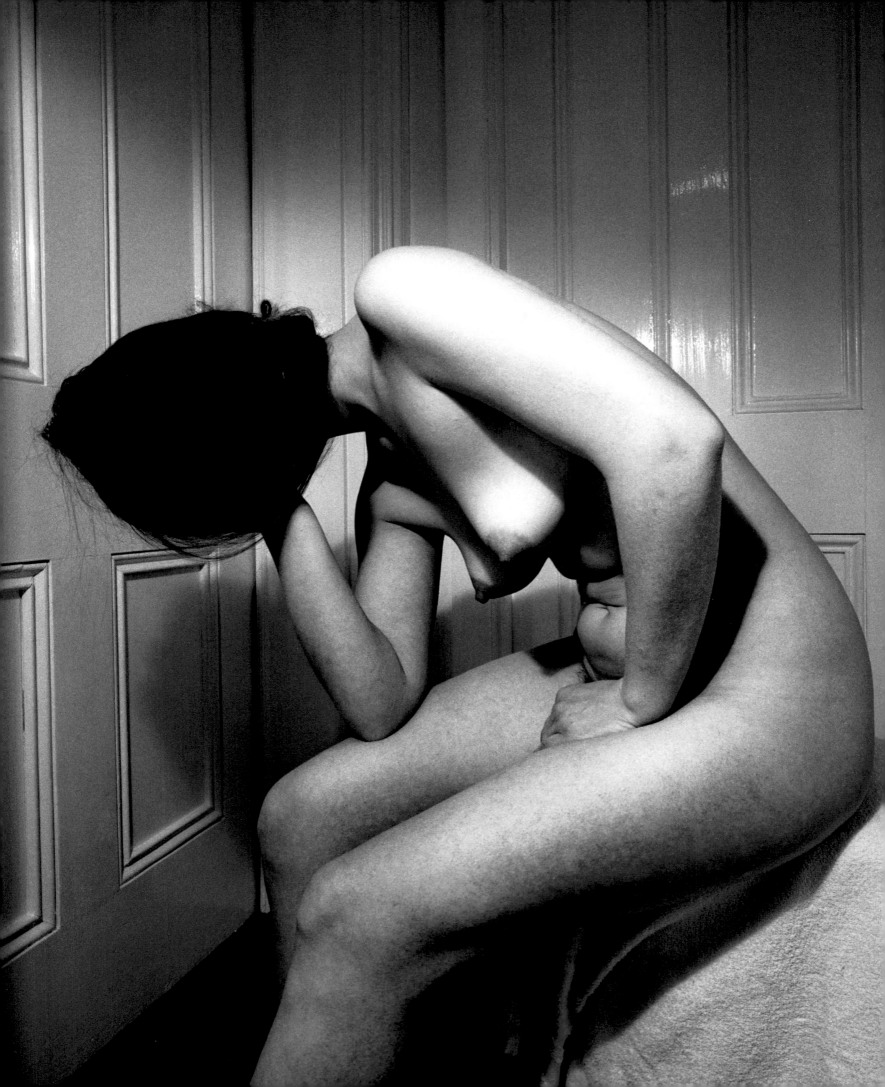

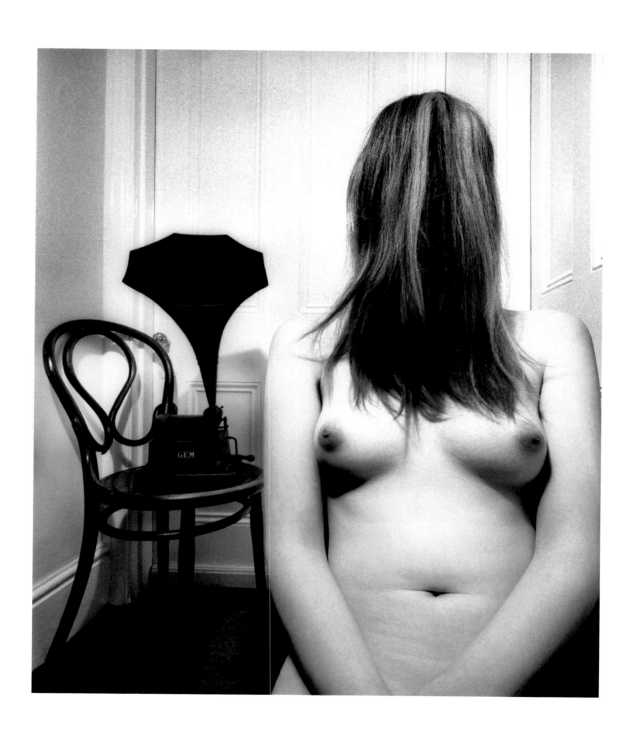

154

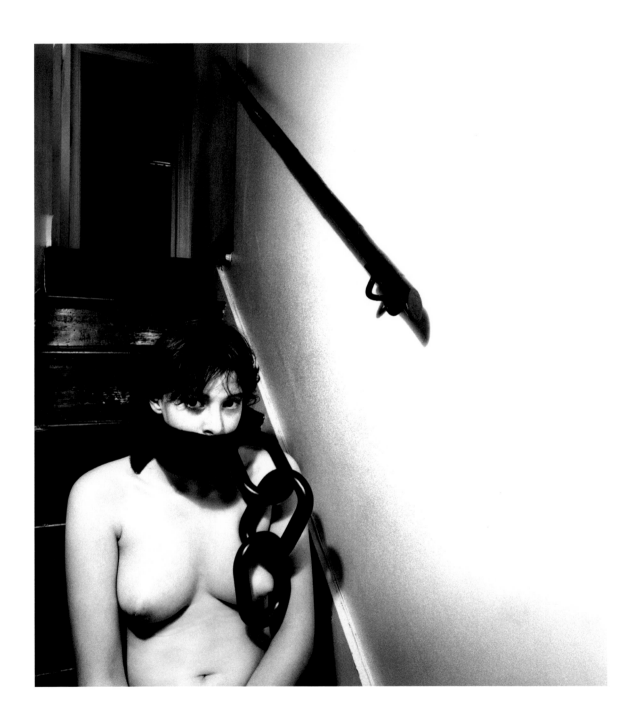

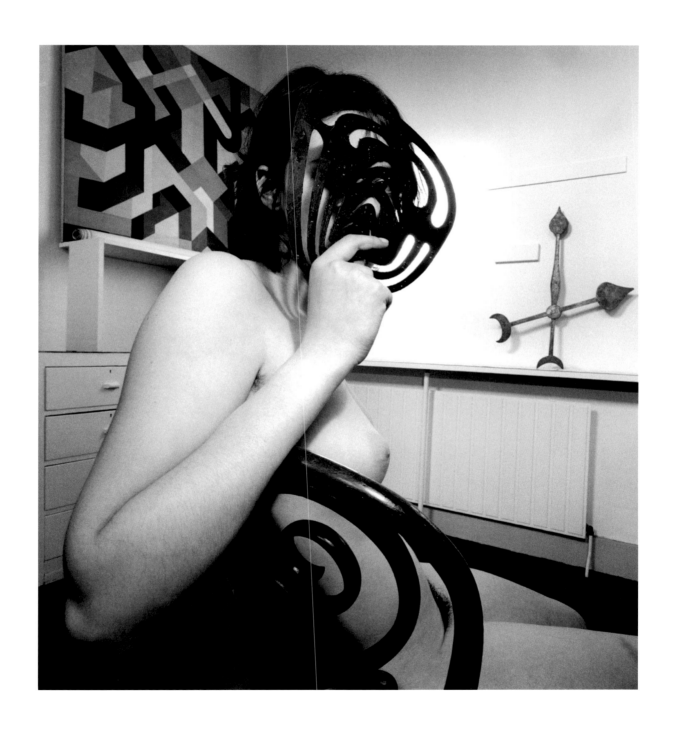

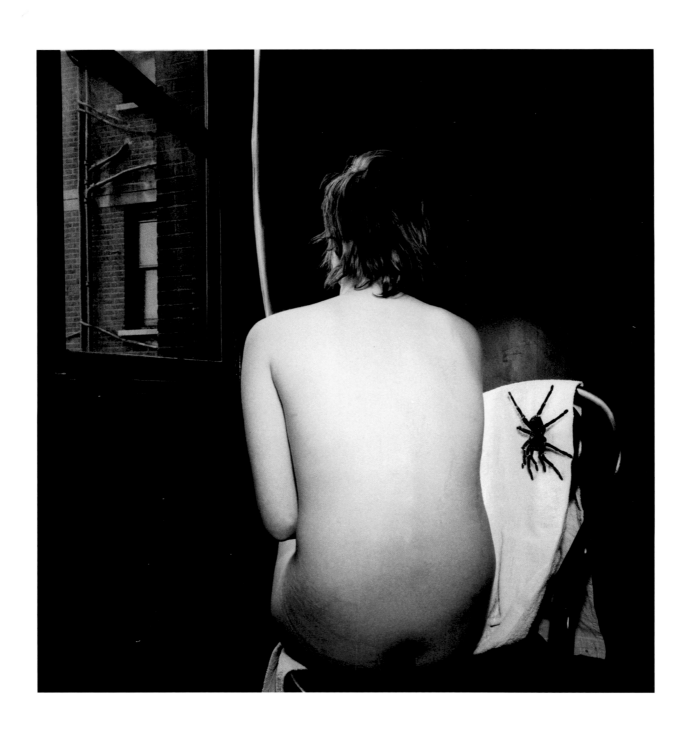

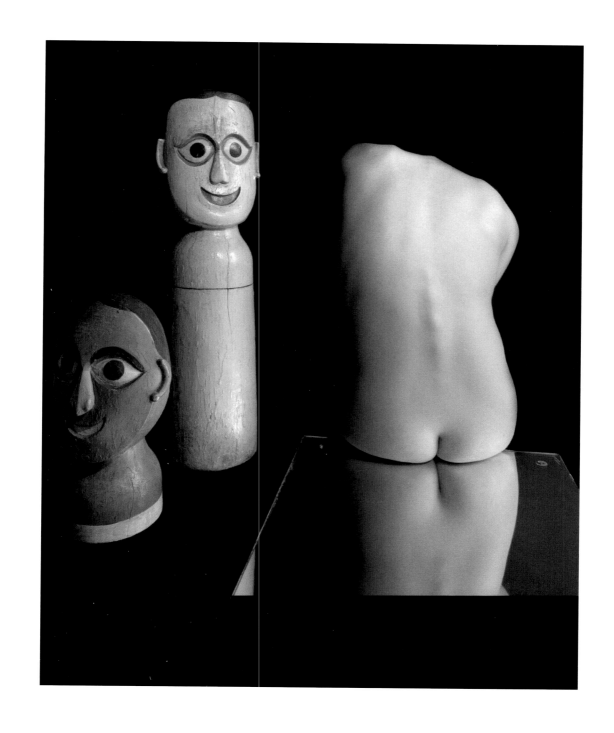

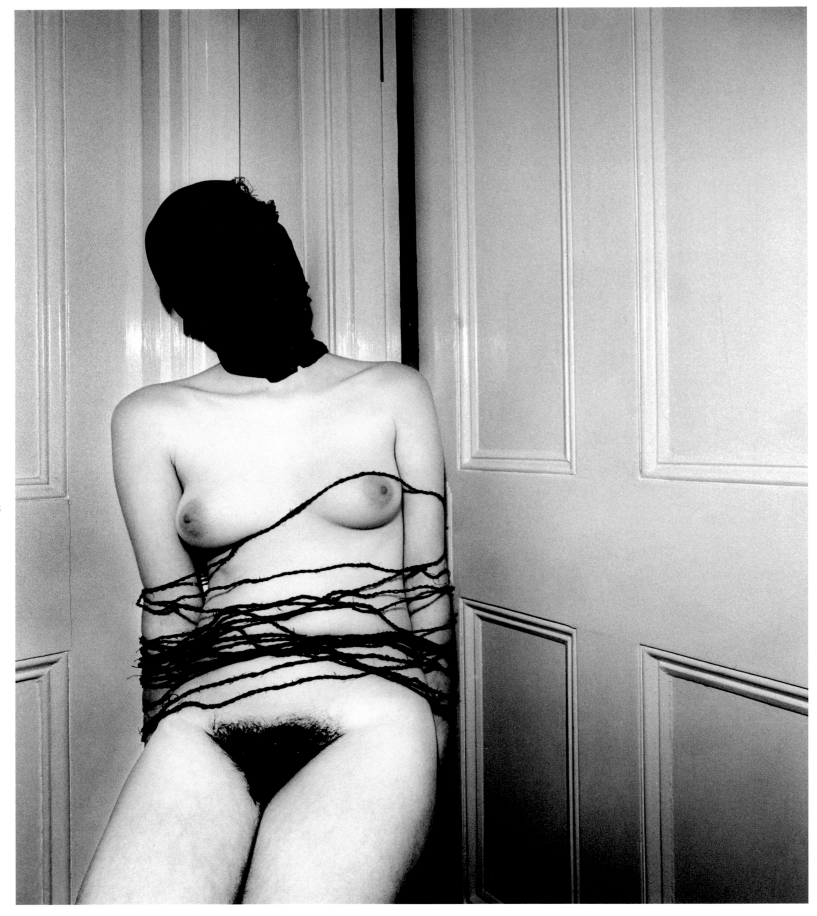

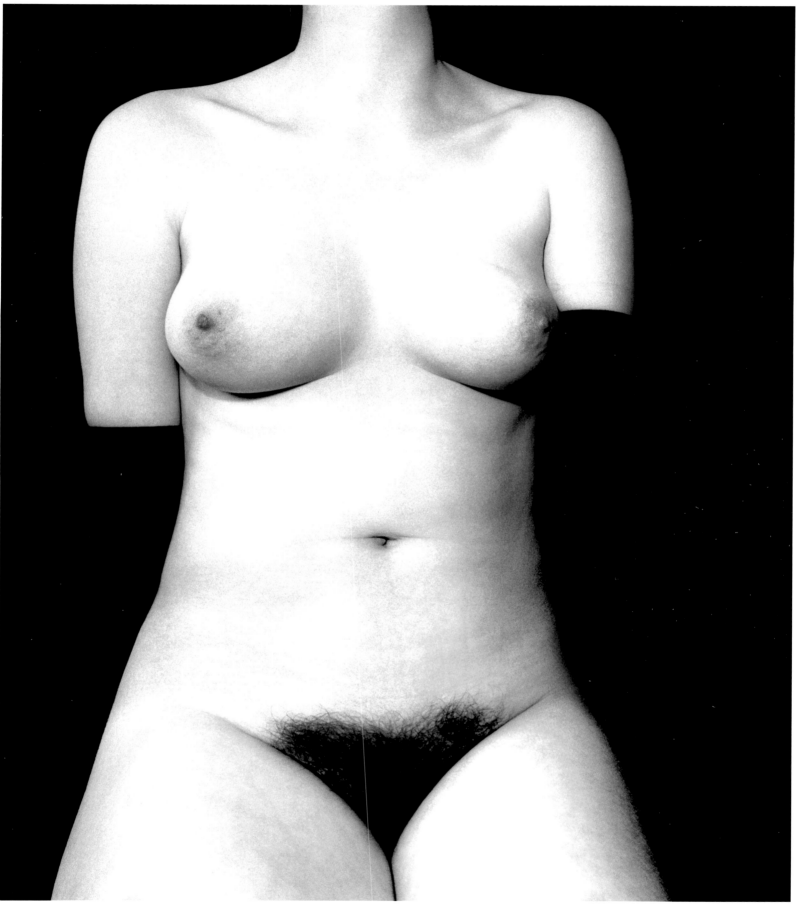

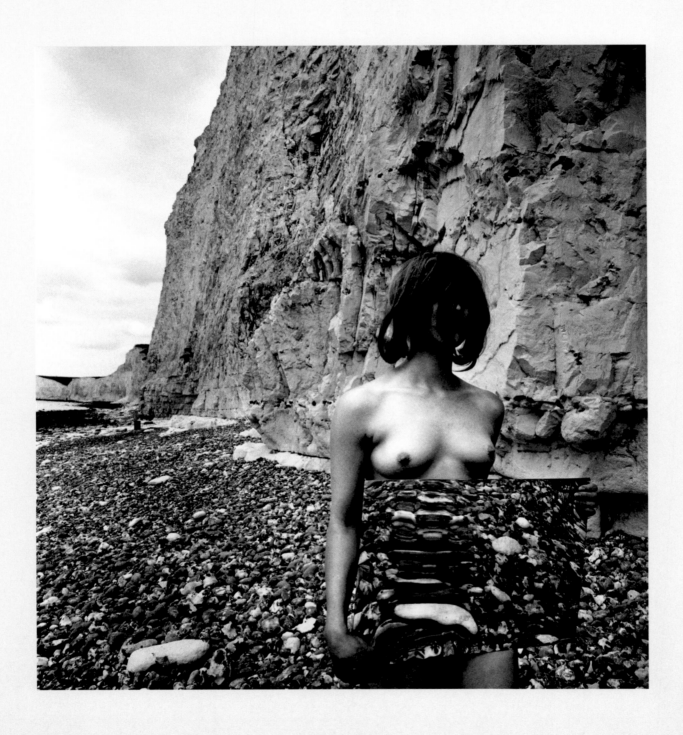

7

'Brandt uses the camera as an extension of the eye – the eye of a poet...his work is a prolonged meditation on the mystery of forms' (Lawrence Durrell – see page 5)

I knew Bill Brandt for the last ten years of his life. We saw each other frequently to talk about exhibitions, acquisitions by the Victoria and Albert Museum and publications of various kinds, as well as meeting at social gatherings. We worked closely on *The Land: Twentieth Century Landscape Photographs* (1975) which Brandt selected for the V&A. I recall him speaking with quiet but genuine distress of growing old (in his case compounded with the problems of diabetes), which is surely part of the subject of the previous section.

Despite this, Brandt remained an engaging, humorous man, delighting in the achievements of the young photographers he admired, thrilled to be photographing individuals he revered: Tom Stoppard and Ted Hughes, for example, whose portraits were commissioned by the V&A. And he was excited by the challenge of making the final nudes of 1977-79. Despite his Old Master status, a charming, innocent and original child remained inside Brandt and perhaps that child-like directness of vision made his nudes so startling. Distinguished photographers, ranging from Ralph Gibson in New York to Eikoh Hosoe in Tokyo, gratefully took their cue from *Perspective of Nudes*.

I remember Brandt's absolute admiration for Edward Weston, whose work took pride of place in *The Land*, and the utter reverence with which he looked at the sculptures of Henry Moore. If Weston sometimes photographed stone as if it were living flesh, Brandt turned the bodies of women into smoothed marine configurations. The sculptures of Henry Moore in timber, stone and bronze inspired Brandt's final campaign on the beach at Newhaven in East Sussex. Brandt described the road from Lewes to Newhaven to me as 'the most beautiful in the world'. One of the late nudes (number 169) is close to a composition from 1934 by his friend Brassaï, while number 162 playfully evokes a feature of the Newhaven beach: the shoals of rounded chalk, fringed with seaweed, uncovered at high tide. Some of his nudes became menhirs.

He continued to the end to make subtle visual metaphors – and metaphors are the surest sign of the poet.

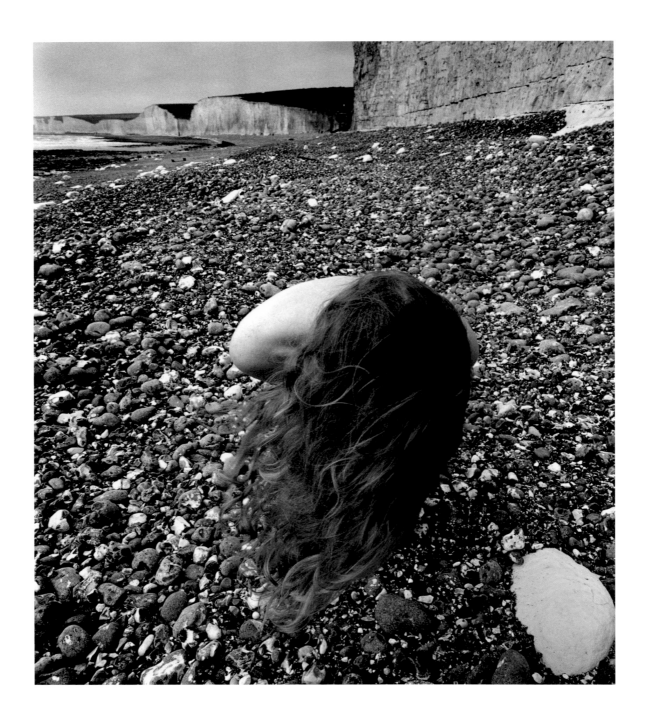

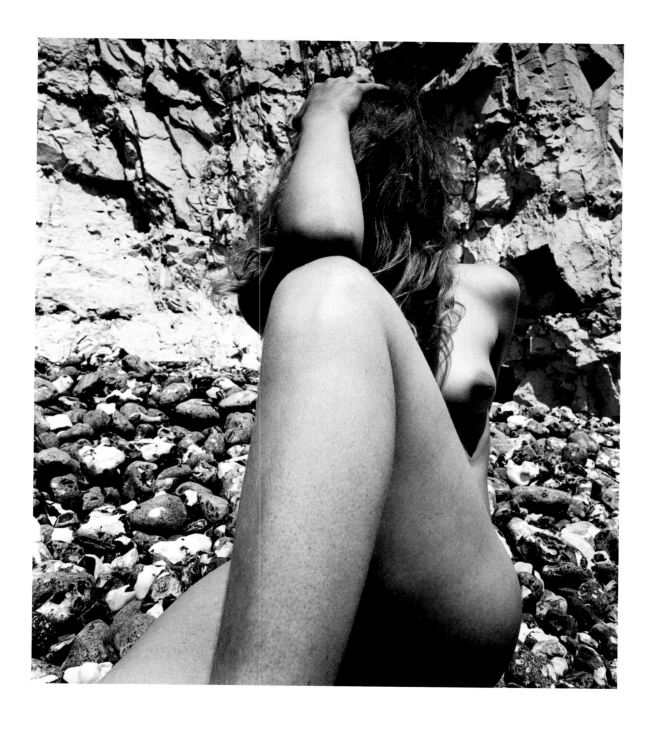

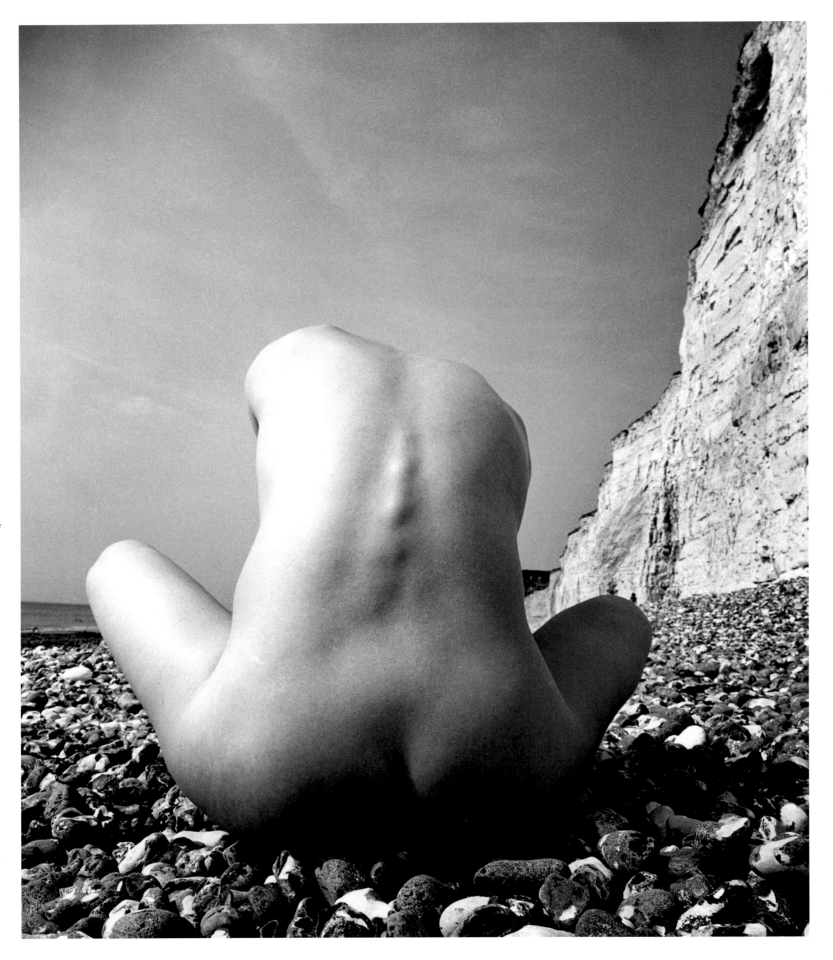

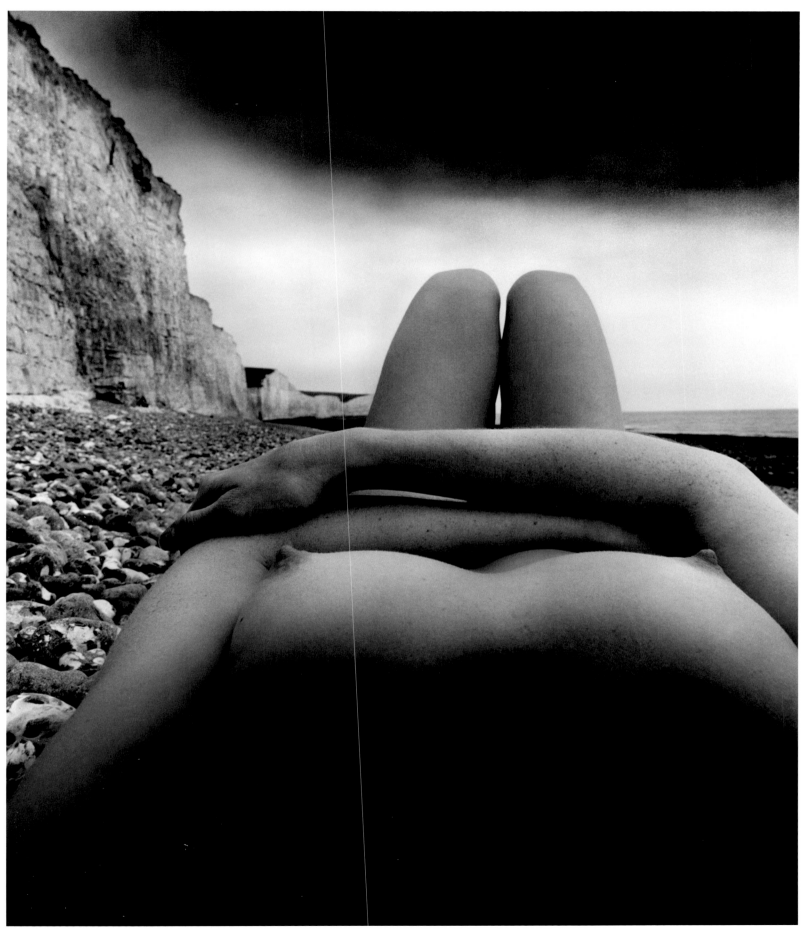

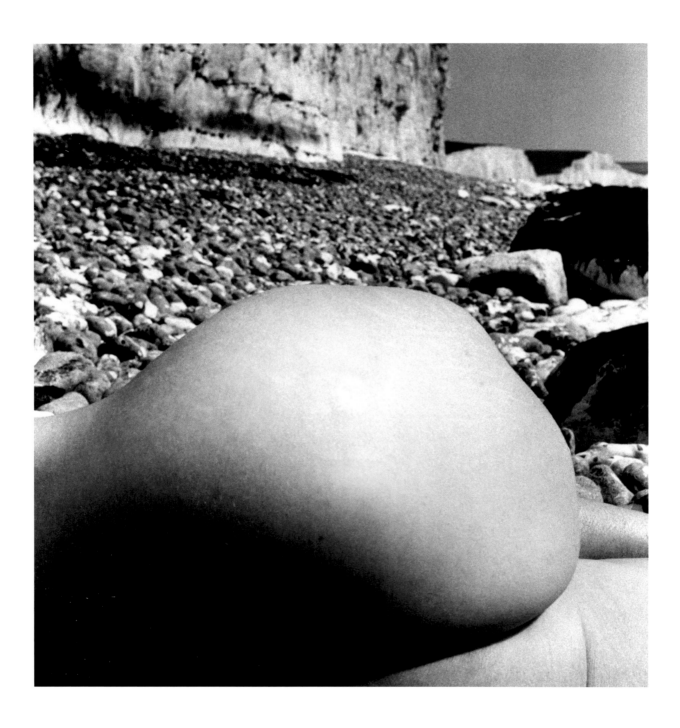

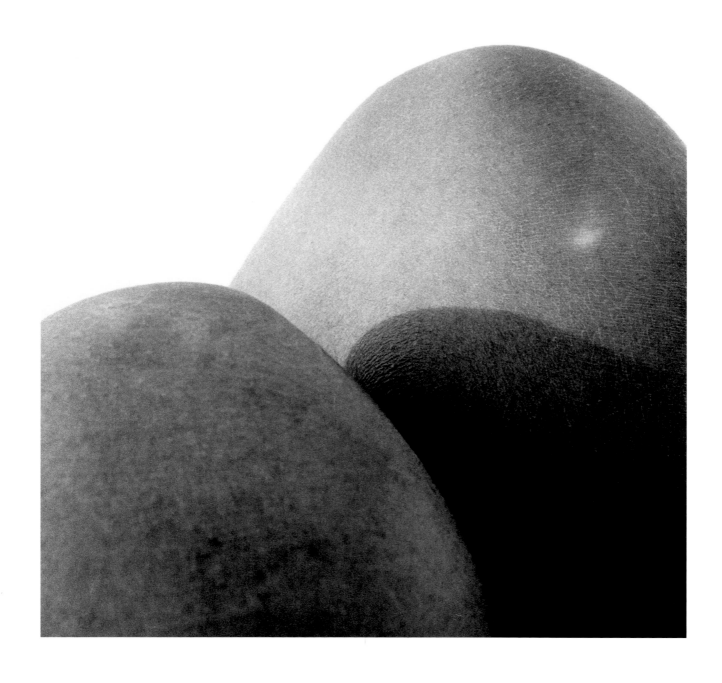

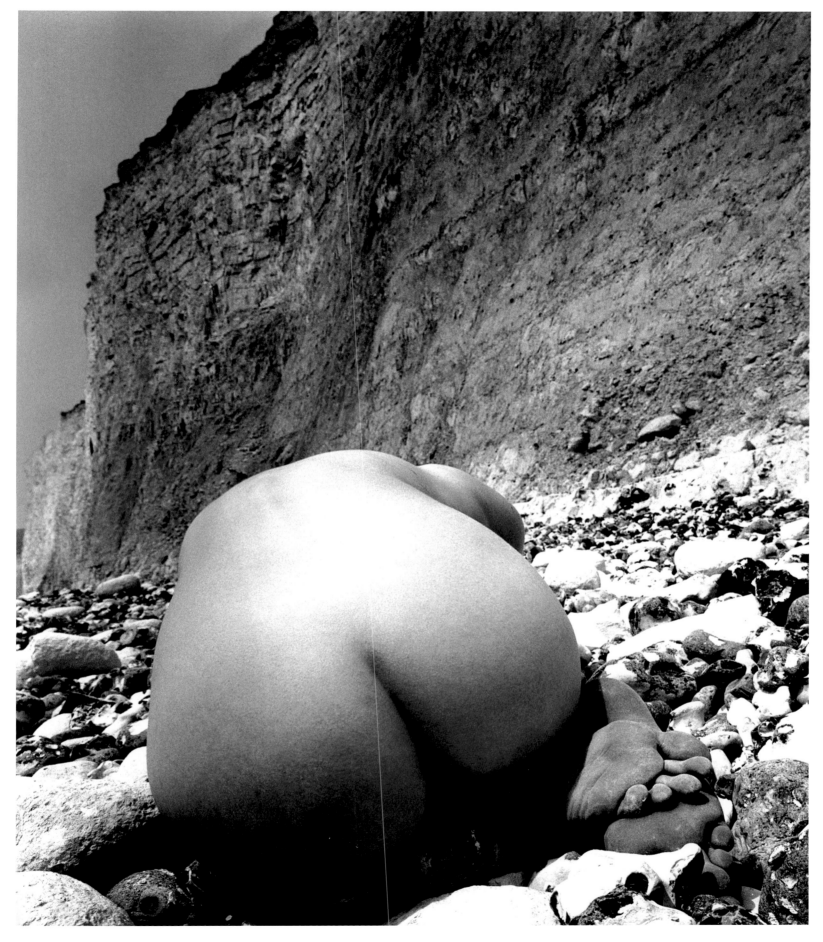

90 Nude, St. Cyprien France, 1957, October

91 Nude, Eygalières France, 1953, October

92 Nude, Baie des Anges, France, 1959

93 Nude, Baie des Anges, France, 1959, October

94 Nude, Baie des Anges, France, 1959

95 Nude, Taxo d'Aval, France, 1957, September

96 Nude, East Sussex Coast, 1959, October

97 Nude, Baie des Anges, France, c. 1959

98 Nude, Vasterival Beach, Normandy, 1954, June

100 Nude, East Sussex Coast, c. 1960

101 Nude, East Sussex Coast, 1960, August

102 Nude, East Sussex Coast, 1960

103 Nude, East Sussex Coast, 1955

104 Nude, East Sussex Coast, 1958, June

105 Nude, Baie des Anges, France, 1959, October

106 Nude, East Sussex Coast, 1959

107 Nude, Baie des Anges, France, 1959, October

109 Nude, East Sussex Coast, 1960

110 Nude, East Sussex Coast, 1959

111 Nude, East Sussex Coast, 1958, January 10

112 Nude, Baie des Anges, France, 1959

113 Nude, East Sussex Coast, 1960

114 Nude, 1950s

115 Nude, East Sussex Coast, c. 1959

116 Nude, Taxo d'Aval, France, 1958

117 Nude, Taxo d'Aval, France, 1957

118 Nude, Hampstead, London, 1957

120 Nude, Hampstead, London, c. 1957

122 Nude, St. John's Wood, London, c. 1955

122 Nude, Campden Hill, London, 1957, May

123 Nude, Campden Hill, London, 1977

124 Nude, Hampstead, London, 1955, June

126 Nude, Campden Hill, London, 1956, February

127 Nude, St. John's Wood, London, 1956

128 Nude, Belgravia, London, 1958, February

129 Nude, St. John's Wood, London, 1957, April

130 Nude, Campden Hill, London, c. 1957

131 Nude, St. John's Wood, London, 1955, December

132 Nude, Campden Hill, London, 1955

133 Nude, Campden Hill, London, 1956

134 Nude, South Kensington, London, 1979, August

136 Nude, London, c. 1942

138 Nude, Campden Hill, London, 1956, April

139 Nude, Campden Hill, London, 1977

140 Nude, Hampstead, London, 1950

141 Nude, Campden Hill, London, 1975, October 29

142 Nude, Campden Hill, London, 1979

143 Nude, Hampstead, London, 1979, October 27

145 Nude, Belgravia, London, 1953, February

146 Nude, Campden Hill, London, 1979, May

147 Nude, Campden Hill, London, 1977

148 Nude, Campden Hill, London, 1977, August

149 Nude, Campden Hill, London, 1975, February 9

151 Nude, Campden Hill, London, 1977

152 Nude, Hampstead, London, 1979, February 11

153 Nude, Campden Hill, London, 1977, February

154 Nude, Campden Hill, London, 1977, July

155 Nude, Hampstead, London, 1950

156 Nude, Campden Hill, London, 1977

157 Nude, Campden Hill, London, 1979, June

158 Nude, Campden Hill, London, 1975

159 Nude, Campden Hill, London, 1975

160 Nude, East Sussex Coast, 1977, July

162 Nude, East Sussex Coast, 1979, June

163 Nude, East Sussex Coast, 1975, August 14

164 Nude, East Sussex Coast, 1978, July 17

165 Nude, East Sussex Coast, 1979, July 19

166 Nude, East Sussex Coast, 1977

167 Nude, East Sussex Coast, 1977, July

168 Nude, Baie des Anges, France, 1959

169 Nude, East Sussex Coast, 1978, August 19

The English at Home
Introduction by Raymond Mortimer. Gravure printed. (London: B.T. Batsford Ltd. Spring 1936, 72pp, 63 illus.) Captions in English and French.

A Night in London: Story of a London Night, in Sixty-Four Photographs.
Introduction by James Bone. (London: Country Life; Londres de Nuit, Paris; Arts et Métiers Graphiques, introduction by André Lejard; New York: Charles Scribner's Sons; 1936, 66pp, 64 illus., paperback only). Captions in English and French.

Camera in London
Introduction 'A Photographer's London' by Bill Brandt. Commentary by Norah Wilson. Technical data by Bill Brandt. (London: The Focal Press, April 1948, 89pp, 59 illus.) Masters of the Camera Series, series editor Andor Kraszna-Krausz.

Literary Britain
Introduction by John Hayward. Excerpts from the work of 76 British writers. (London: Cassell and Company Ltd, 1951, 200pp, 100 illus.) See also revised edition below.

Perspective of Nudes
Preface by Lawrence Durrell. Introduction by Chapman Mortimer. (London: The Bodley Head; New York: Amphoto; Perspectives Sur Le Nu, Paris: Le Belier-Prisma ed.; 1961, 108pp, 90 illus.)

Shadow of Light. A Collection of Photographs from 1931 to the Present
Introduction by Cyril Connolly. Notes on the photographs by Marjorie Beckett. (London: The Bodley Head; New York: The Viking Press; Ombres d'une Ile, Paris: Les Editions Prisma, introduction by Michel Butor; Bill Brandt, Bilder fran fyra årtionden, Stockholm: Nordisk Rotogravyrs Forlag/P.A. Norstedt & Söner, foreword Annagreta Dyring, 1966, 148pp, 161 illus, including 8 in colour). See also the revised and extended edition below.

The Land: Twentieth Century Landscape Photographs
Selected by Bill Brandt Mark Haworth-Booth, Editor. Texts by Jonathan Williams, Aaron Scharf and Keith Critchlow. (London and Bedford: The Gordon Fraser Gallery Ltd., 1975; New York: Da Capo Press, 1976. 80pp, 48 illus.) This book of landscape photographs by various photographers, selected by Bill Brandt, was originally published as an exhibition catalogue to accompany an exhibition of the same name at the Victoria and Albert Museum, London (13 Nov 1975 - 15 Feb 1976).

Shadow of Light, 2nd (revised and extended) edition
Dedicated to Norman Hall. Introduction to the previous edition by Cyril Connolly. Introduction by Mark Haworth-Booth. (London: The Gordon Fraser Gallery Ltd. (Gordon Fraser Photographic Monographs 7); New York: Da Capo Press Inc.; Ombre de Lumière, Paris: Editions du Chêne; 1977, 182pp, 169 illus., bibliog.)

Bill Brandt: Nudes 1945-1980
Introduction by Michael Hiley in English, French and German. (London and Bedford: The Gordon Fraser Gallery Ltd. (Gordon Fraser Photographic Monographs 8); Boston: The New York Graphic Society/Little Brown and Company, 1980, 20pp, 100 illus.)

Bill Brandt: Portraits
Introduction by Alan Ross. (London and Bedford: The Gordon Fraser Gallery Ltd. (Gordon Fraser Photographic Monographs 11); Austin: University of Texas Press, 1982, 116pp, 104 illus.)

Bill Brandt
Introduction 'Photographie Solitaire et Inquiet' and afterword 'Portraits, Paysages et Nus' by Mark Haworth-Booth. (Milan: Gruppo Editoriale Fabbri S.P.A., 1982 (I Gran Fotografi); Paris: Union des Editions Modernes, 1984, 64pp, 50 illus., bibliog., chronol., note on technique. Les Grandes Maîtres de la Photo 1).

Literary Britain, 2nd (revised) edition
Foreword by Sir Roy Strong. Introduction by John Hayward. Excerpts from the work of 42 British writers. Edited with an afterword and notes by Mark Haworth-Booth and 'Poetry: Bill Brandt Photographer' (reprinted from Lilliput, Aug. 1942, p. 130) and 'A Retrospect' by Tom Hopkinson. (London and Bedford: The Gordon Fraser Gallery Ltd.; London: Victoria and Albert Museum in association with Hurtwood Press; London: Victoria and Albert Museum in association with Aperture; New York: Da Capo Press Inc.; New York: Aperture in association with Westerham Press, 1986, 173pp, 79 illus., 75 of these landscapes). Mark Haworth-Booth's notes indicate the changes made in this revised edition of the book. This edition was originally published as a catalogue to accompany an exhibition of the same name, London: Victoria and Albert Museum (6 March - 20 May 1984).

Bill Brandt: London in the Thirties
(London and Bedford: The Gordon Fraser Gallery Ltd., 1983; New York; Pantheon Books, 1984, 98pp, 96 illus.)

Bill Brandt: Behind The Camera, Photographs 1928 - 1983.
Introductions 'European Background'; 'The English at Home'; 'A Night in London'; 'Wartime and Its Aftermath'; 'Portraits'; 'Literary Britain'; 'Perspective of Nudes' by Mark Haworth-Booth. Essay 'Brandt's Phantasms' by David Mellor. (Oxford: Phaidon; New York: Aperture, 1985, 99pp, 89 illus., bibliog.) Originally published as a catalogue to accompany an exhibition at the Philadelphia Museum of Art (8 June - 21 Sept 1985). It is a principal source of biographical and bibliographical material about Brandt.

Shelters: Living Underground in the London Blitz
Mike Seabourne; Editor. Images by Bill Brandt and Other Unrecorded Photographers Introduction 'Shelters: Living Underground in die London Blitz' by Mike Seabourne. (London: Nishen, 1988, 32pp, 30 illus., seven by Brandt, paperback only, Nishen Photography: The Photo-Library 7).

Bill Brandt: Essai (French)
Patrick Roegiers. (Paris: Pierre Belfond, 1990. 212pp, 16 illus., bibliog. Les Grands Photographes. Series editor Jean-Luc Monterosso). This is a critical biography of Brandt containing extensive bibliographical material in the notes.

Bill Brandt: The Assemblages.
Zelda Cheatle and Adam Lowe, Editors. (Kyoto, Japan: Kyoto Shoin, 1993, 102pp, 57 illus., 31 colour, 26 duotone). This book reproduces colour photographs of 31 of Brandt's collages together with Brandt's own black-and-white images of some of them.

172

Bill Brandt Photographs 1928 - 1983
Ian Jeffrey, Editor. Introduction by Ian Jeffrey. (London: Thames and
Hudson, 1993, 192 pp, 200 illus, bibliog., chronological appendices).
This book was originally published to accompany an exhibition at the
Barbican Art Gallery, London (30 Sept - 12 Dec 1993). It includes
many previously unpublished photographs by Brandt together with
a long critical essay and detailed bibliographical information about
Brandt's magazine work, including the locations of photo-stories and
individual pictures for Weekly Illustrated, Lilliput, Picture Post and
Harper's Bazaar.

Bill Brandt: Selected Texts and Bibliography
Nigel Warburton, Editor. Introduction by Nigel Warburton (Oxford:
Clio Press; New York: G K Hall, 1993).

Bill Brandt (Photo Poche Series and Photofile Series)
Introduction by Ian Jeffrey. Bibliography by Nigel Warburton. (Paris:
Centre Nationale de la Photographie, 1994; London: Thames &
Hudson, 2007; and Tokyo: Sogensha Co., 2012, 144pp, 61 illus.)

Brandt
Introduction by Bill Jay. Catalogue of works by Nigel Warburton.
(London: Thames & Hudson; New York: Harry N. Abrams; Paris:
Editions de la Martinière, 1999, 320pp, 378 illus.), bibliography, note
on Brandt's printing styles.

Brandt: Icons
A centenary tribute. Essay by Nigel Warburton. (London: The Bill
Brandt Archive Ltd. 2004, 48pp, 30 illus.)

Bill Brandt, A Life
Paul Delany, Author (London: Jonathan Cape; Stanford: Stanford
University Press, 2004, 336pp, 106 illus.) The authorised biography.

Homes Fit for Heroes: Photographs by Bill Brandt 1939 - 43
Peter James, Author; Richard Sadler, Author; (Stockport: Dewi
Lewis Publishing, 2004, 112pp, 63 illus.). Examines work carried
out between 1939 and 1943 when Brandt worked on a commercial
assignment for the Bournville Village Trust.

Brandt Nudes: A New Perspective (Limited Edition)
Collector's Edition in clamshell box 1,000 copies declared / 550
copies printed. (London: Bill Brandt Archive; 2004, 160pp, 142 illus.)

Bill Brandt: Behind The Camera (Aperture Monograph Series)
David Mellor, Author; Mark Haworth-Booth, Contributor (New York:
Aperture, 2005, 100pp, 89 illus., bibliog.)

173

1900 Sigmund Freud's *The Interpretation of Dreams* is published.

1904 Bill Brandt (Hermann Wilhelm Brandt is born, 3 May, Hamburg. His father is British, of Russian descent; his mother is German.

1921 Man Ray moves to Paris.

1923 Brandt suffers from tuberculosis and is sent to a sanatorium near Lugano.

1923 Berenice Abbott begins work as Man Ray's assistant.

1924 Brandt is moved to the Schweizerhof sanatorium near Davos, Switzerland, and while there he is psychoanalysed by Wilhelm Stekel. During this time he does some painting and experiments with a Brownie Box Camera.

1924 André Breton publishes *The First Surrealist Manifesto*.

1926 Brandt leaves the sanatorium at Davos.

1927 Brandt travels to Vienna; Eugène Atget dies in Paris.

1928 Brandt photographs Ezra Pound. Luis Buñuel and Salvador Dali's film *Un Chien Andalou* is shown in Paris.

1930 Brandt works as Man Ray's assistant in Paris.

1932 Brandt's photographs are published in the German magazine *Der Querschnitt*.

1933 Brandt travels to Spain and Hungary. Arts et Métiers Graphiques publishes Brassaï's *Paris de Nuit*.

1934 Brandt travels to England to work as a freelance photojournalist. J.B. Priestley's *English Journey* and Man Ray's *The Age of Light* are published. Brandt contributes to Weekly Illustrated, Britain's first popular picture magazine and works for the Black Star picture agency. Brandt's photograph of a tailor's dummy appears in *Minotaure* accompanied by a text written by Réne Crevel.

1936 Brandt visits Georges Braque in Normandy and is introduced to the wonders of the beaches of northern France. Brandt's first book, *The English at Home*, is published.

1937 George Orwell's *The Road to Wigan Pier* is published. Brandt travels to the Midlands and North of England to photograph life in towns. Stefan Lorant founds *Lilliput*.

1938 Brandt has his first exhibition, Galerie du Chasseur d'Images, Paris. *A Night in London* is published. Brandt begins regular freelance contributions to Lilliput and to the newly founded *Picture Post*. He continues to contribute to these magazines for a period of twelve years.

1939 Brandt's photographs are published in art magazine *Verve*.

1940 The Battle of Britain; the London Blitz begins. Henry Moore makes his 'Shelter Drawings'. Brandt makes shelter photographs for the Ministry of Information: a set of these is given to Wendell Wilkie.

1941 Brandt begins work for the National Buildings Record, documenting historic buildings and monuments endangered by Luftwaffe 'Baedeker' raids targeted on ancient cities.

1942 Brandt's first published nude, *Lilliput* (August).

1943 Brandt begins working freelance for *Harper's Bazaar*, both British and American editions. His photographs, mostly portraits, appear intermittently in this magazine over a period of more than twenty years.

1945 Brandt buys a Kodak Wide-Angle camera in Covent Garden and uses it to photograph nudes.

1948 Brandt's photographs are included in a group exhibition, '4 Photographers' with those of Lisette Model, Ted Croner and Harry Callahan at the Museum of Modern Art, New York. Focal Press publishes Brandt's *Camera in London*, which includes his major statement about photography: 'A Photographer's London'.

1949 Focal Press publishes Brassaï's *Camera in Paris*. Carol Reed's film *The Third Man* is released.

1951 The Festival of Britain takes place in London. Brandt's *Literary Britain* is published and widely reviewed.

1961 Publication of Brandt's *Perspective of Nudes*.

1963 Brandt's photographs are exhibited at George Eastman House, Rochester, New York (15 Apr - 17 Jun).

1966 The first edition of Brandt's selection from his work *Shadow of Light* (including 8 colour photographs) is published to great critical acclaim. R.B. Kitaj paints *Screenplay* based on two of Brandt's photographs.

1968 Brandt begins work on his three-dimensional collages, made from beach flotsam displayed in flat perspex boxes.

1969 Brandt has a major retrospective exhibition at the Museum of Modern Art, New York (16 Sept - 30 Nov).

1970 The Museum of Modern Art exhibition moves to the Hayward Gallery, London (30 April - 31 May) – it is the first photography exhibition to be sponsored by the Arts Council of Great Britain.

1974 Brandt's collages are exhibited at the Kinsman Morrison Gallery, London (17 June - 12 July). Brandt is awarded the 1974 Society of Industrial Artists and Designers medal.

1975 Brandt selects photographs for *The Land: Twentieth Century Landscape Photographs* at the Victoria and Albert Museum, London.

1977 Brandt is made an honorary doctor of the Royal College of Art, London. A revised edition of his *Shadow of Light* is published.

1980 Brandt's *Nudes 1945-1980* is published. He is made an Honorary Member of the Royal Photographic Society.

1981 A major retrospective of Brandt's photography at the Royal Photographic Society, Bath.

1982 Brandt's portrait photographs are exhibited at the National Portrait Gallery, London. *Bill Brandt: Portraits* is published.

1983 Brandt's *London in the Thirties,* a book which reprints some of his earliest work, is published. Two films about Brandt are made. Brandt dies in London, 20 December.

1985 A major retrospective exhibition of Brandt's work, *Bill Brandt: Behind the Camera, Photographs 1928-1983* at the Philadelphia Museum of Art (8 June - 21 Sept).

1993 A major retrospective exhibition of Brandt's work at the Barbican Art Gallery, London (30 Sept - 12 Dec).

1999 Publication of a major monograph covering Brandt's entire career coincides with a retrospective exhibition held at the ICP, New York (Sept - Dec).

2004 The centenary year is marked by a retrospective at the Victoria & Albert Museum, London, and by the publication of this book as a limited edition.

2013 Second major retrospective at The Museum of Modern Art, New York (5 March - 12 August).

Production Note

Brandt's nudes were first published in 1961 in the now classic and much sought after first edition entitled *Perspective of Nudes*. This book is now acknowledged as one of the seminal photography books of the 20th century. The printing process used in that edition was the gravure process which enhances black and white prints to a velvety richness on paper. This highly compressed black and white tonality is also an acknowledged hallmark of Bill Brandt's printing style. Later, in 1976, the publisher Gordon Fraser printed *Nudes 1945-80*, which was an even more tonally absent reworking and updating of the original edition.

I was lucky enough to have seen Bill Brandt at work in his cramped home darkroom, hunched under his towering Kodak enlarger. The consequence of sandwiching his negatives between two heavy plate glass carriers in his faithful enlarger was a plethora of dust and a diffusion of some of the detail in these images. Furthermore, he did not keep darkroom notes and the highly skilled printers who are currently printing from Brandt's negatives consider them to be some of the most difficult that they have ever faced. However, book printing has changed considerably since the first edition of *Perspective of Nudes* and into the new digital age, and with modern reproduction techniques most of this can be avoided. The images in this book have been produced from the best originals we have had access to, allowing us to take every care to provide the sharpest and cleanest images possible whilst maintaining the mystery and atmosphere that Brandt sought.

John-Paul Kernot
Director of The Bill Brandt Archive

First published in the United Kingdom in 2012 by
Thames & Hudson Ltd., 181A High Holborn, London WC1V 7QX

www.thamesandhudson.com

First published in 2013 in hardcover in the United States of America by
Thames & Hudson Inc., 500 Fifth Avenue, New York, New York 10110

thamesandhudsonusa.com

Editorial direction	Roger Sears
Art direction	David Pocknell
Layout design	Silvia Benavente

British Library Cataloguing-in-Publication Data
A catalogue record for this book is available from the British Library.

ISBN: 978-0-500-97042-3
Library of Congress Catalog Card Number 2012943211

Printed and bound in Italy by Arti Grafiche Amilcare Pizzi S.p.a.

La Géante

The Giantess

Charles Baudelaire

Du temps que la Nature en sa verve puissante
Concevait chaque jour des enfants monstrueux,
J'eusse aimé vivre auprès d'une jeune géante,
Comme aux pieds d'une reine un chat voluptueux.

J'eusse aimé voir son corps fleurir avec son âme
Et grandir librement de ses terribles jeux;
Deviner si son coeur couve une sombre flamme
Aux humides brouillards qui nagent dans ses yeux;

Parcourir à loisir ses magnifiques formes;
Ramper sur le versant de ses genoux énormes,
Et parfois en été, quand les soleils malsains,

Lasse, la font s'étendre à travers la campagne,
Dormir nonchalamment à l'ombre de ses seins,
Comme un hameau paisible au pied d'une montagne.

176

When Mother Nature filled the early world
With mammoth creatures suckled at her teat
I could have lived near some gigantic girl,
Like a little cat, sprawled at a queen's feet,

And watched her body ripen and grow wise,
Her soul grow strong in terrifying games,
Or from the smoke clouds darkening her eyes,
Guessed when her heart was going up in flames;

Wandering through her wilderness at ease,
I could have conquered those enormous knees,
And some hot summer when she lay at rest

Stretched out across the fertile earth, I'd put
My head down in the shadow of her breast
A sleepy hamlet at the mountain's foot.

From Complete Poems, *translated by Walter Martin, (1997),* Carcanet Press Ltd.
This poem appeared in the first edition of Perspective of Nudes *(1961).*